This book is dedicated to the memory of my father and mother Ron and Isa

The Jokers

First published in Great Britain in 1999 by
PAVILION BOOKS LIMITED
London House, Great Eastern Wharf
Parkgate Road, London SW11 4NQ

Photography © Trevor Leighton
Design and layout © Pavilion Books Ltd

The moral right of the author
and illustrator has been asserted

Designed by Grant Scott

A CIP catalogue record for this book is available from the British Library.

ISBN 1 86205 252 2

Printed in Spain by EGEDSA, Spain
Colour origination in England by Colourpath

10 9 8 7 6 5 4 3 2 1

This book can be ordered direct from the publisher.
Please contact the Marketing Department. But try your bookshop first.

The Jokers

Photographs
by Trevor Leighton

Foreword by
Dawn French

Designed by Grant Scott

PAVILION

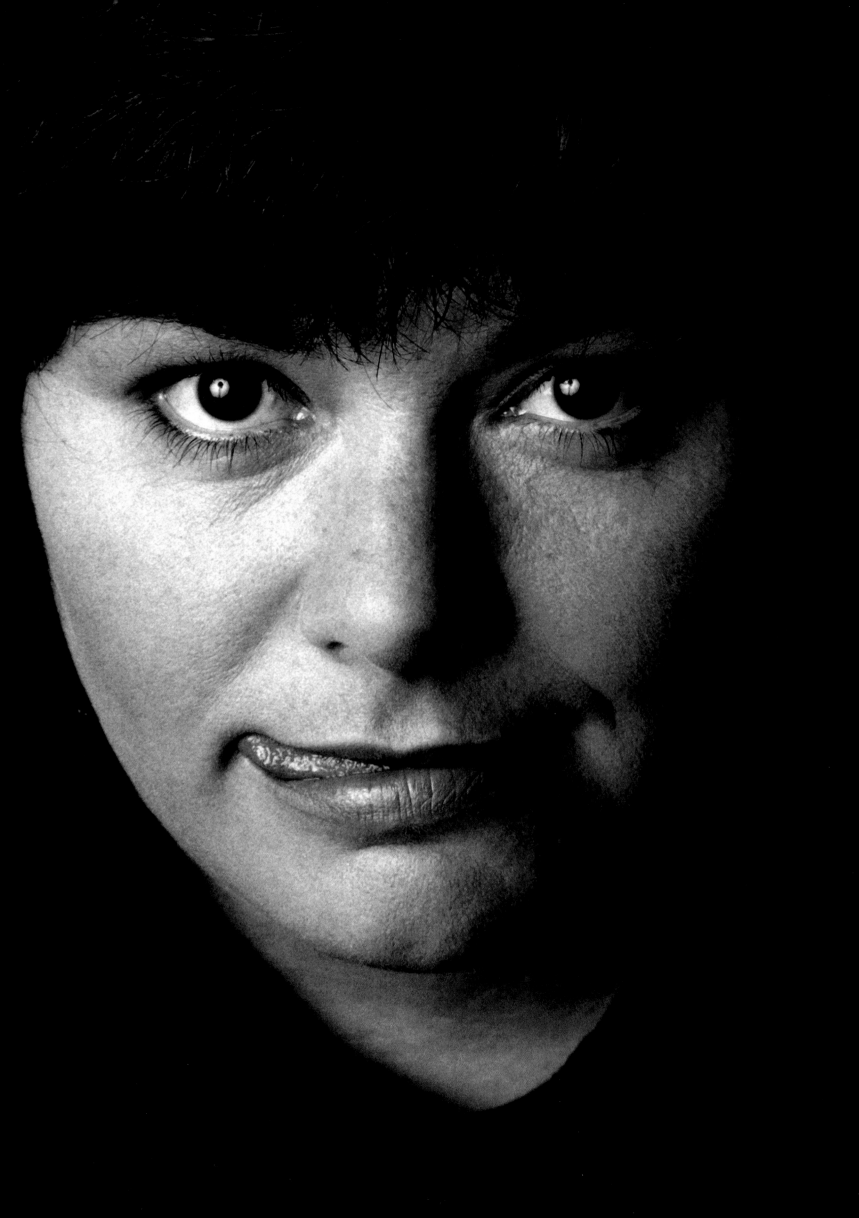

DAWN FRENCH

To: Trevor Leighton

Trev — here it is. Hope you
like it. I've tried to
be funny + affectionate
+ truthful.

Big Love.

DAWN x

I first met him in 1981 when he came to take my picture in a house I shared with four other people, one of whom was Jennifer Saunders. Alternative comedy was the hip thing to like at the time and we had just joined the pack at the Comic Strip. We weren't very good at the job, but that didn't really matter at all because we were (and still are) women and really, considering both the p.c. and novelty value, that was all that counted. Any road up spotty Trevor was sent along to our student house to take a snap of me looking female and alternative, but mainly female. He was quite nervous. This could have been because of his fear of my rapier wit but was more likely because of his fear of my industrial and rather threateningly huge bosoms. He dropped most of his equipment several times whilst setting up. Trying to break the ice, I endeavoured to engage him in some friendly chat. I asked him if he had photographed any dead famous people (not dead and famous you understand) and if so what were they like? He puffed up like a bantam cock and regaled me with stories of a comedian he had photographed the day before. Oh how they had laughed together, oh what a lot they had in common, two blokey working-class, leftey, blokey blokes together laughing all the livelong day. Yep, they were best mates all right. Turned out this bloke was Lenny Henry off the telly. I laughed a lot at this revelation and called out Len, come here now! to grumpy Len who was asleep upstairs at the time. Trevor, somewhat bemused at my strange behaviour, laughed inanely, supposing it was alternative humour from London, and beyond his understanding, what with him being from Carlisle. I will never forget the look of utter stupefaction on his face when two minutes later Len walked into the room. The blokey photographer, Len's best mate, had been revealed as a resounding wanker. A glorious victory indeed. Obviously this incident gave me the upper hand in my relationship with Trevor, which is how I like it. This dynamic has remained much the same during the last twenty years. That is how long I have known him, and that is how long I've loved him.

It is rare to have a friend with such tangible talent, and to have the opportunity to watch that talent develop into a consummate skill over the years. Although Trevor is a jobbing photographer and director whose time is mainly filled with lots of advertising, editorial and fashion work, his true passion is portraiture. There is a distinctive signature to his work, the key elements for me being simple, elegant, classic, powerful and arresting images. His interpretations are various, dependent I suppose on his mood and the mood of the subject, and of course the circumstances.

Trevor is a confident person in many ways. He flies aeroplanes, he builds kitchens, he fastidiously processes and edits his own work. But to see him in the studio just before he takes a portrait is to witness a nervous, twitchy, surly chap. Not confident at all. He puts loud music on, stomps up and down pulling out his hair, tutting and being generally discourteous. It is usually during this little combative ritual, this percolating time, that he is at his most creative. It can be

mightily offputting if you are the ~~patient victim sucker~~ sitter. He is determined to achieve a good portrait, to somehow represent the person, not simply render a likeness but present some kind of clue as to the nature of that person. Often of course, he doesn't know the person he's photographing but his talent is to capture some predominant quality in the abstract. A sort of distilled version of that person. A tall order.

It must surely help if he likes the person he's working with. With this book in particular, Trevor has chosen to portray lots of people who have made him laugh. He happened to have occasion to photograph many comedians, comic actors and writers long before he knew he was going to compile such a book. It was a natural step to ask those he hadn't yet met, but admired, to help him complete this wonderful record of important comedy folk. Of course, we will all feel that there are those he has omitted, but this book is the result of a) choice; b) happy accident; and c) twenty odd years of hard work.

For me the outcome is a feast. The people in these pages are all very different and their responses to having their photos taken is intriguing. For many, sitting for a photo is a regular event. Some are clearly suspicious of both the process and the photographer, most are tentative and a few see it as a chance to perform. I know that when your job is comedy there is a huge temptation to gurn or mug, partly because you are endlessly encouraged to do so, and partly because comedians on the whole have a natural dramatic ability and a massive need to please. Trevor instinctively knows this and makes interesting choices precisely because of it. I usually end up smiling with far more teeth than I've actually got so that my gran will like it and know I'm happy. The performances of the faces in this book are very satisfying.

I don't believe it's possible to have your picture taken without thinking about how you are representing yourself. There are so many facets of a human being, no one picture can represent them all. Both the photographer and the sitter are working together on the sitter's appearance. It's a fascinating and vulnerable position to be in and I thank the participants all the more for co-operating. They are all attractive, attentive to their personal hygiene and extremely good in bed.

This book is both beautiful and important. Trevor has realised some of his best work in these pages and has set down for us through portraiture, a kind of personal record of comedy at this particular time. Excellence in art, as I suppose in everything else, can only be achieved by dint of painstaking hard graft. It is not accidental that this book is wonderful. Because so is Trev.

DAWN FRENCH

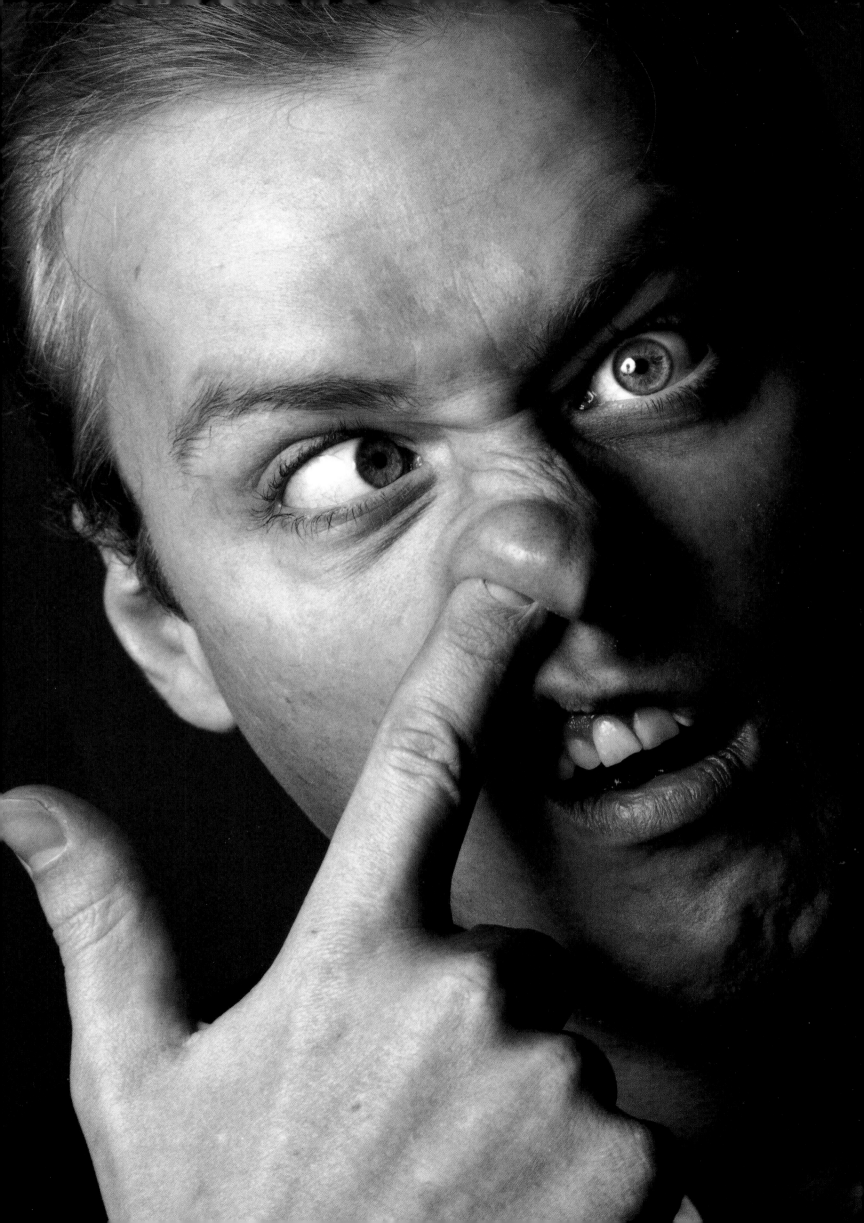

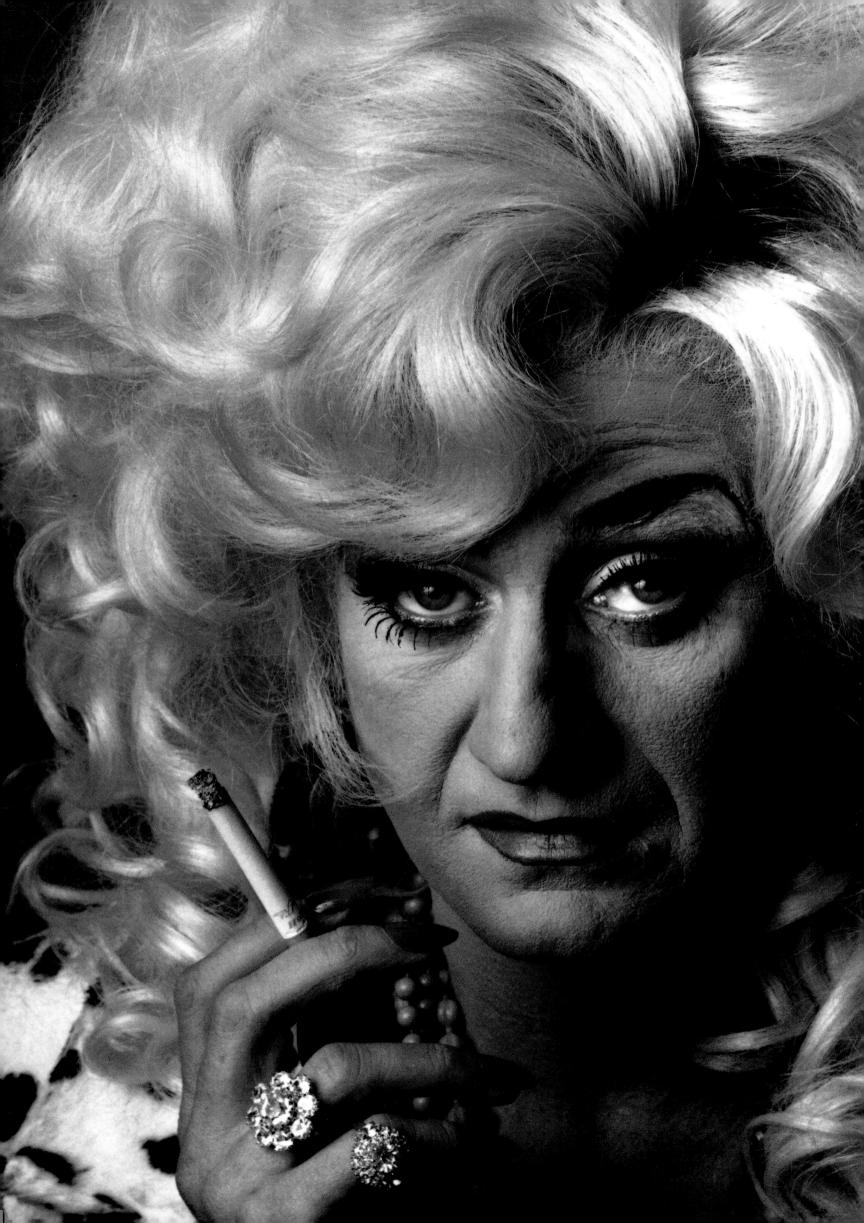

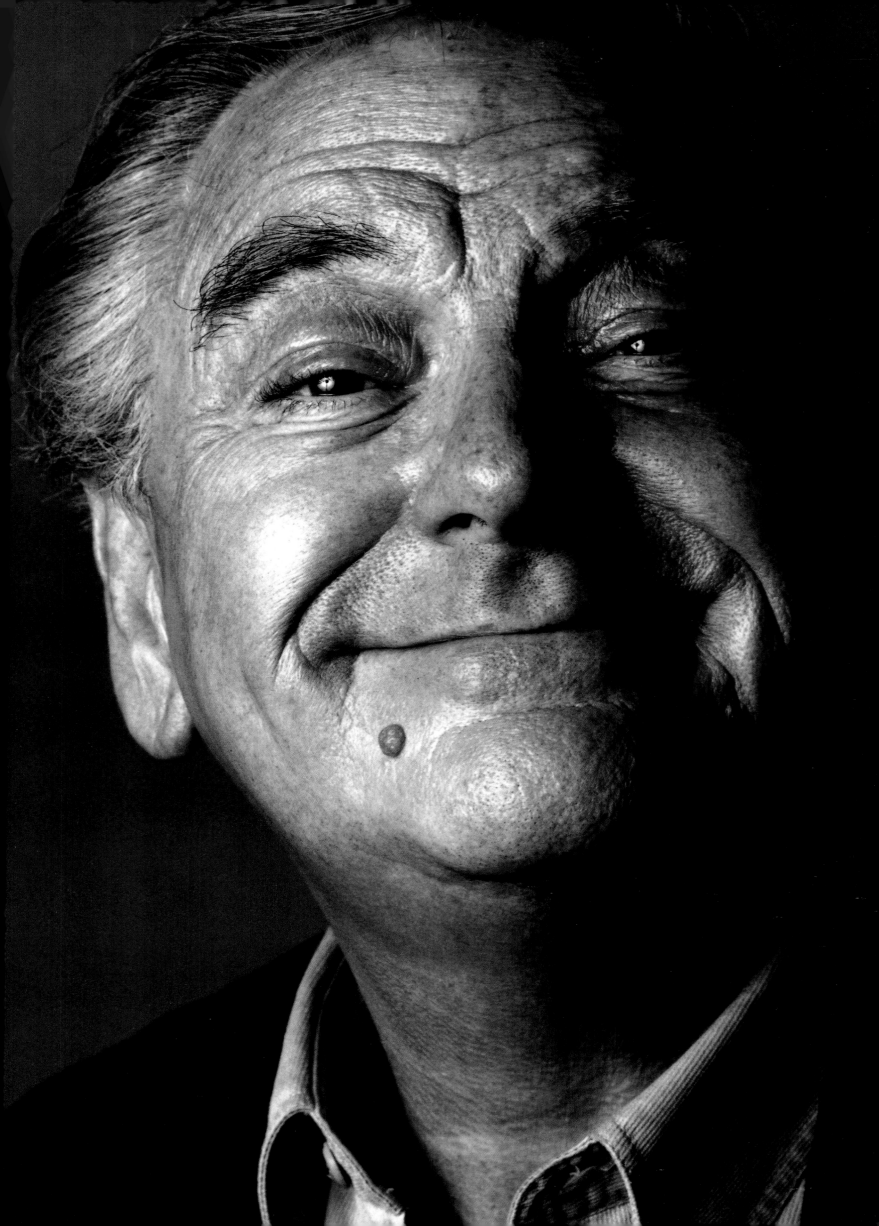

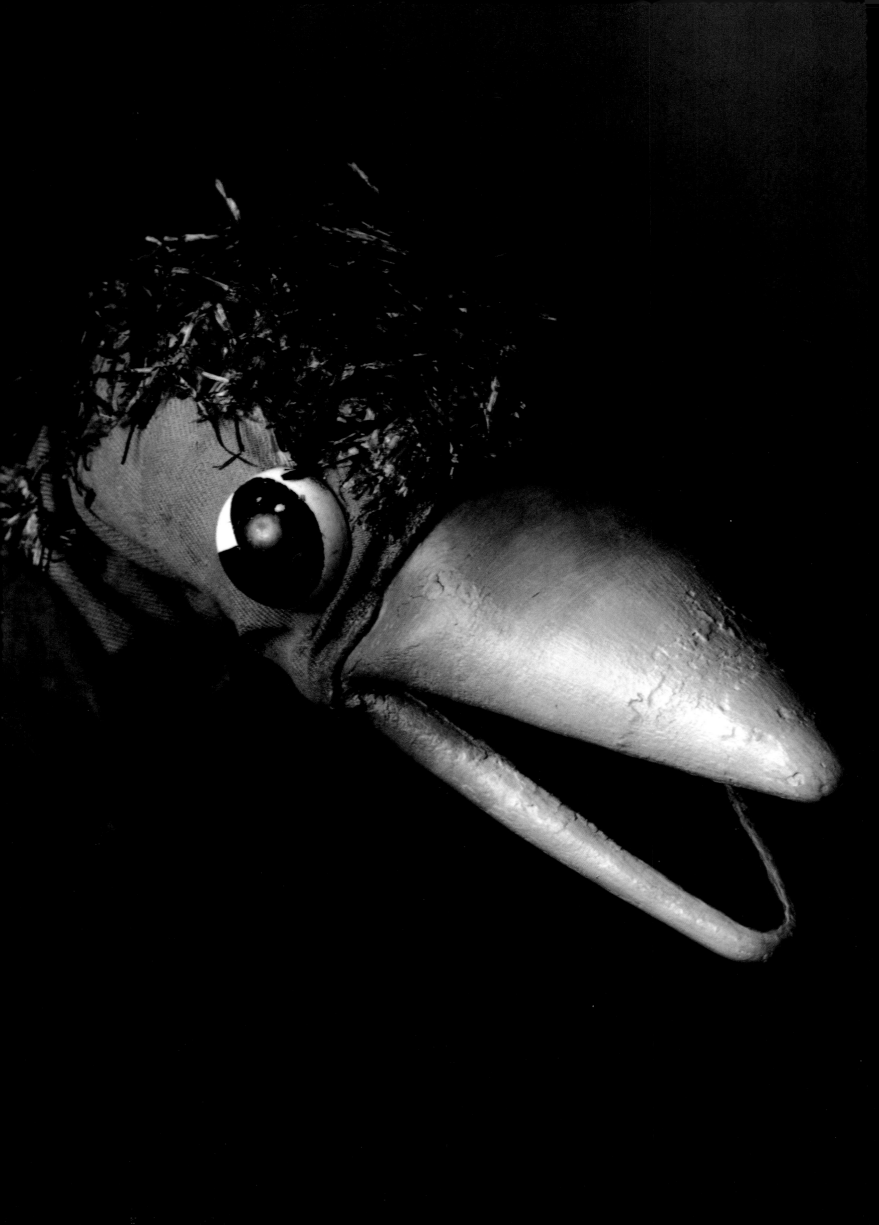

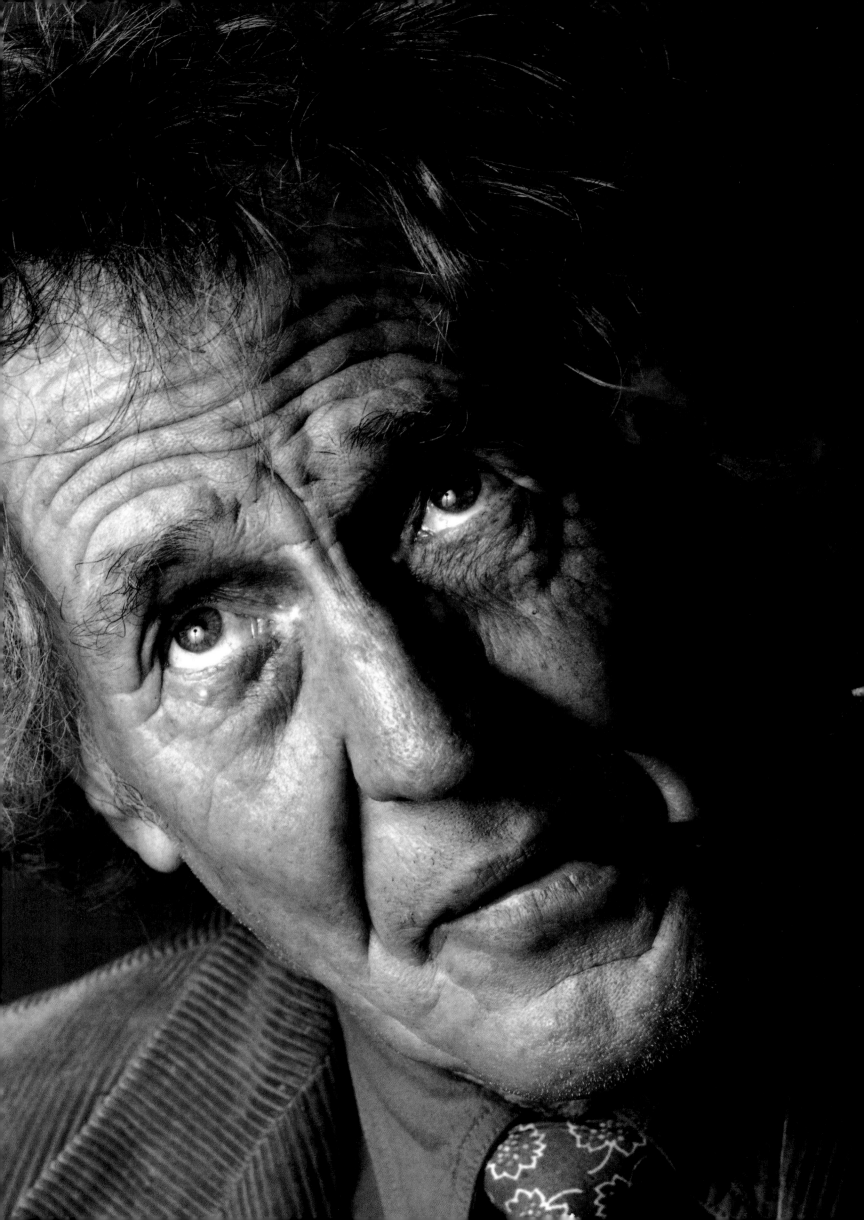

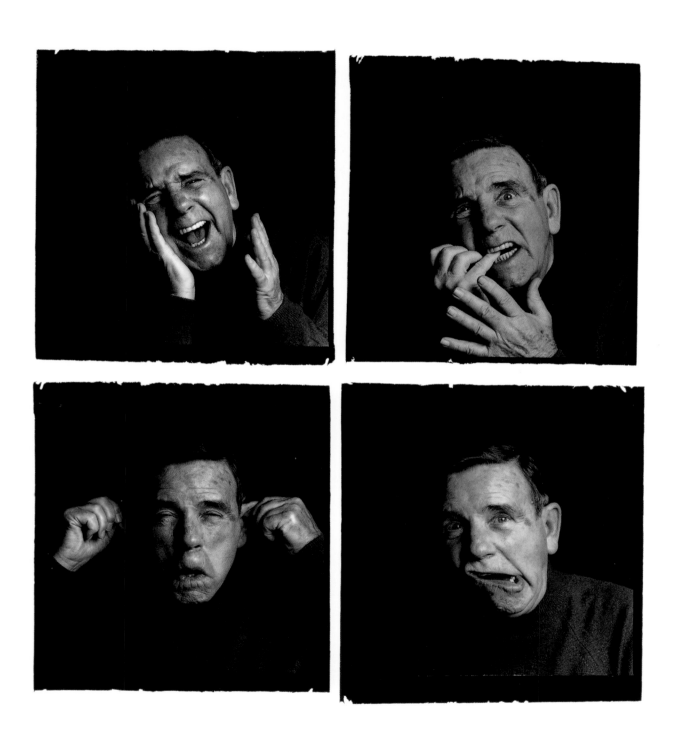

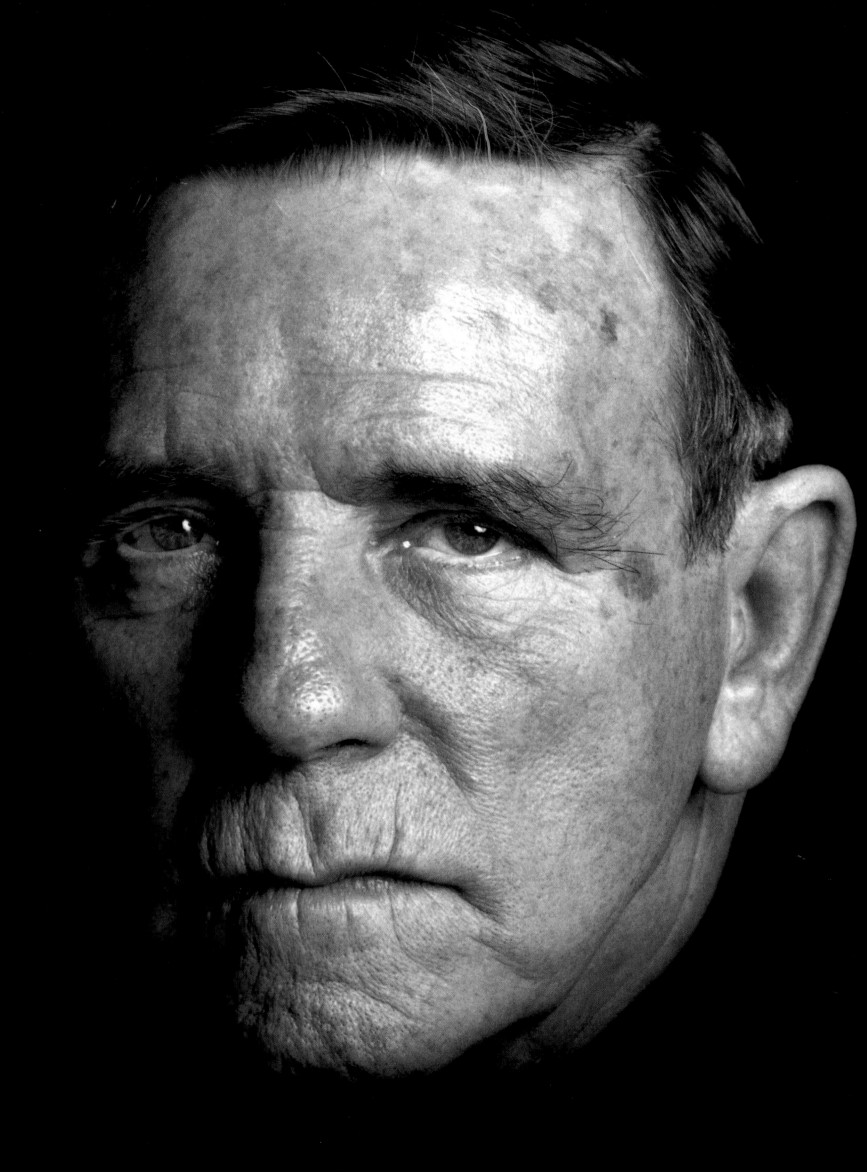

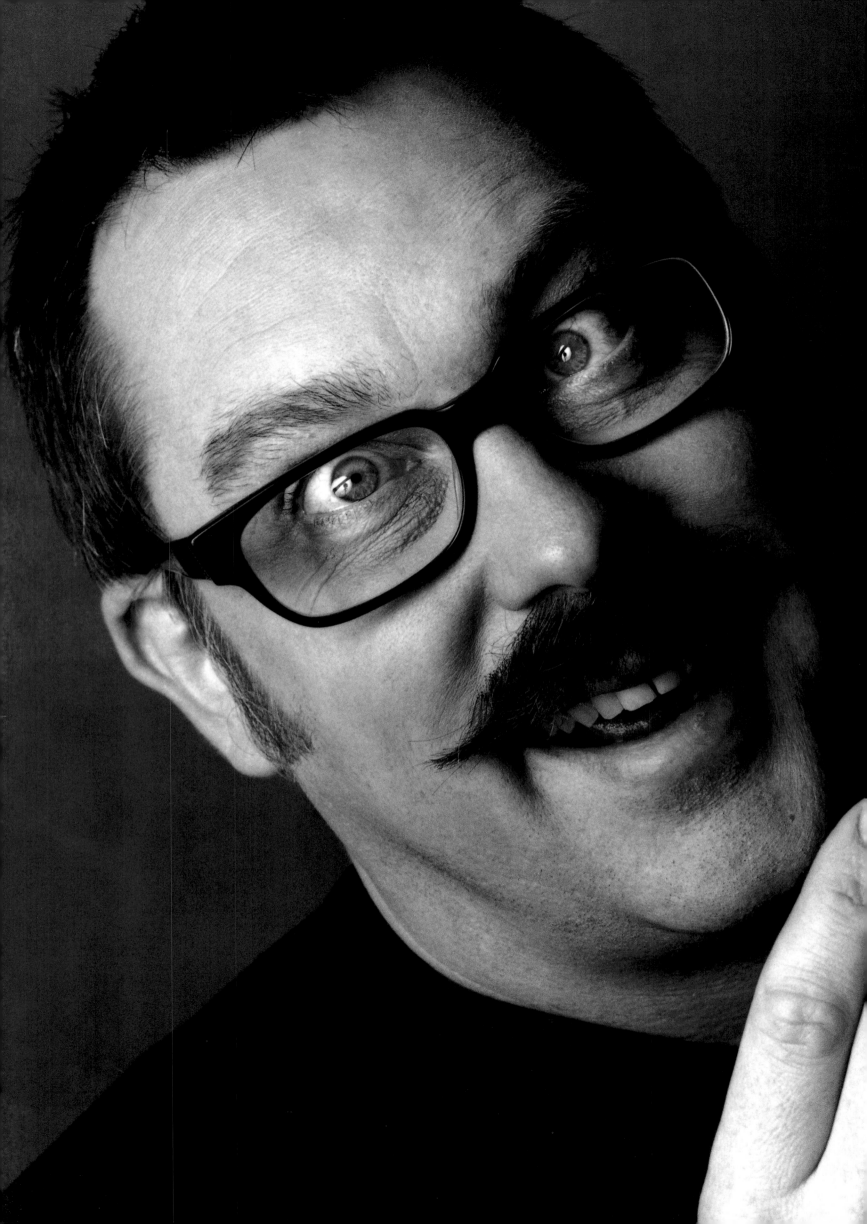

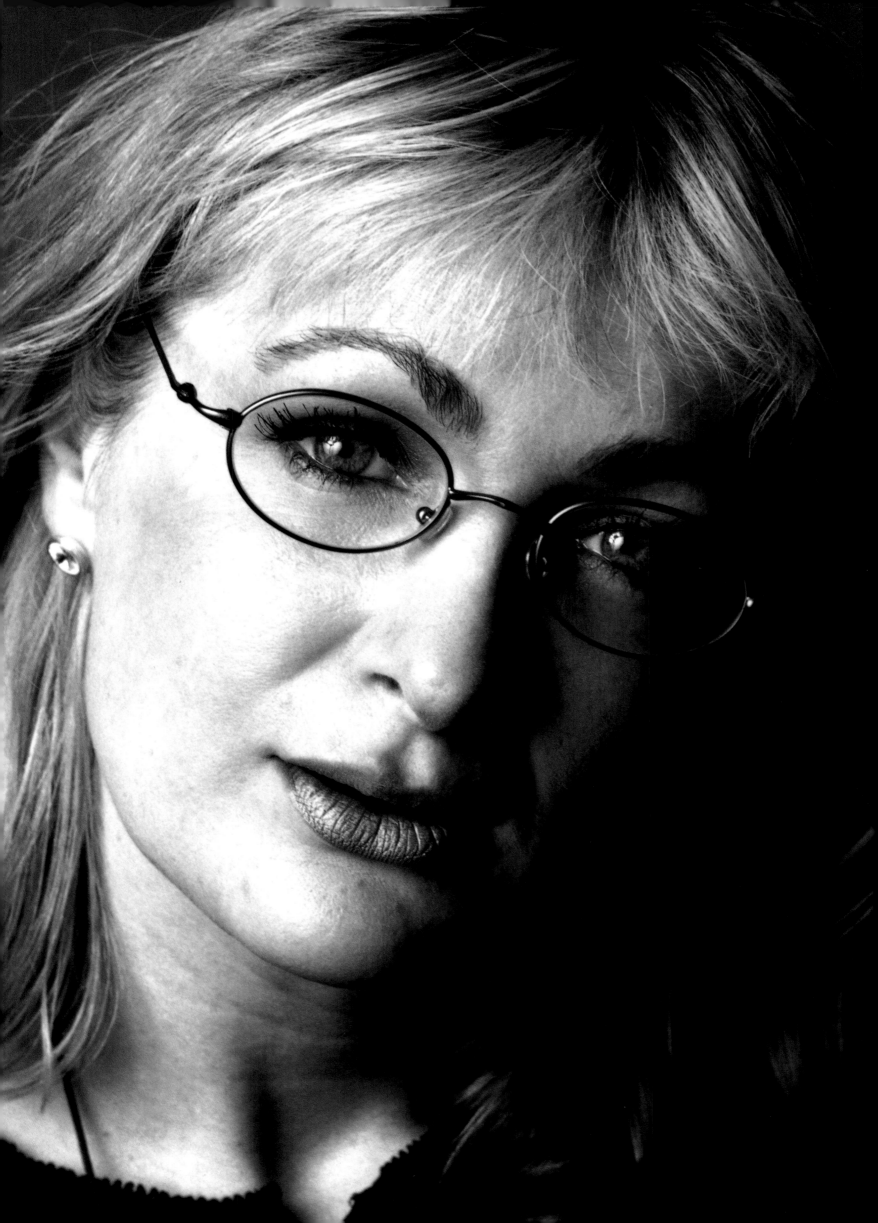

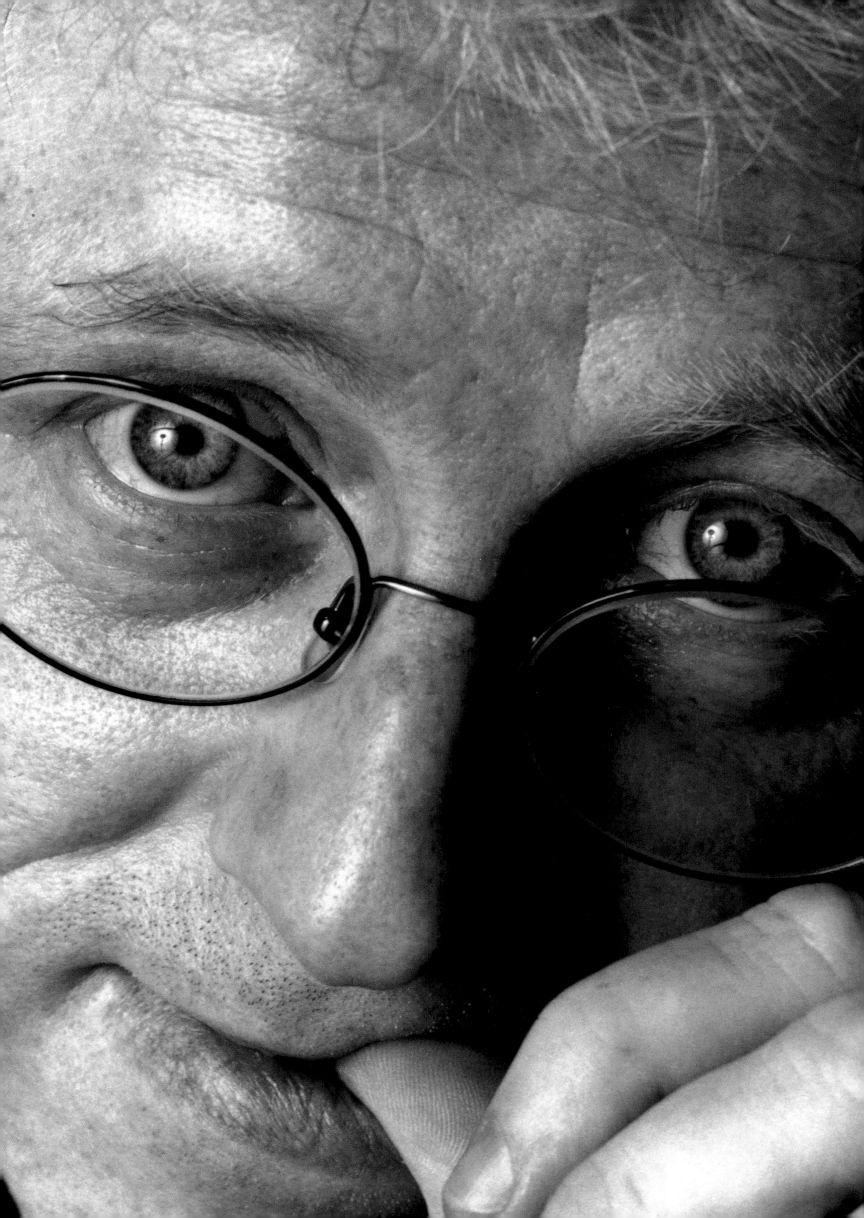

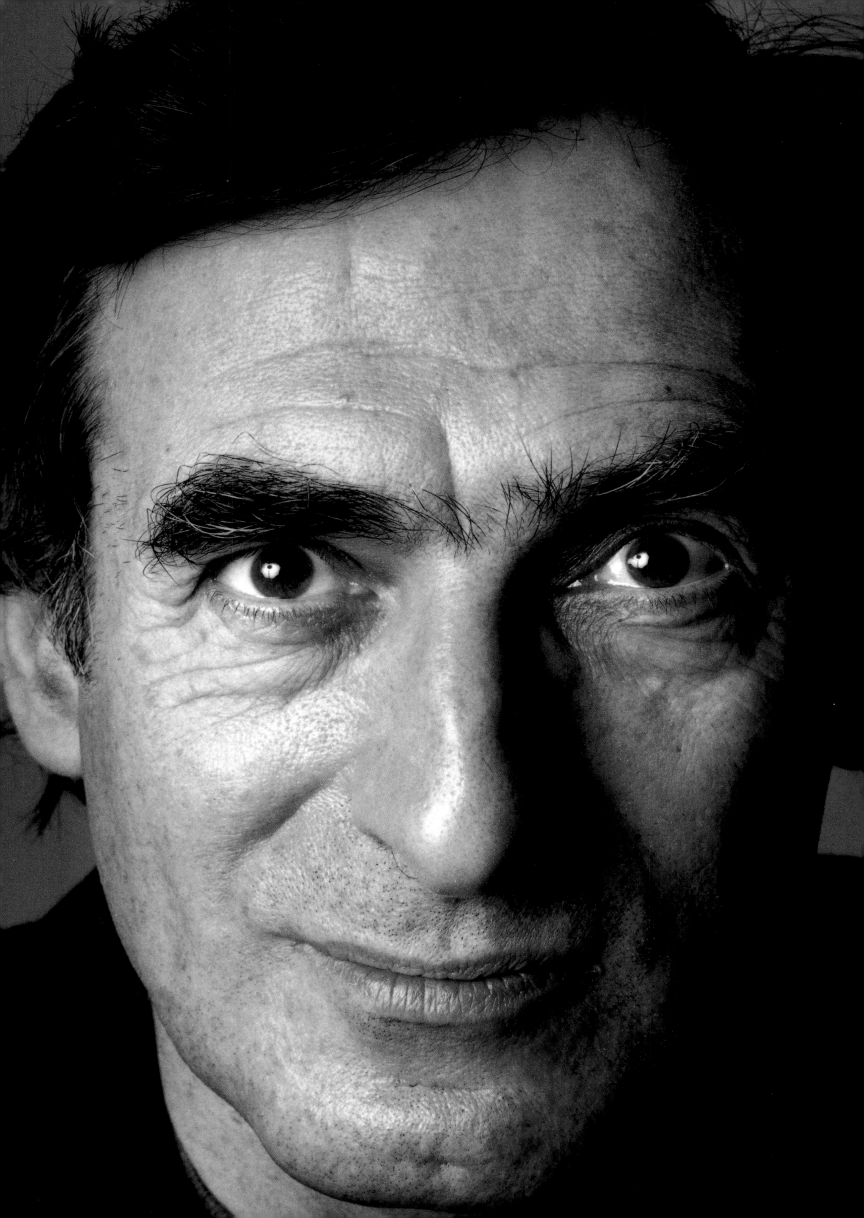

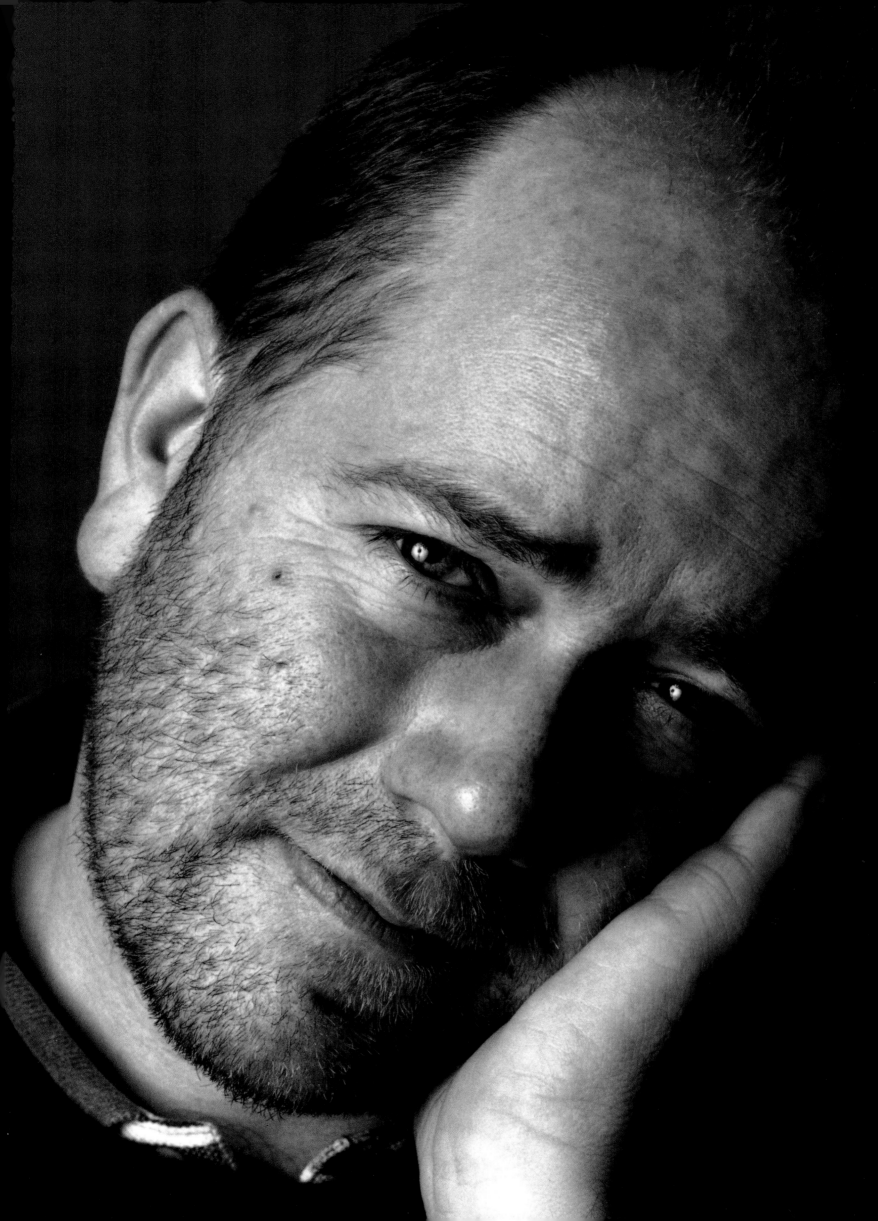

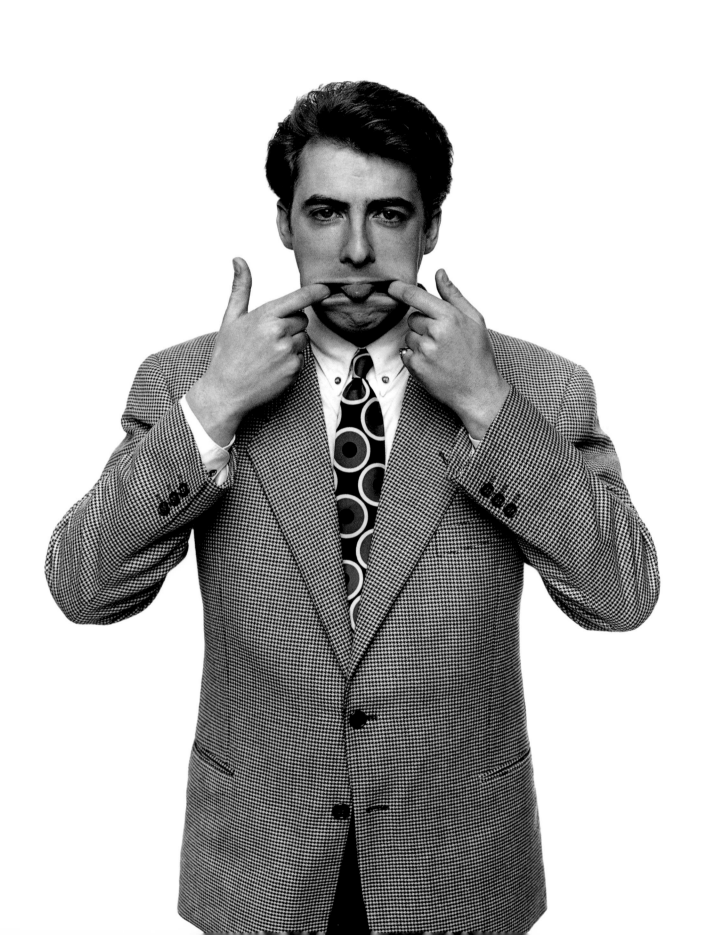

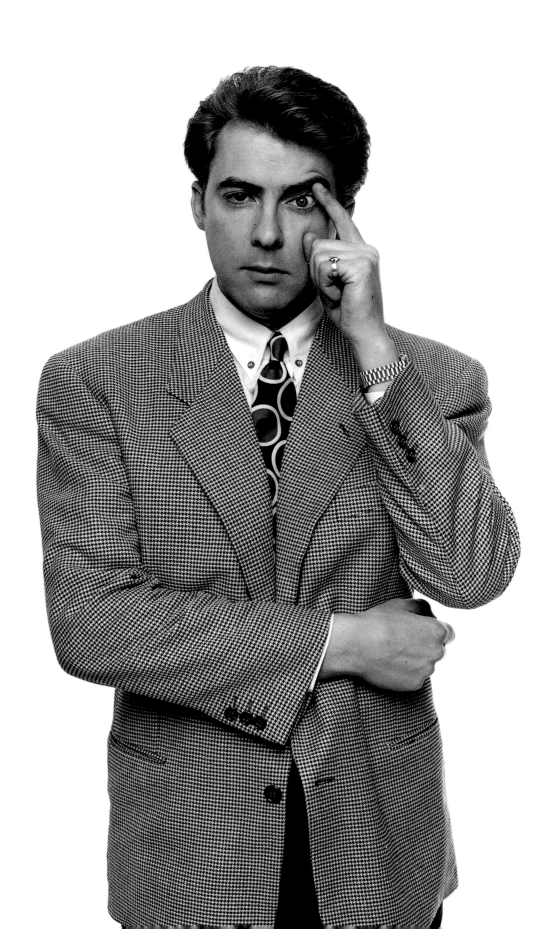

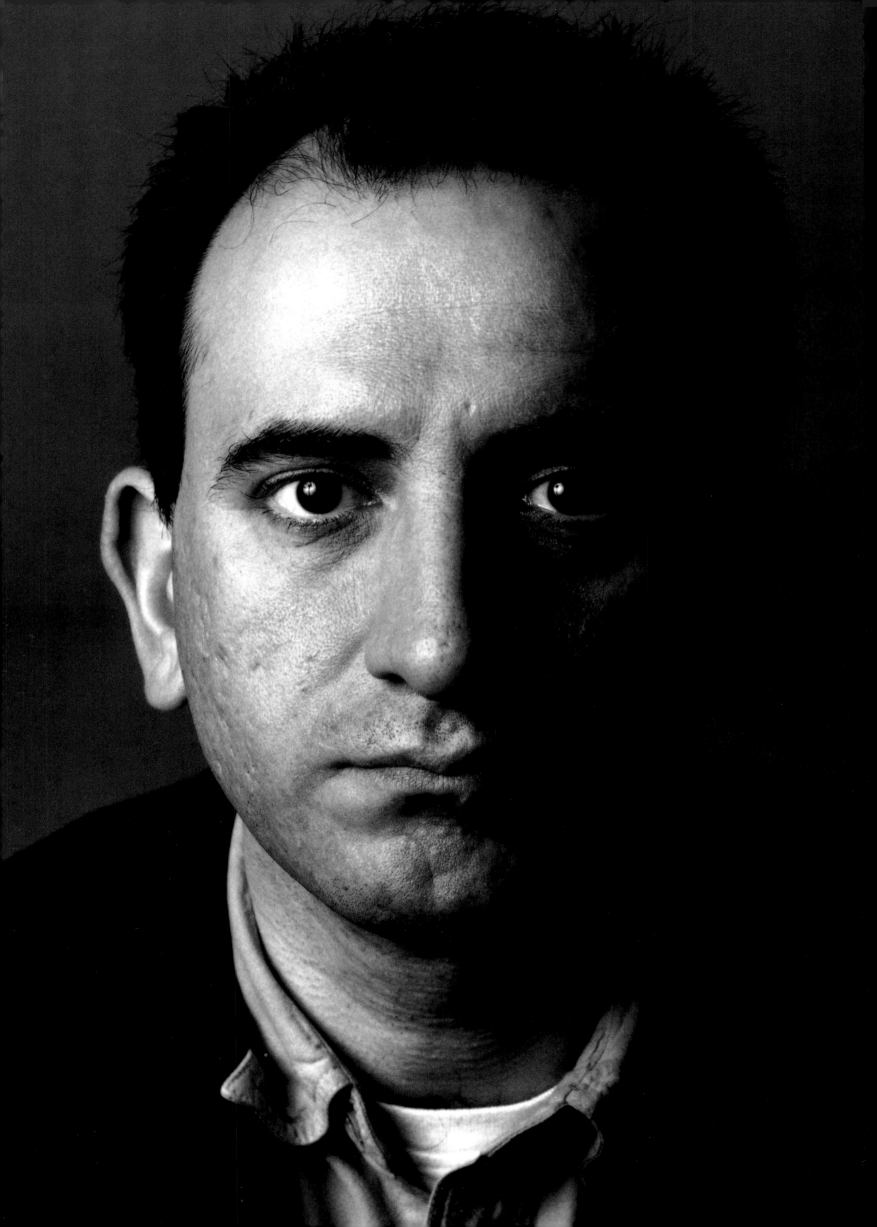

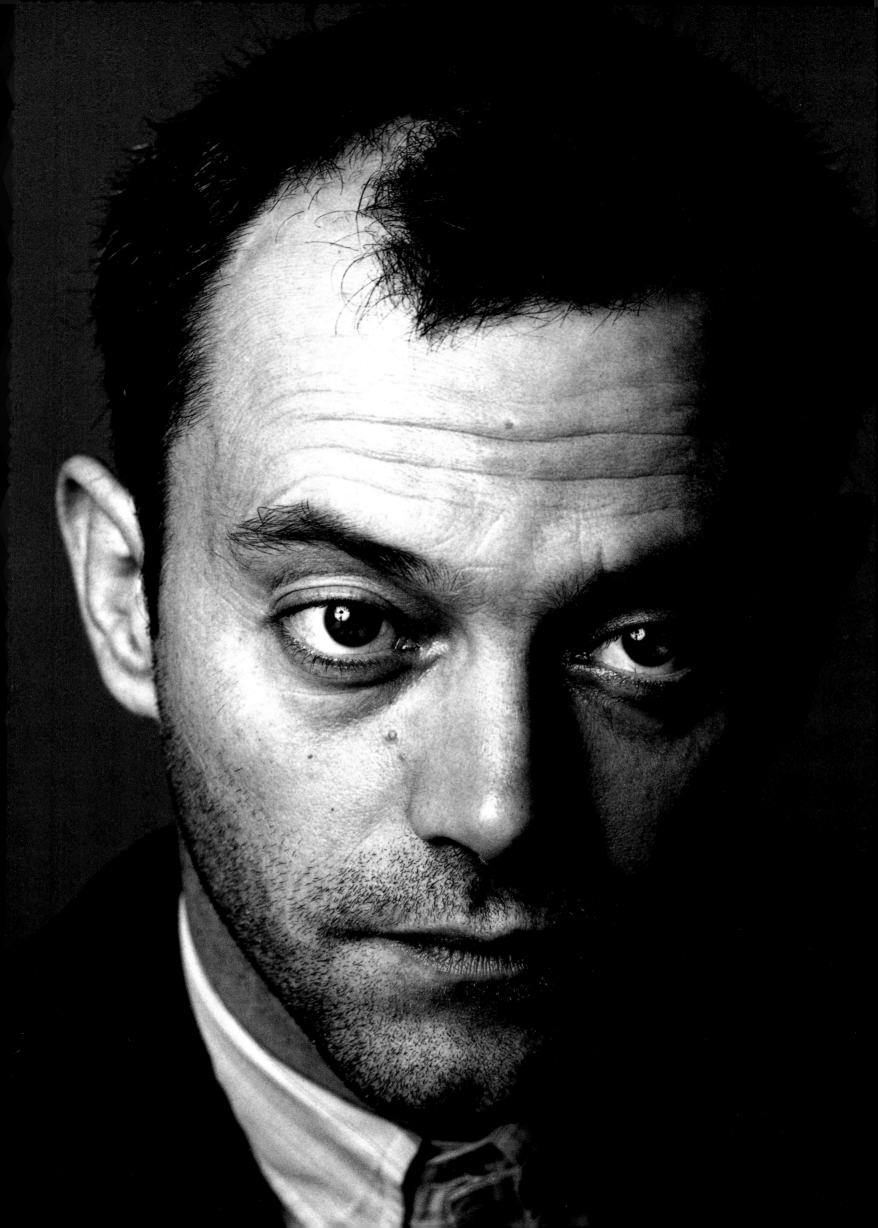

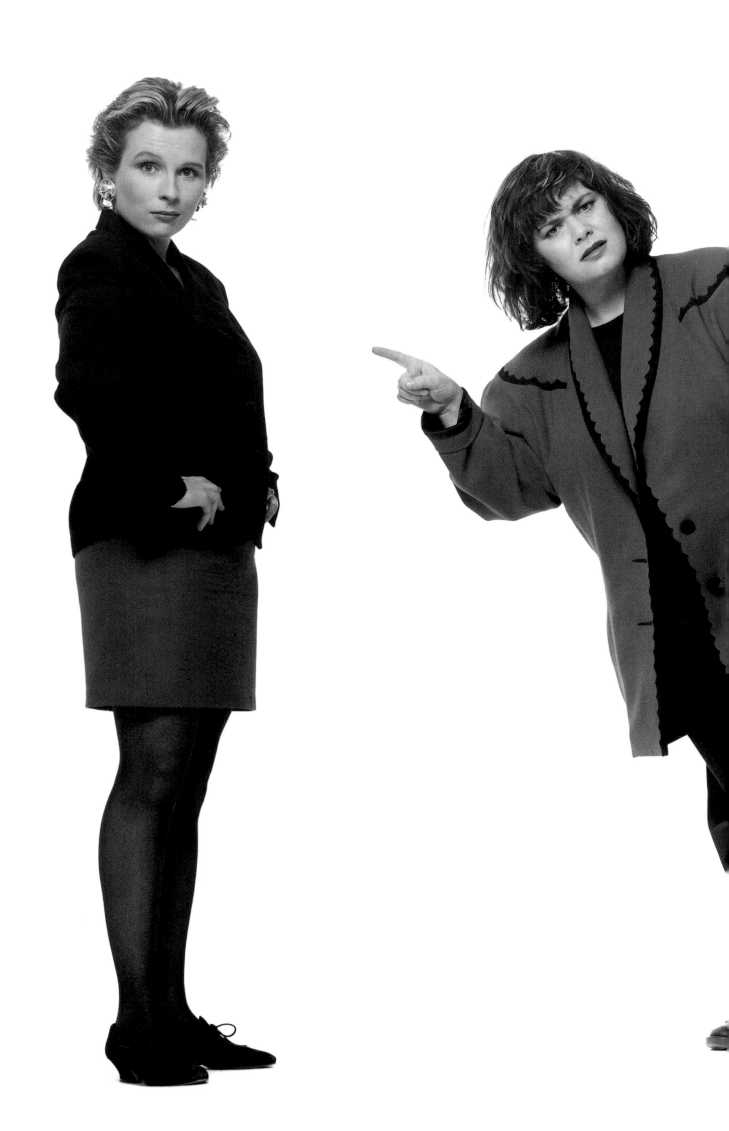

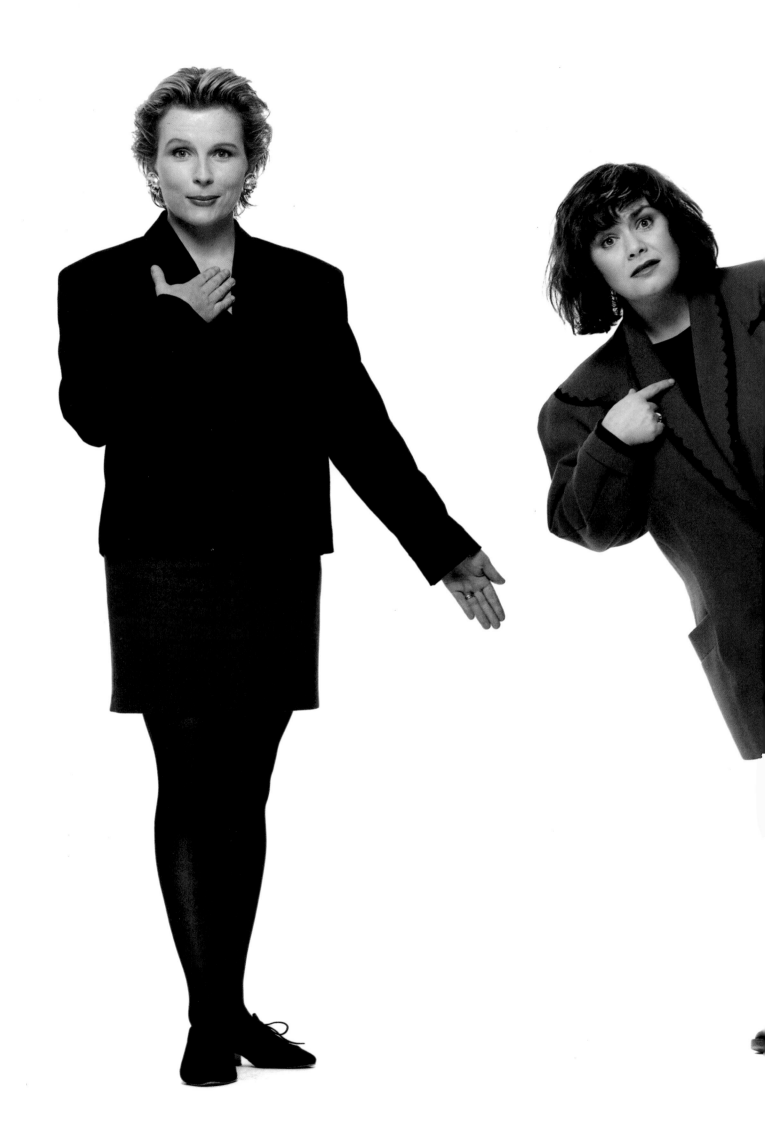

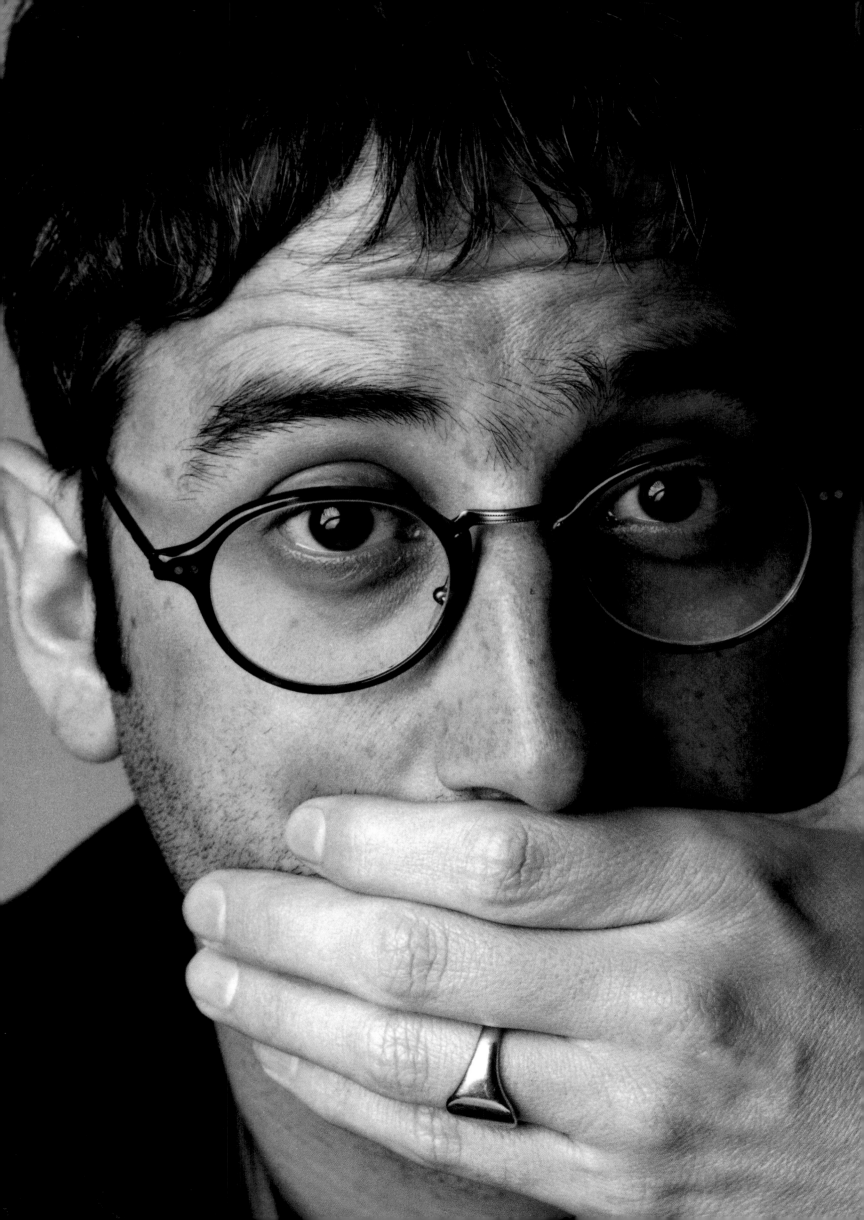

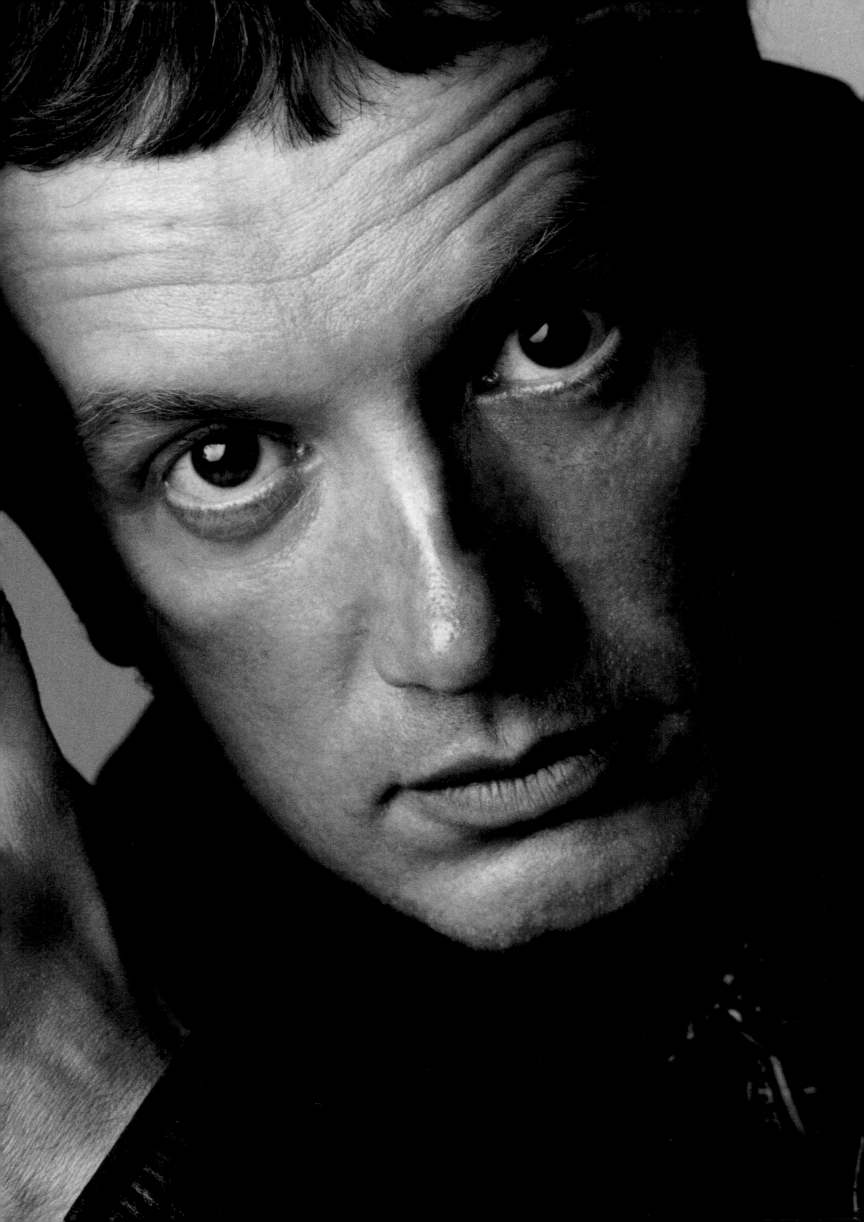

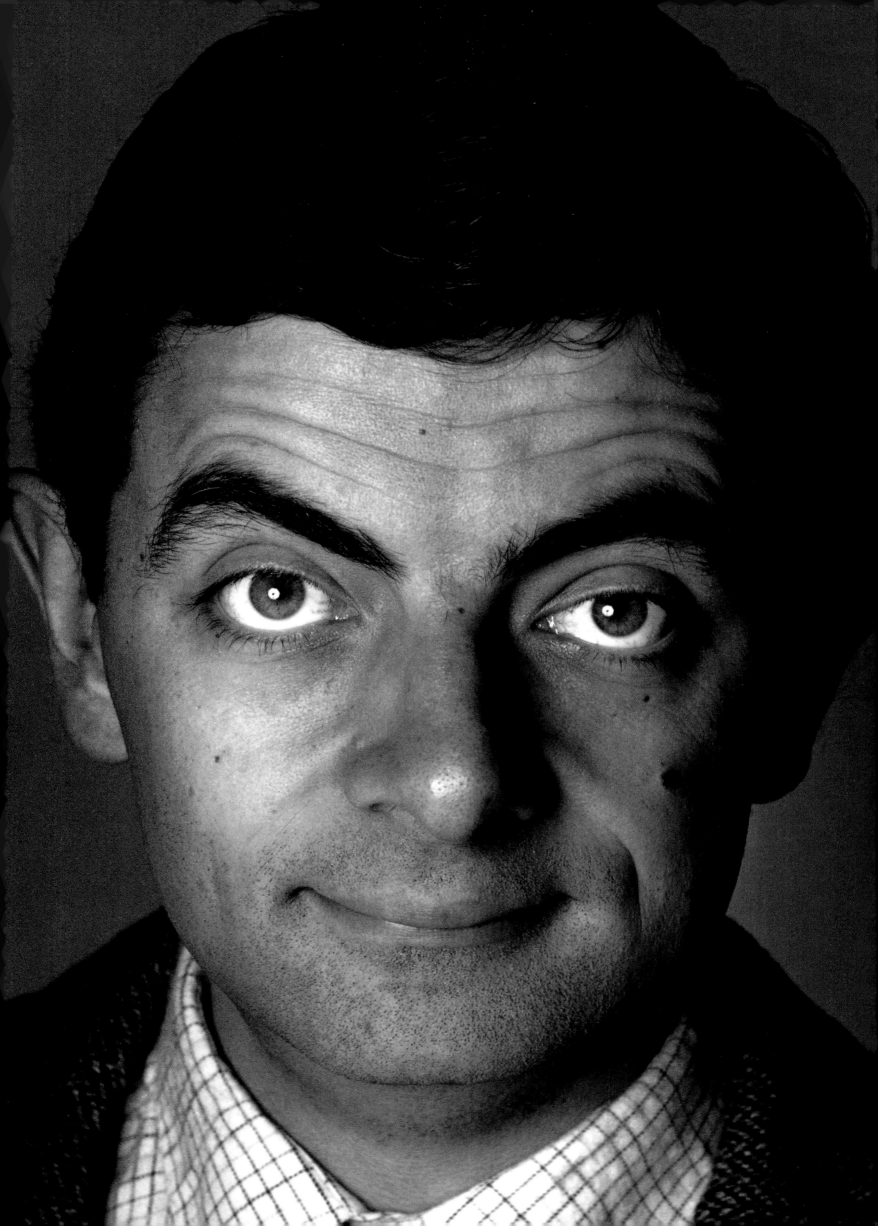

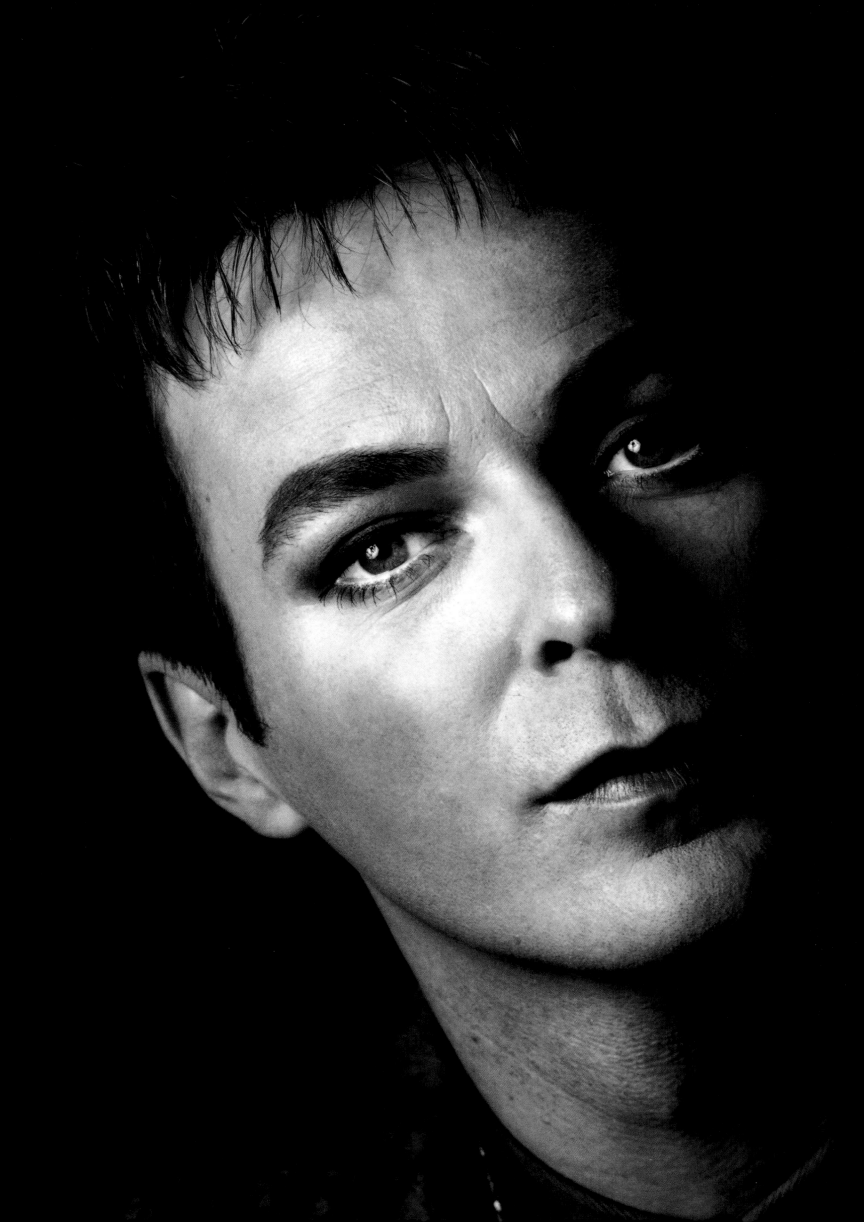

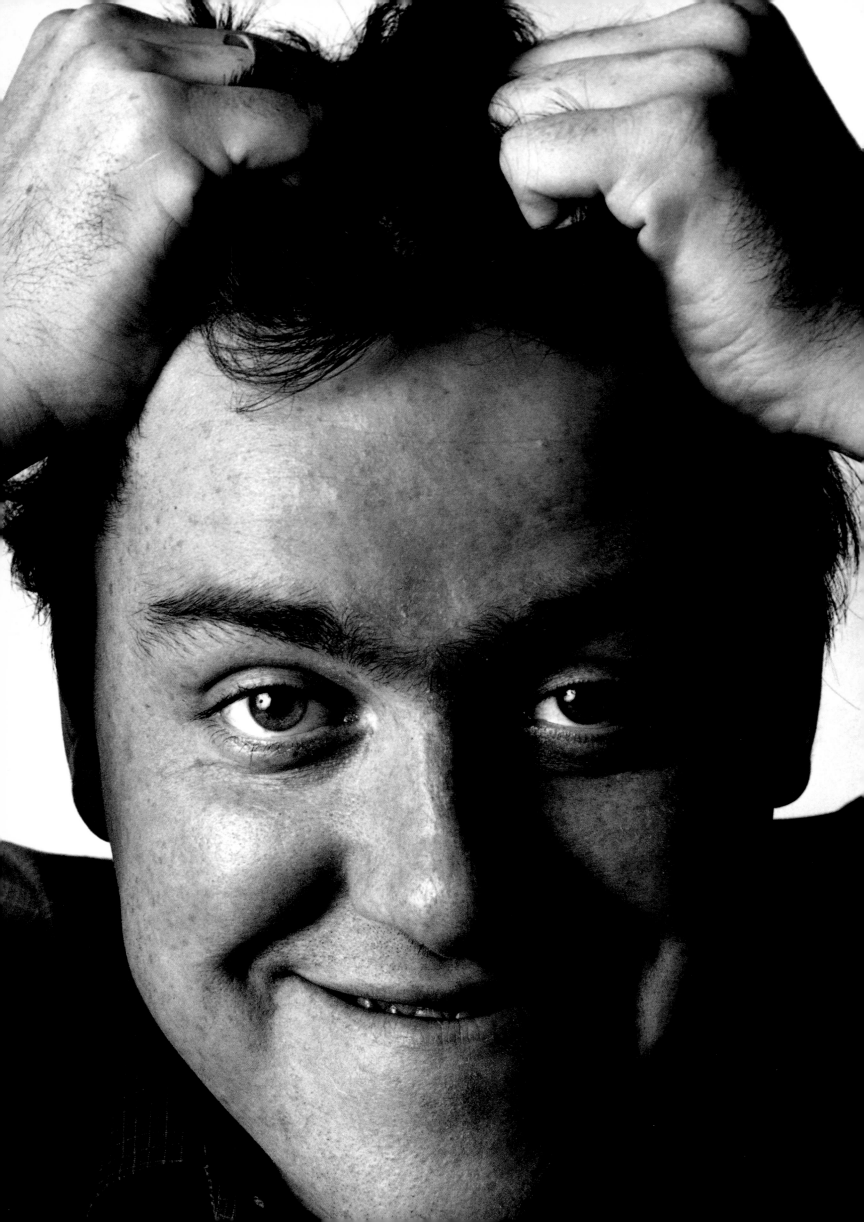

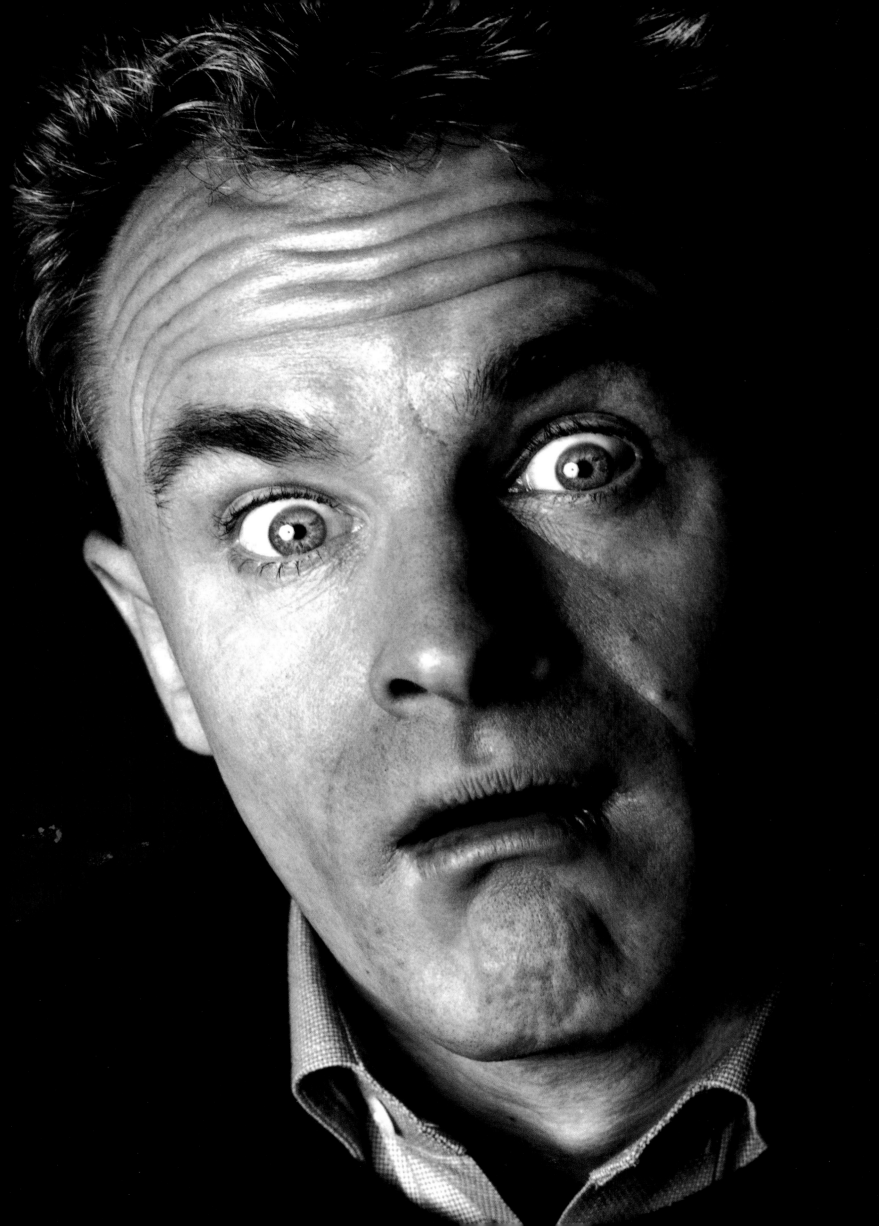

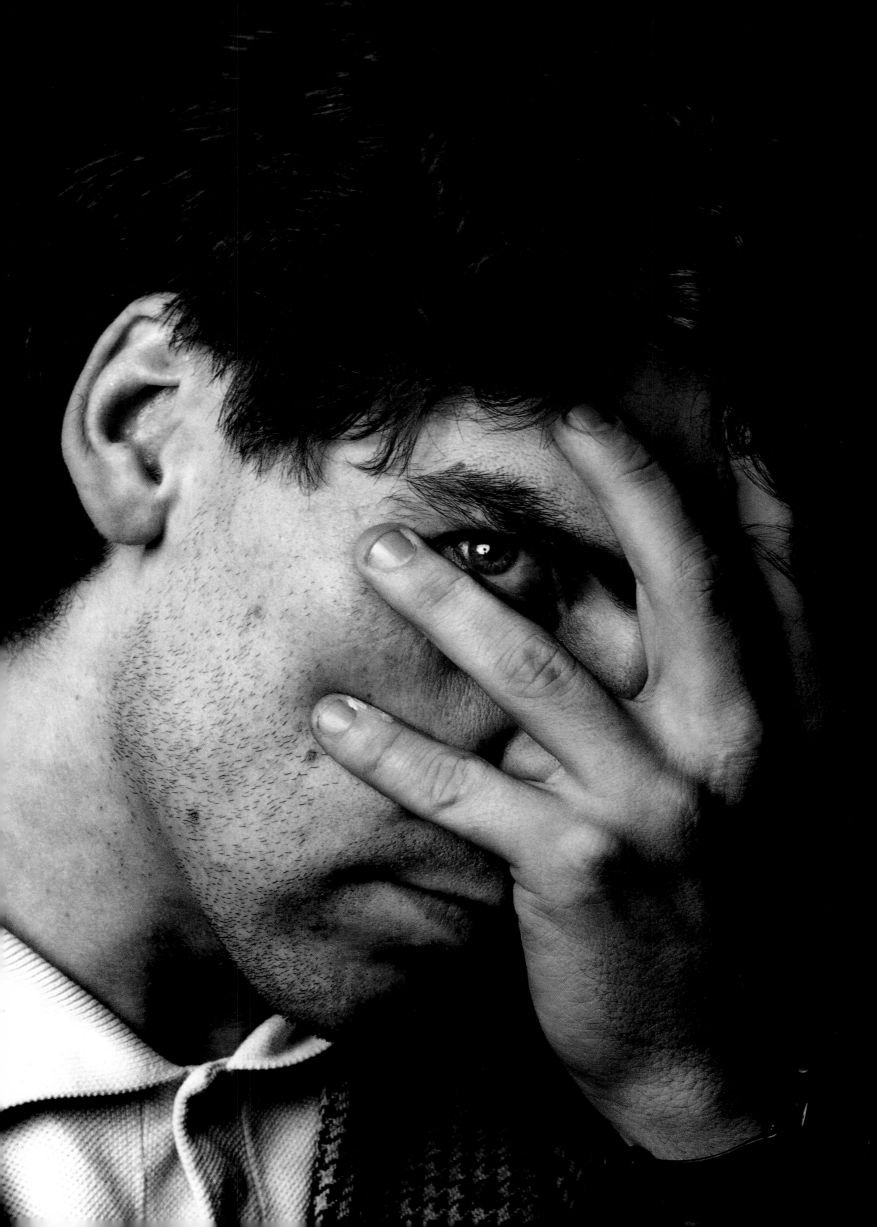

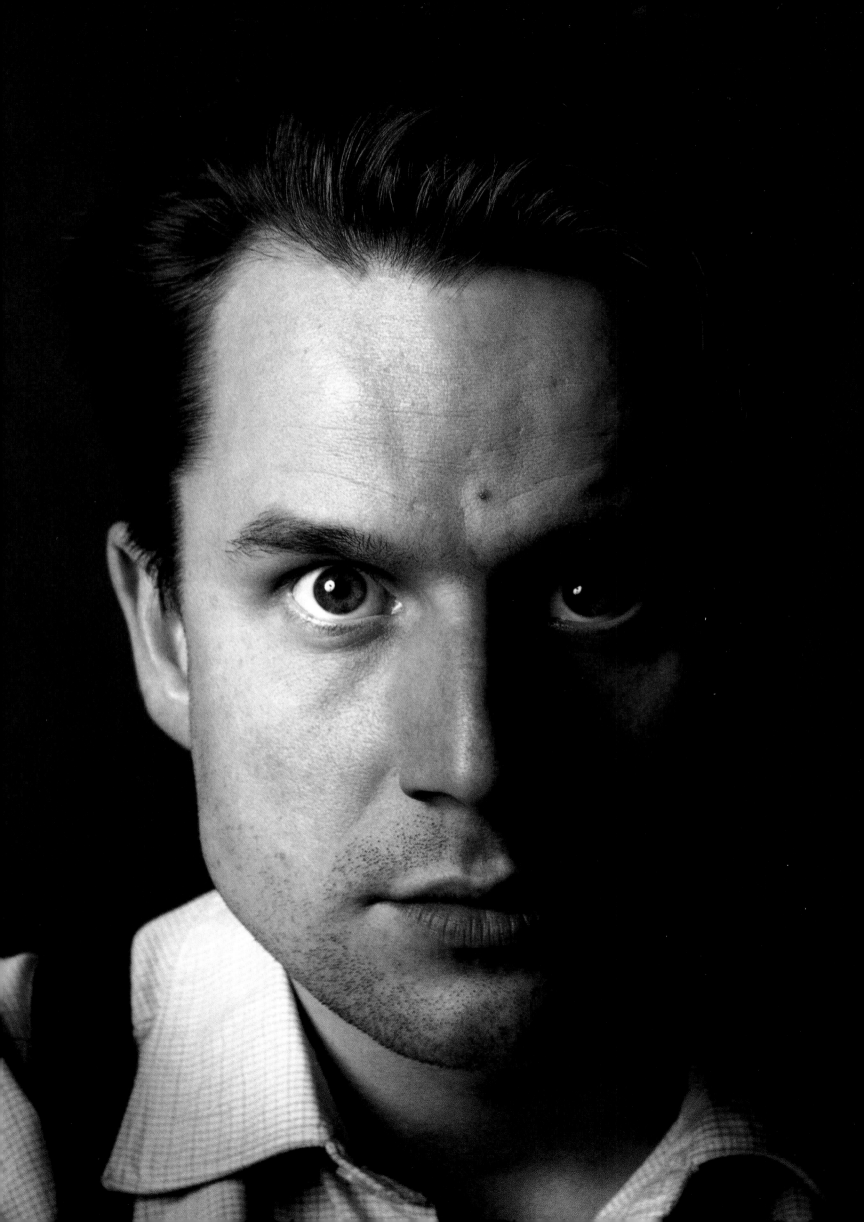

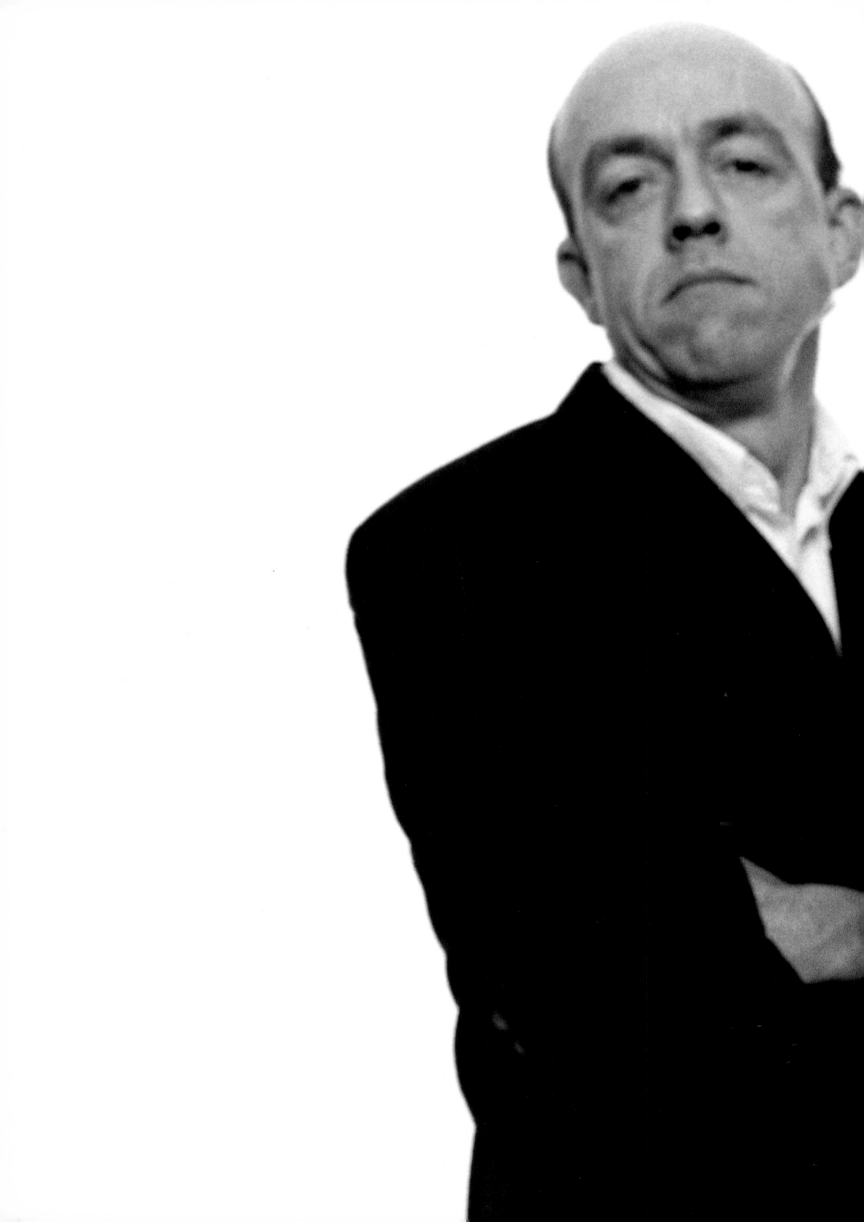

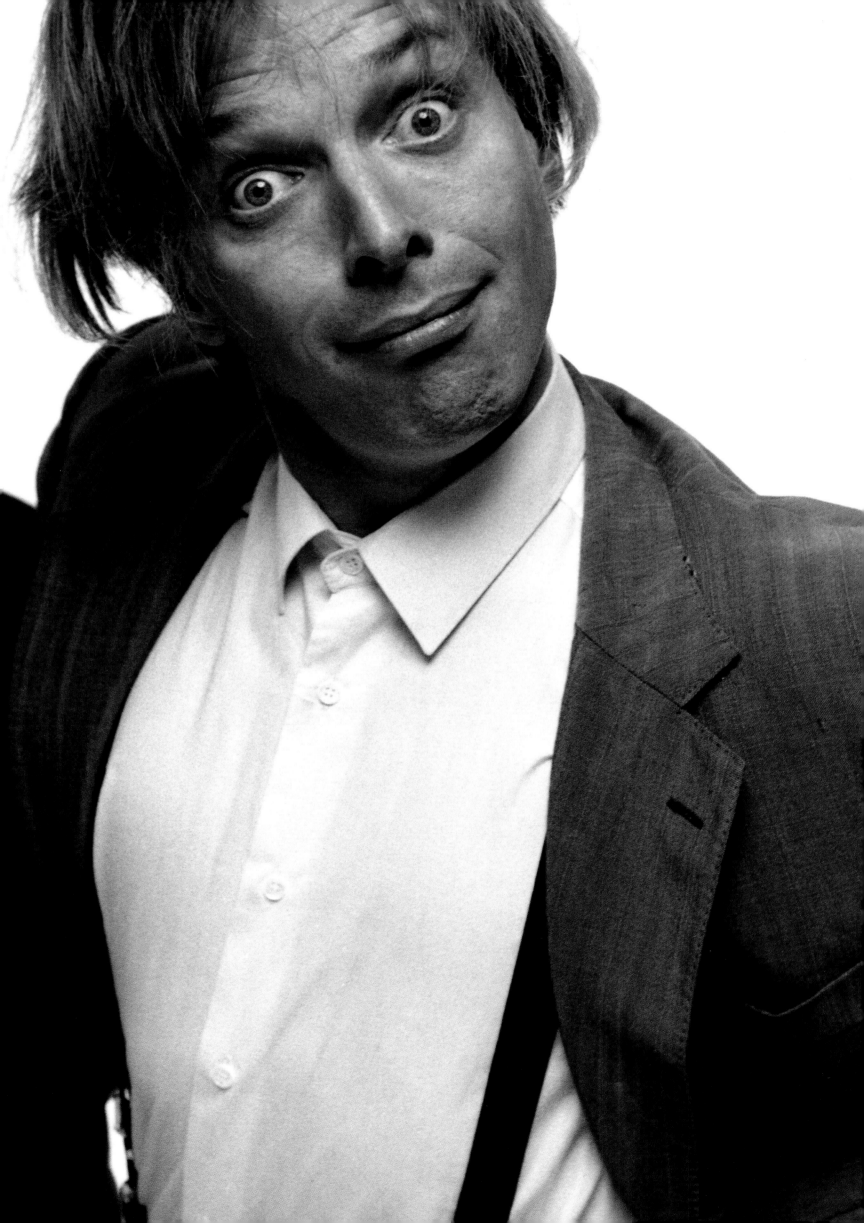

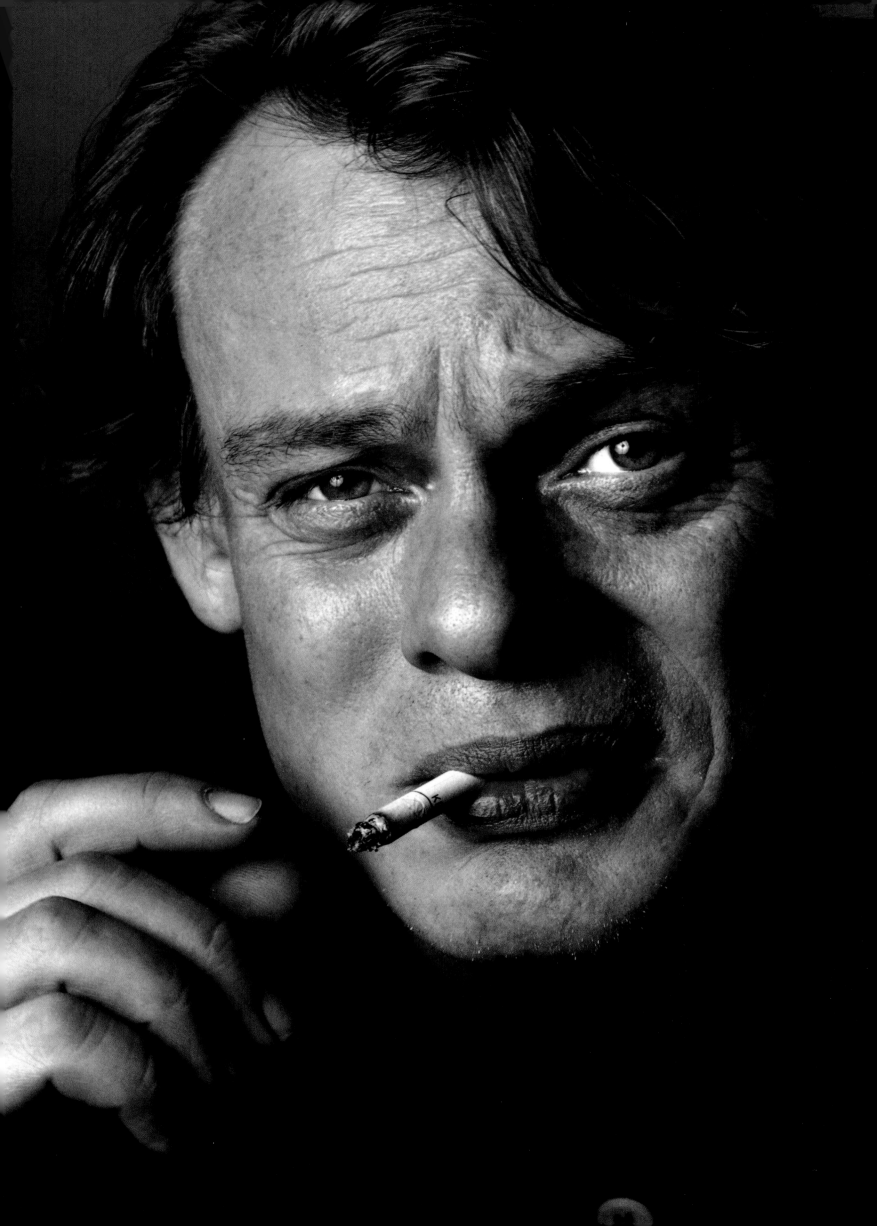

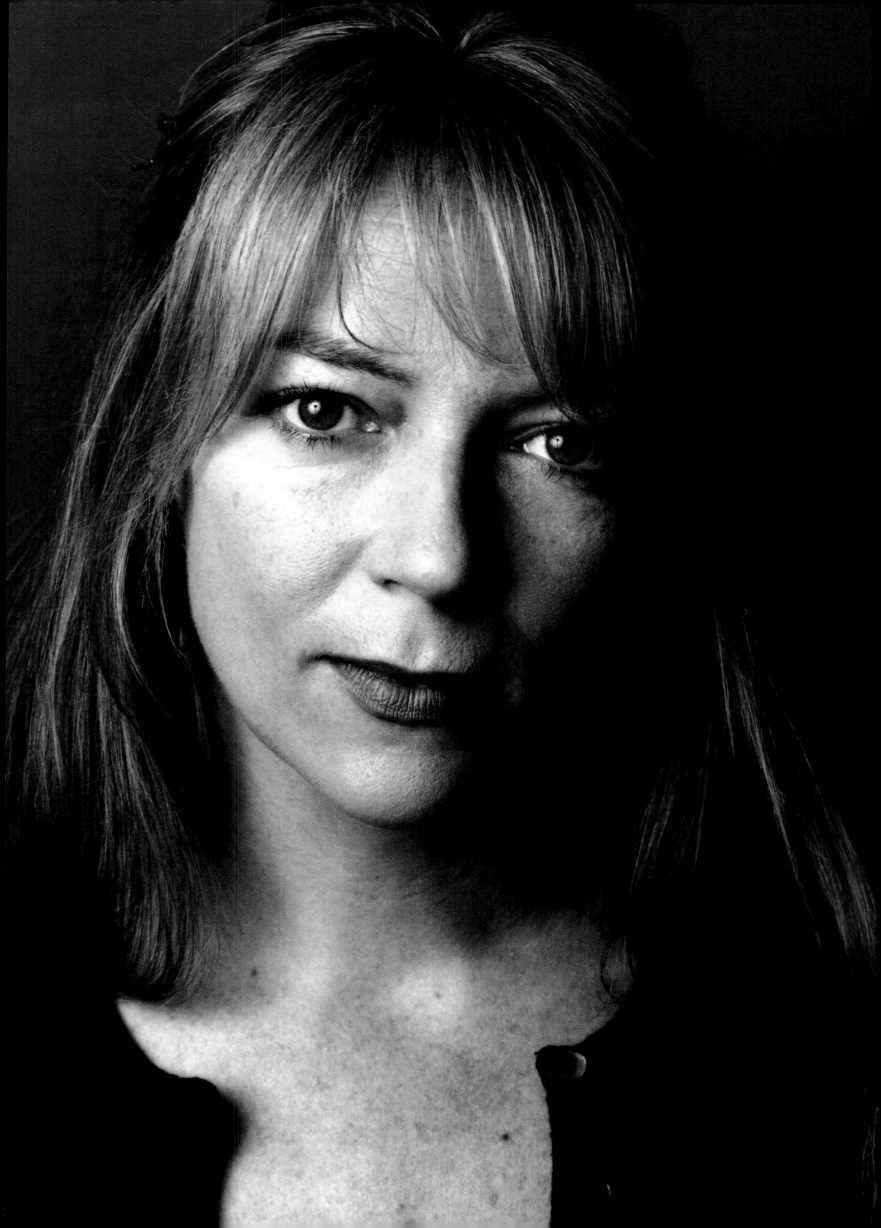

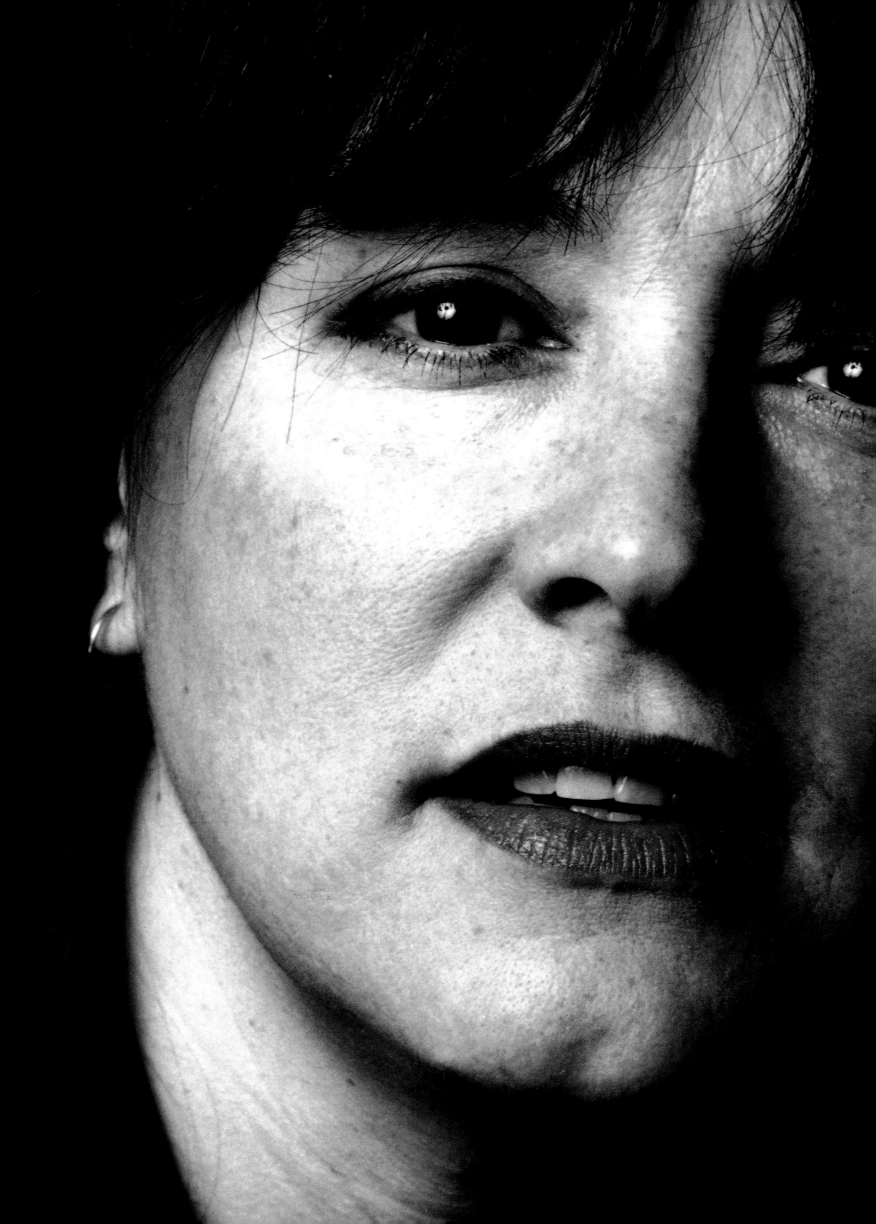

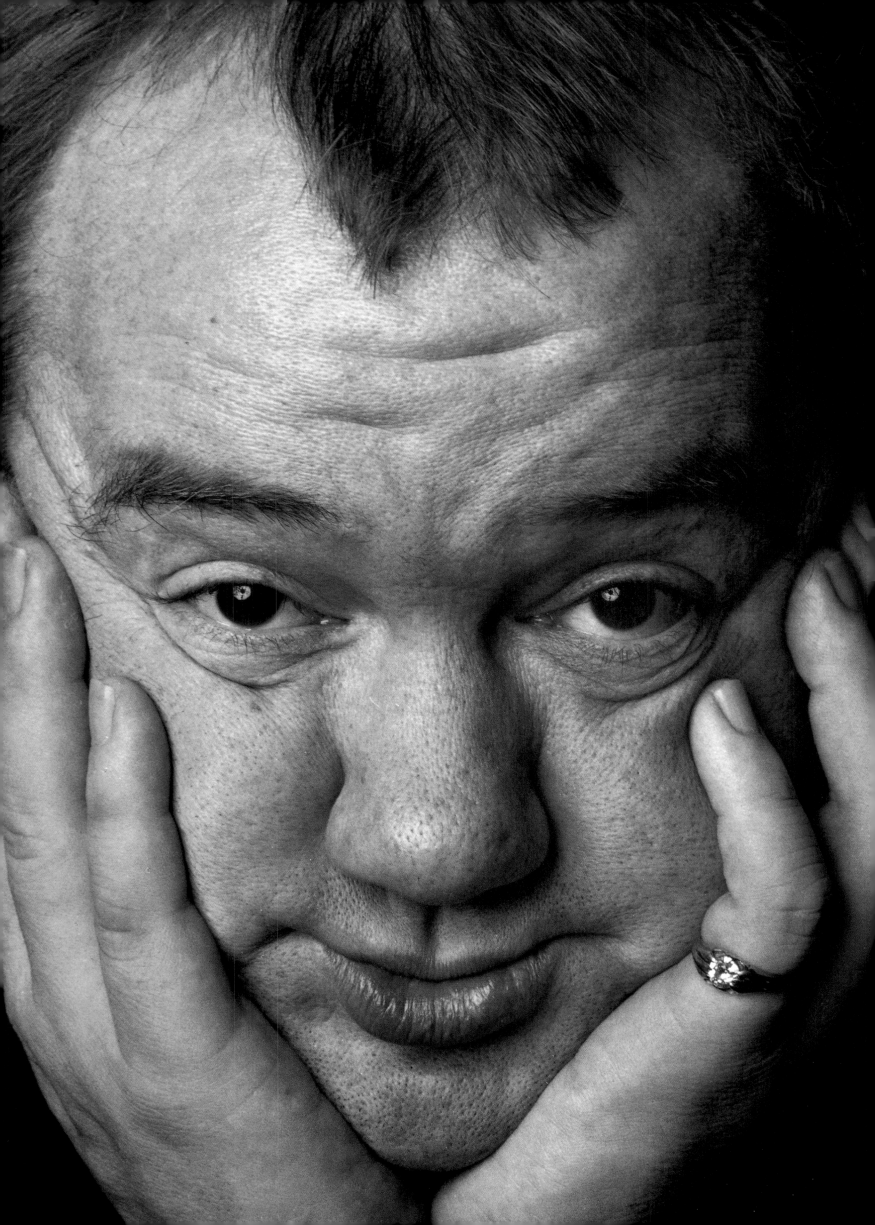

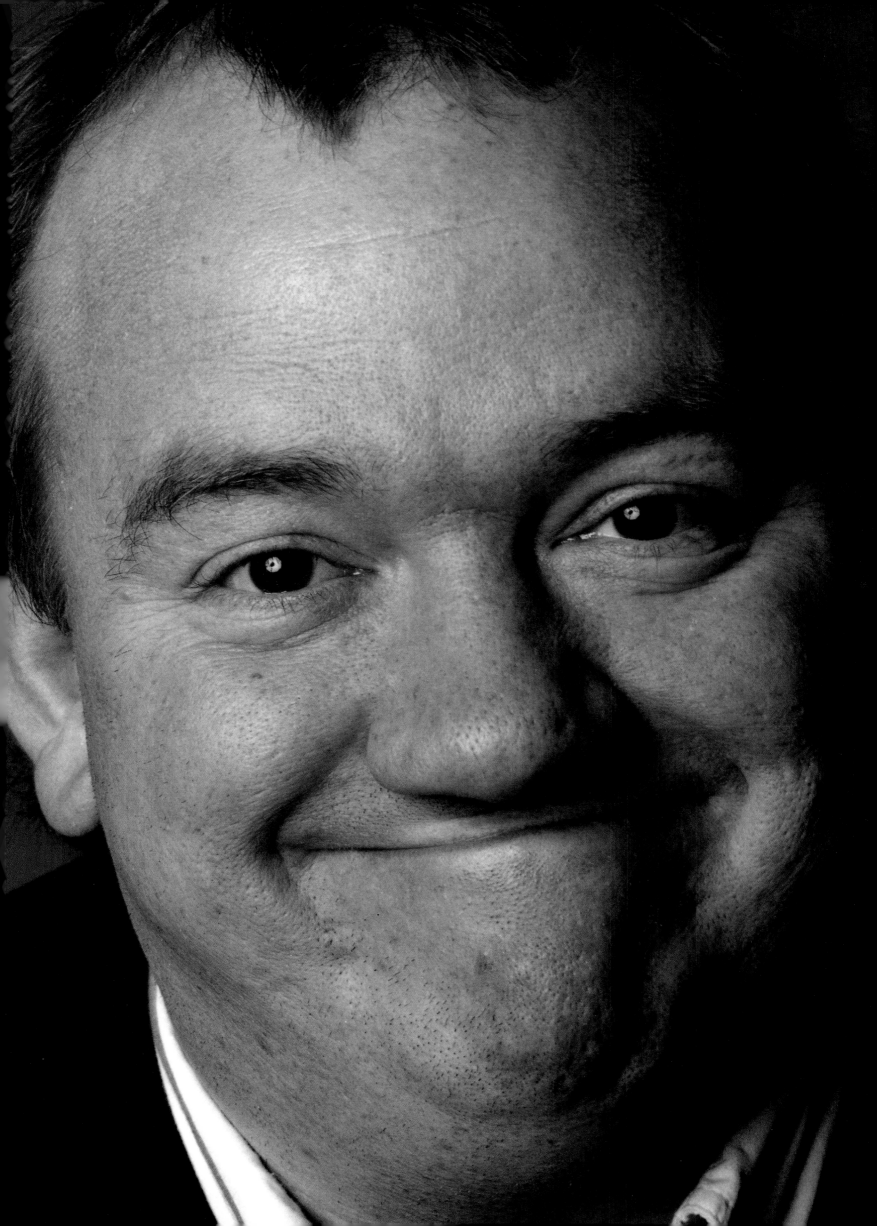

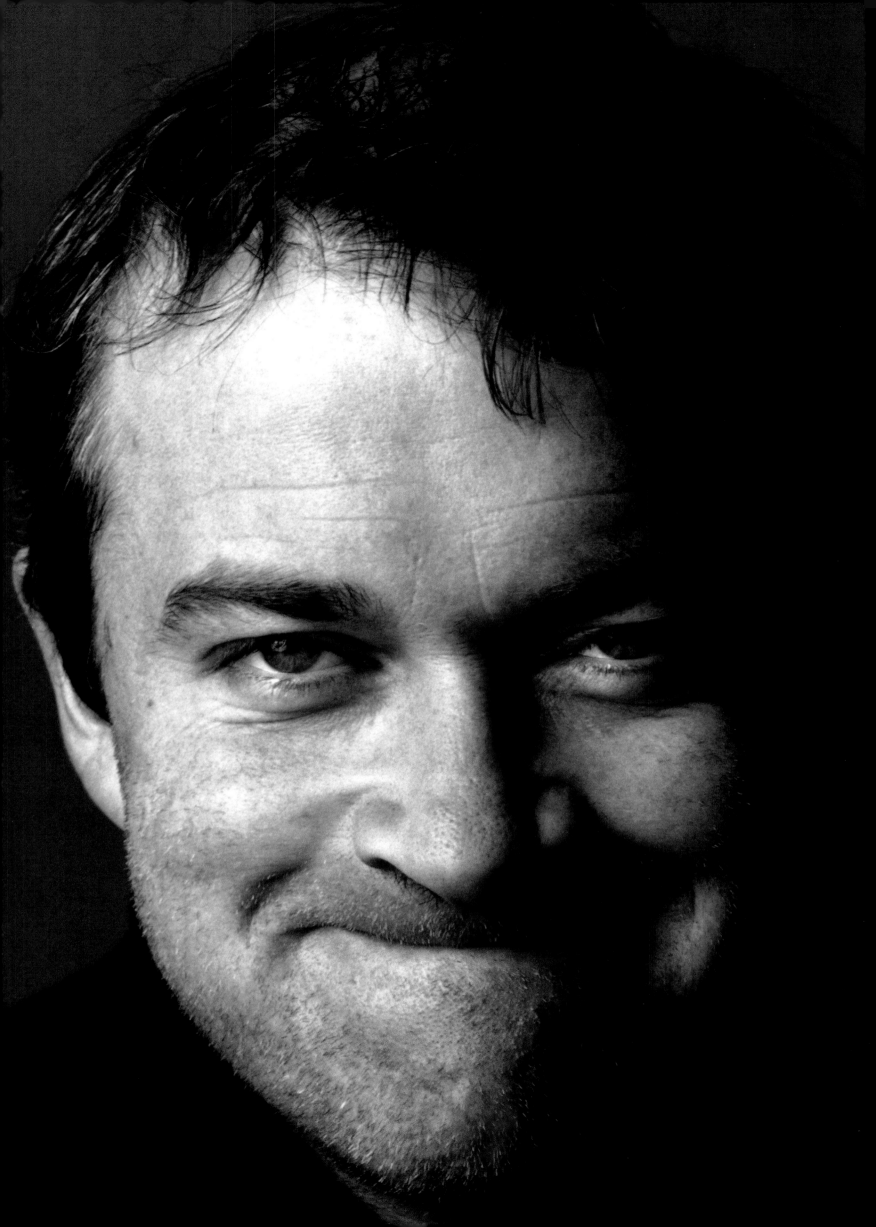

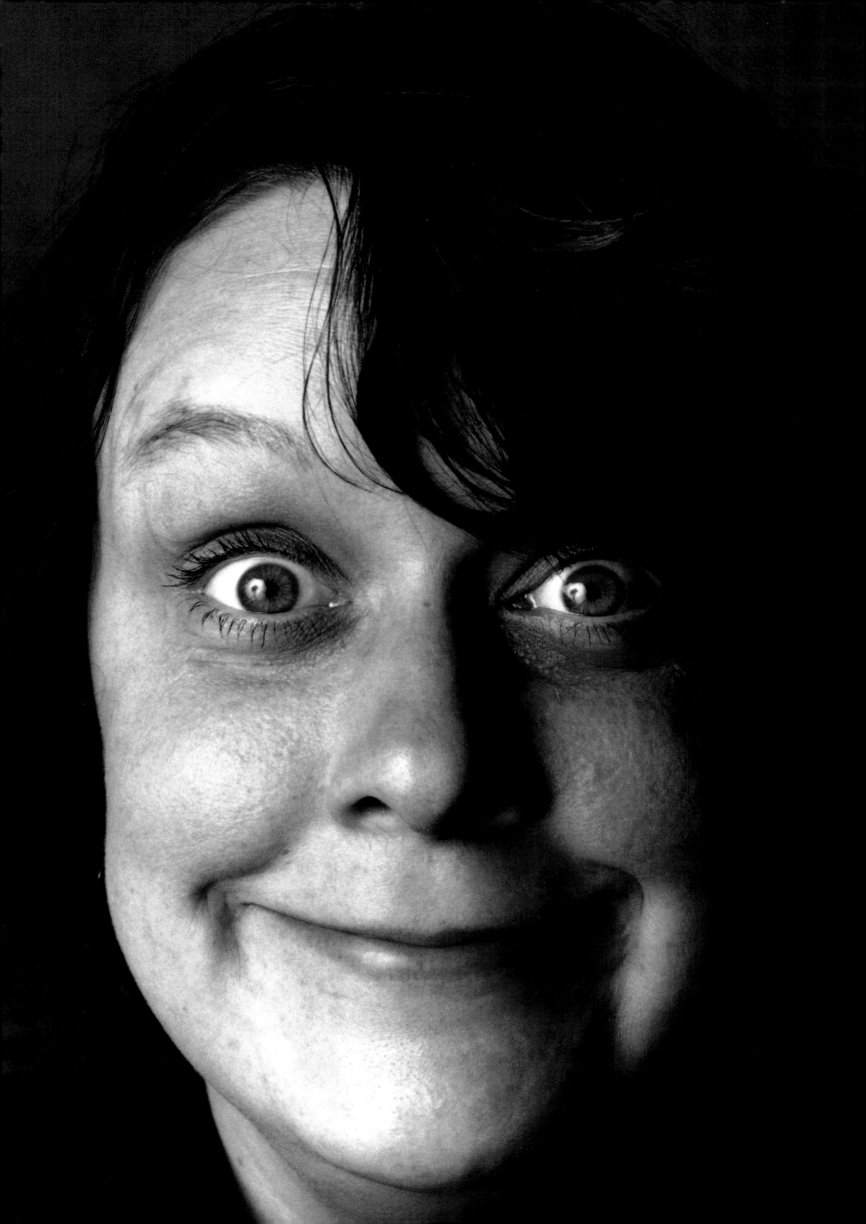

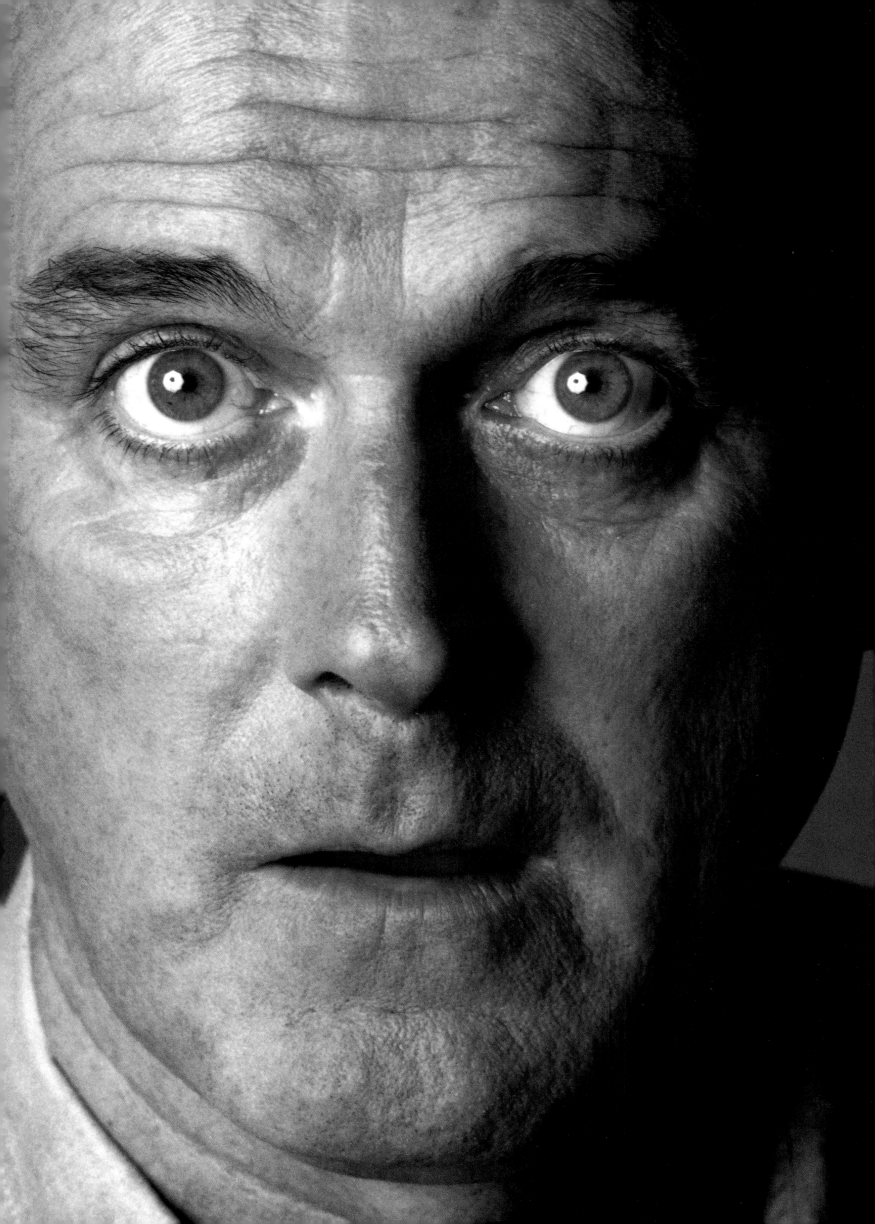

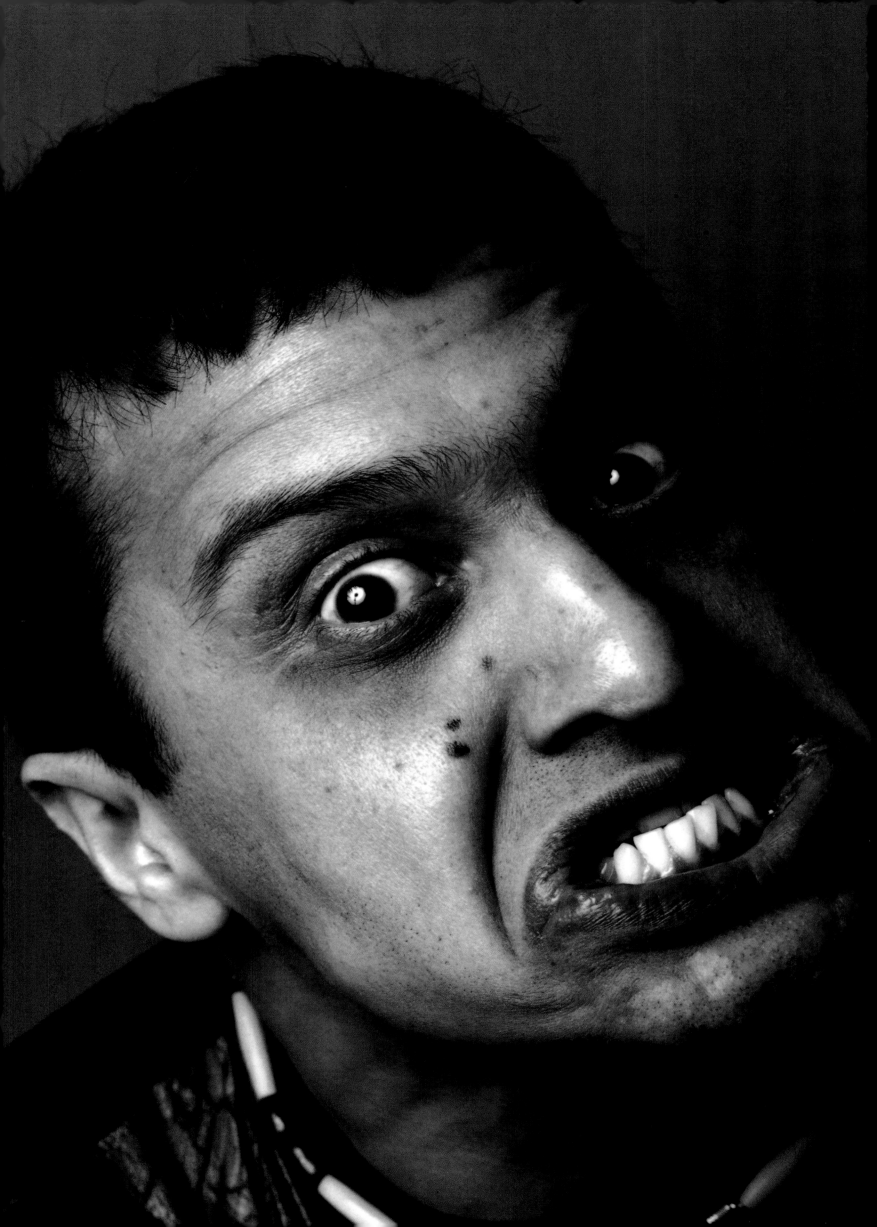

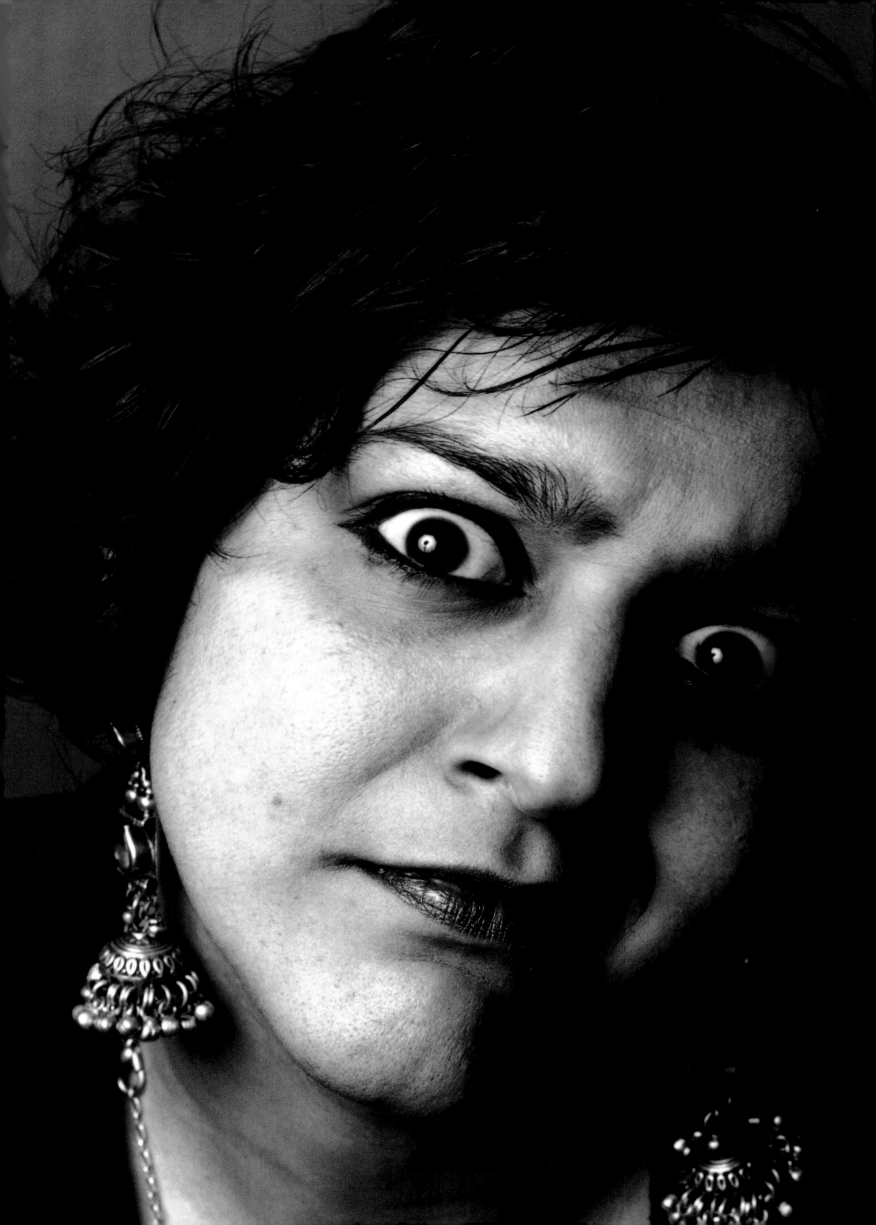

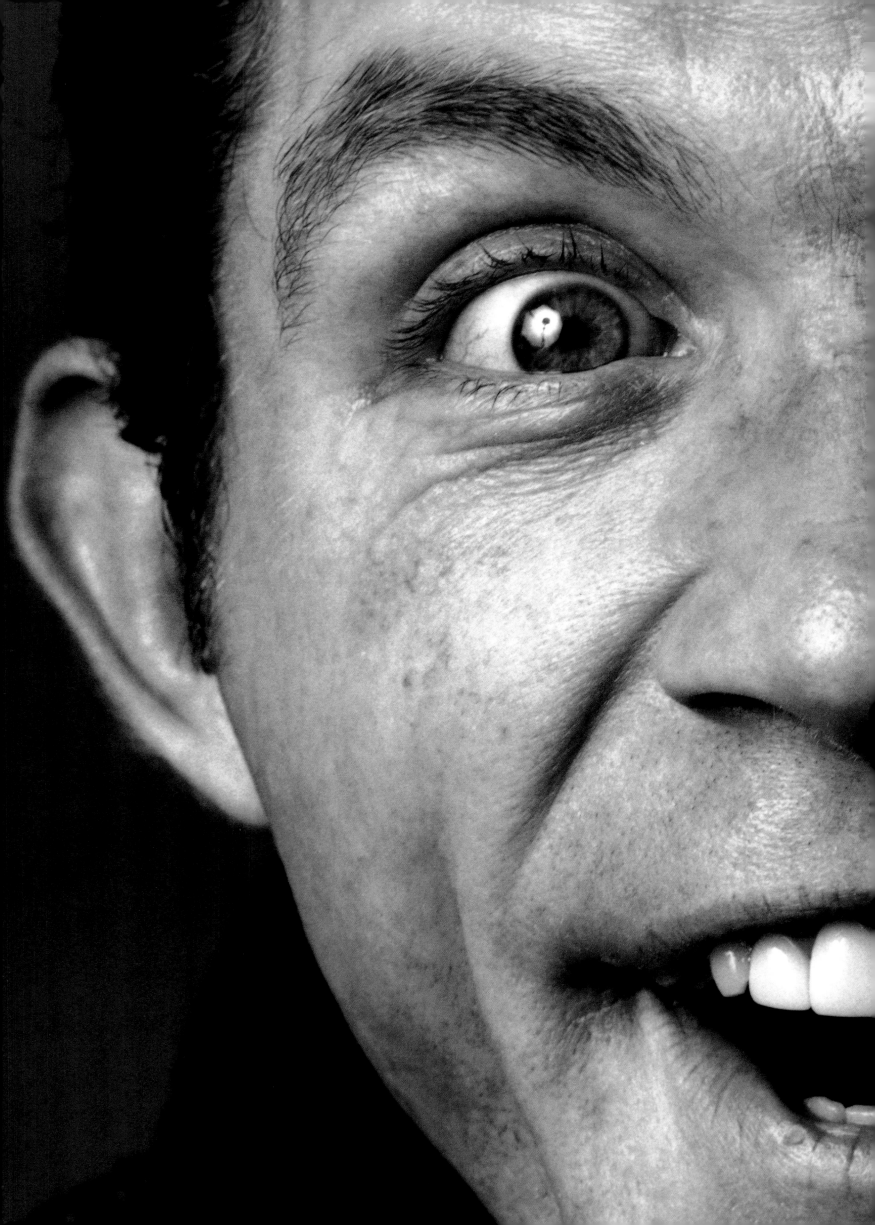

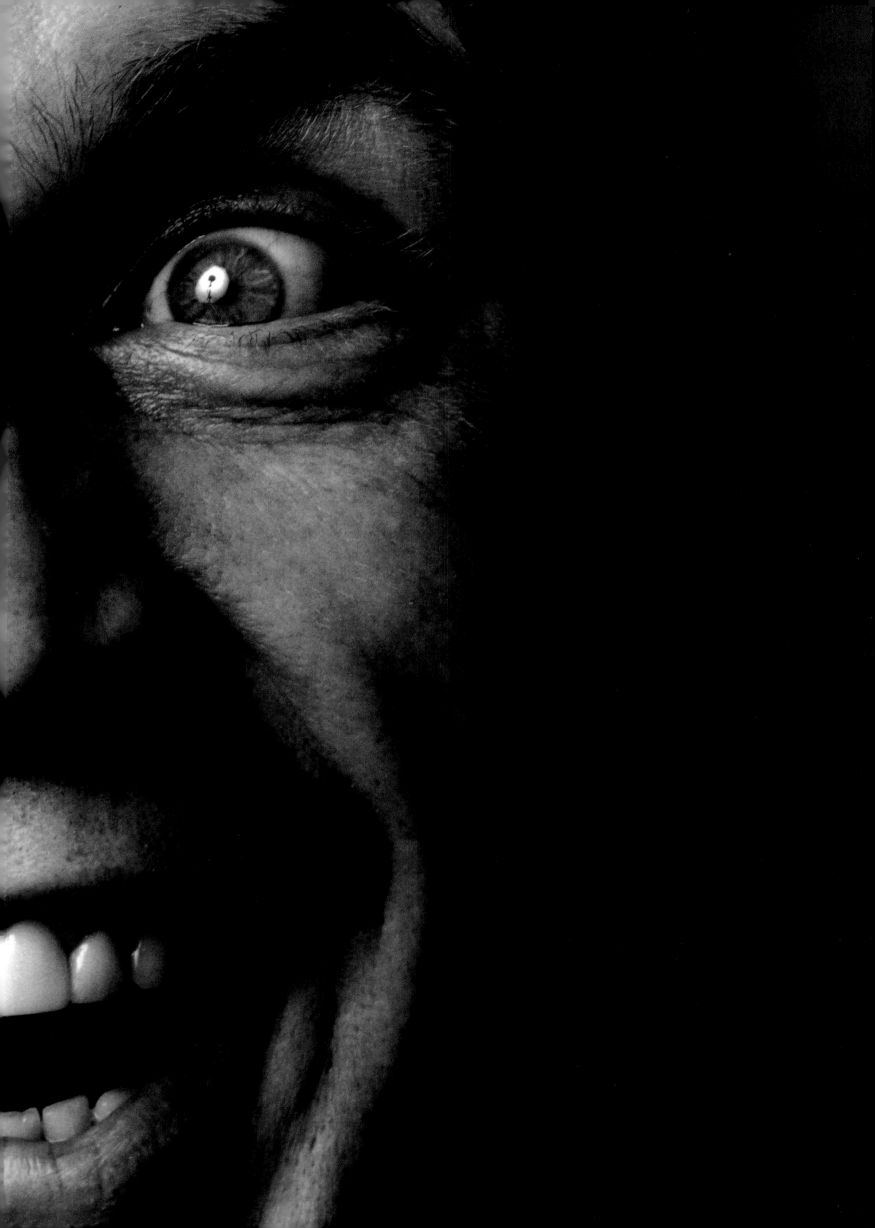

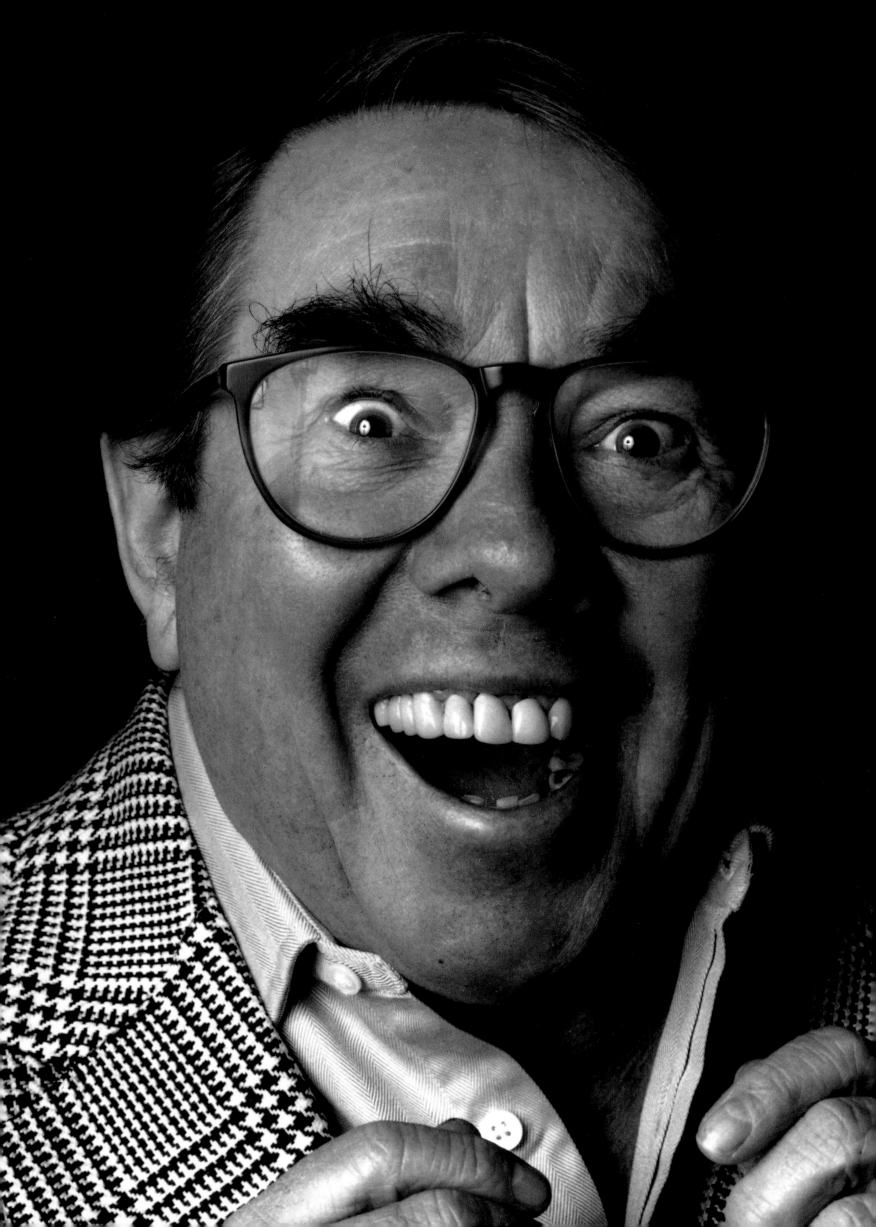

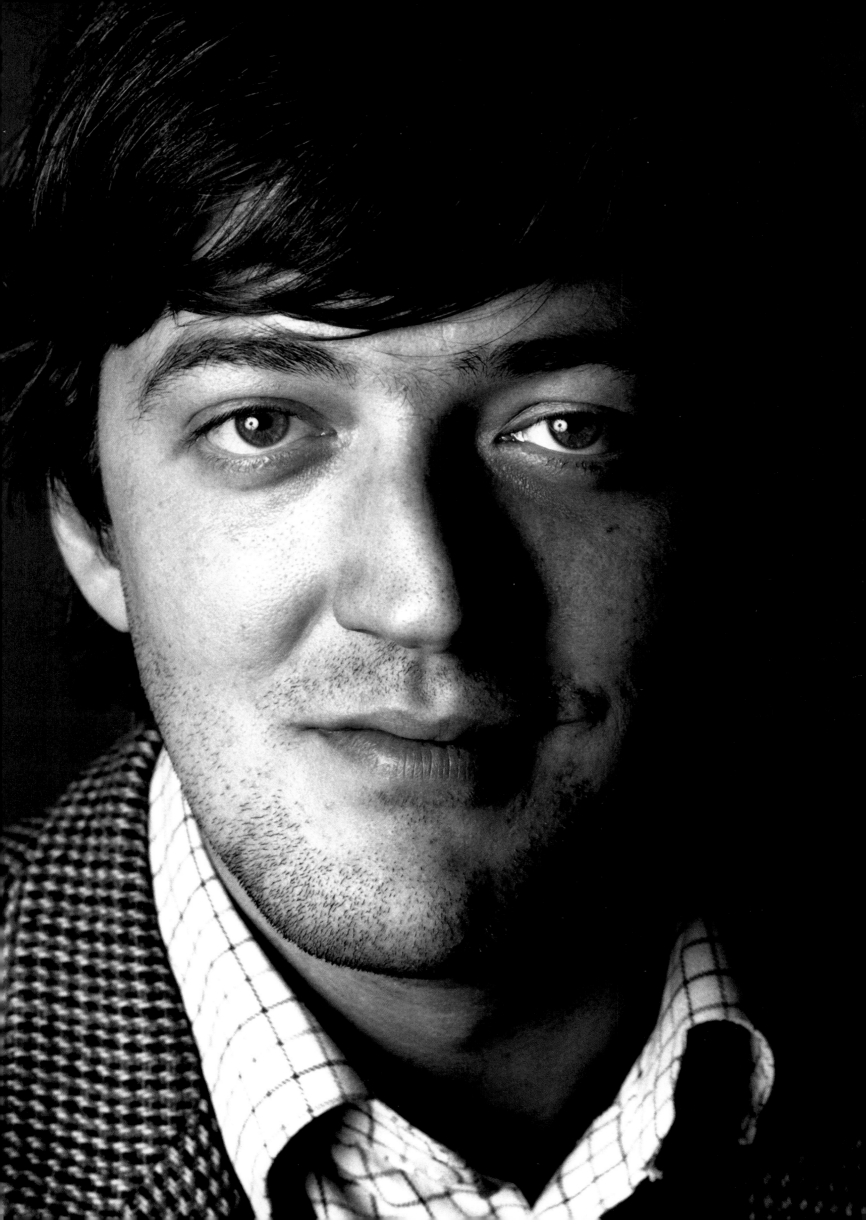

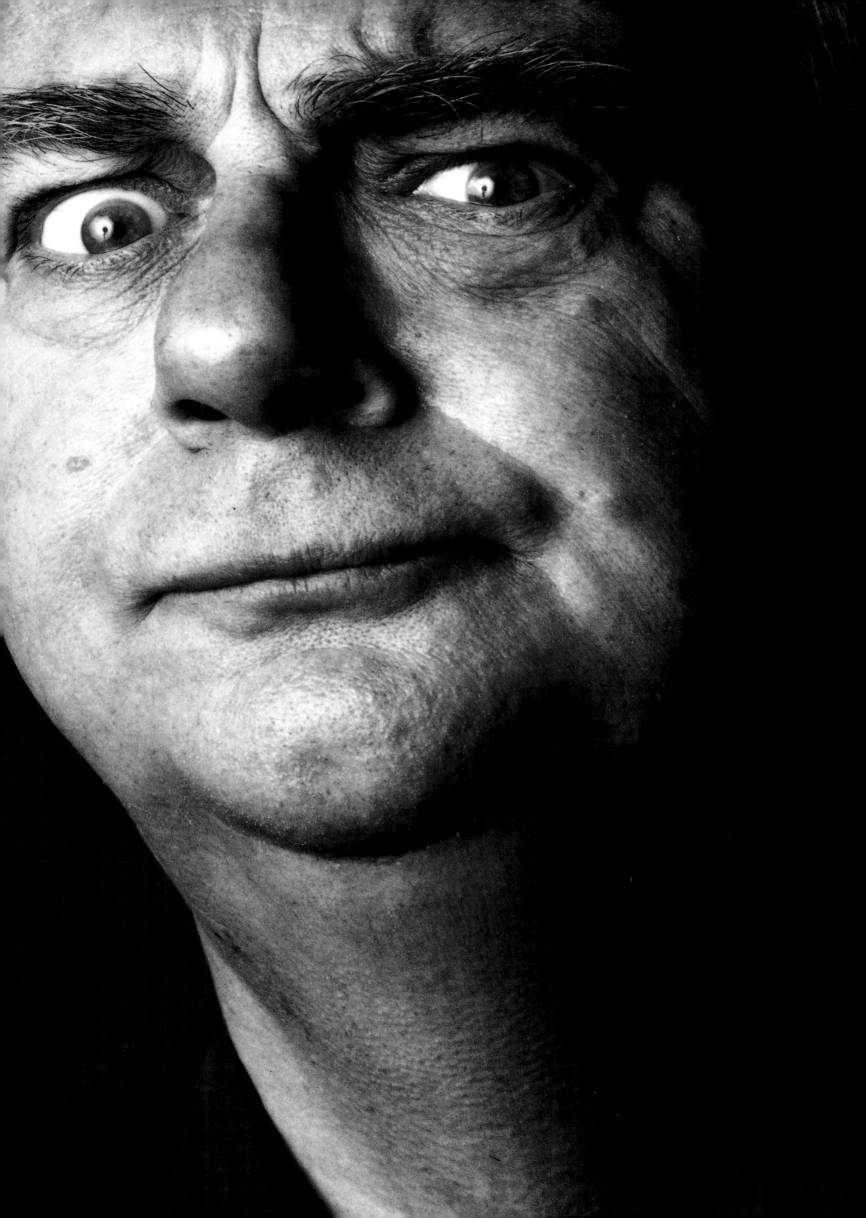

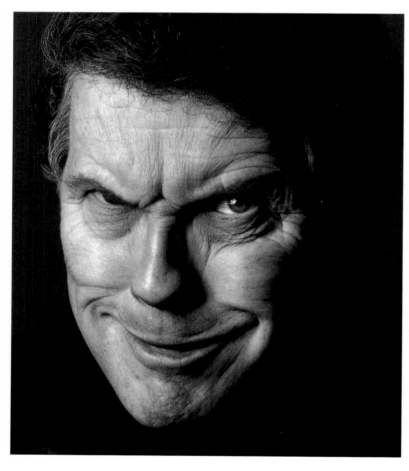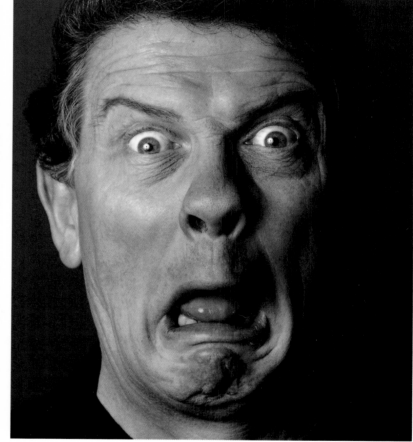

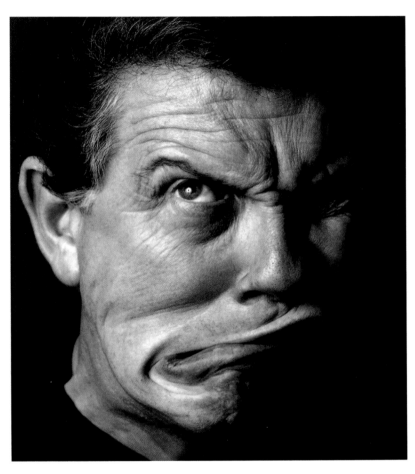
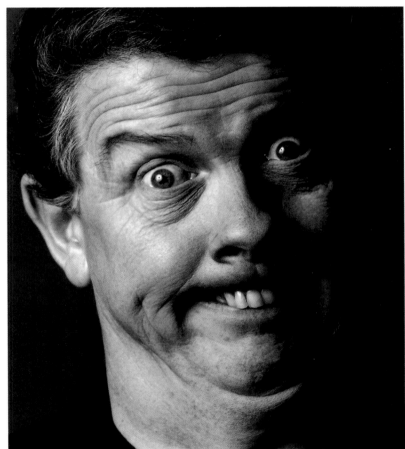

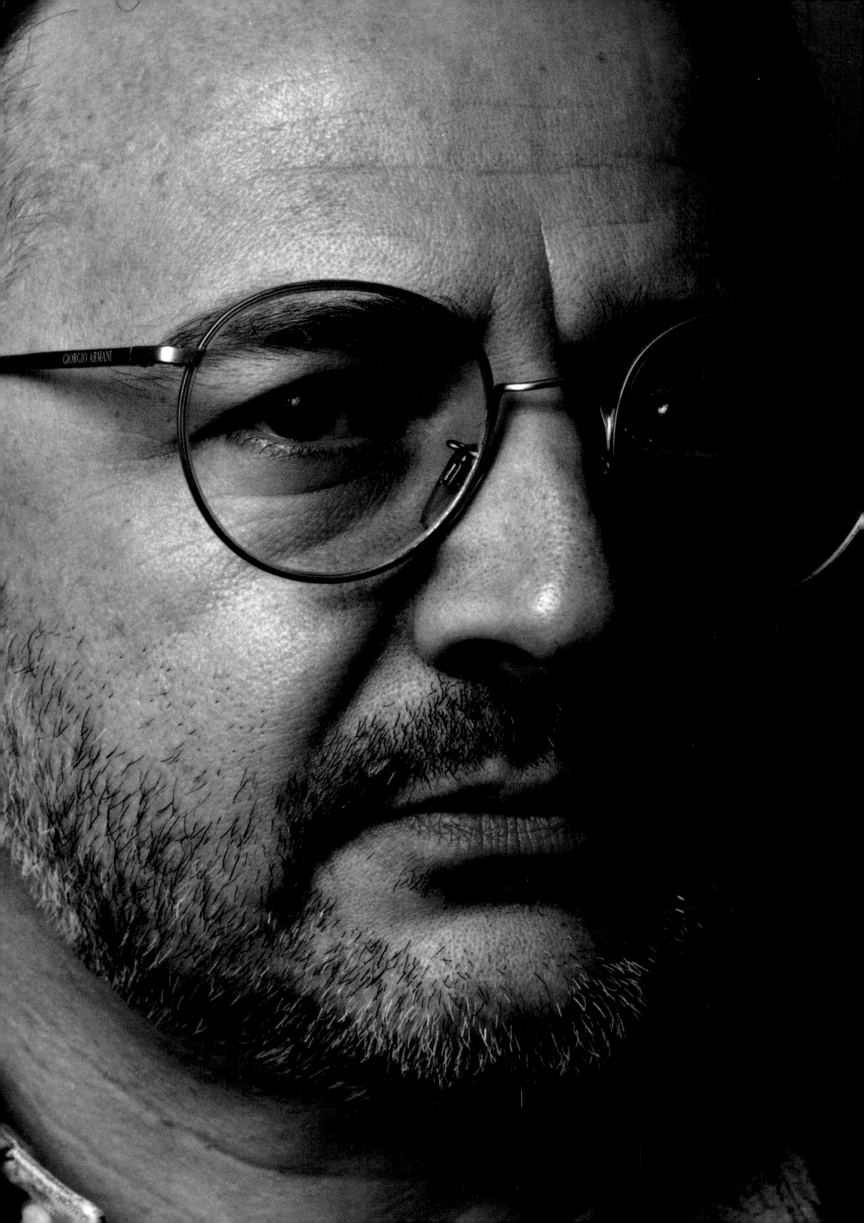

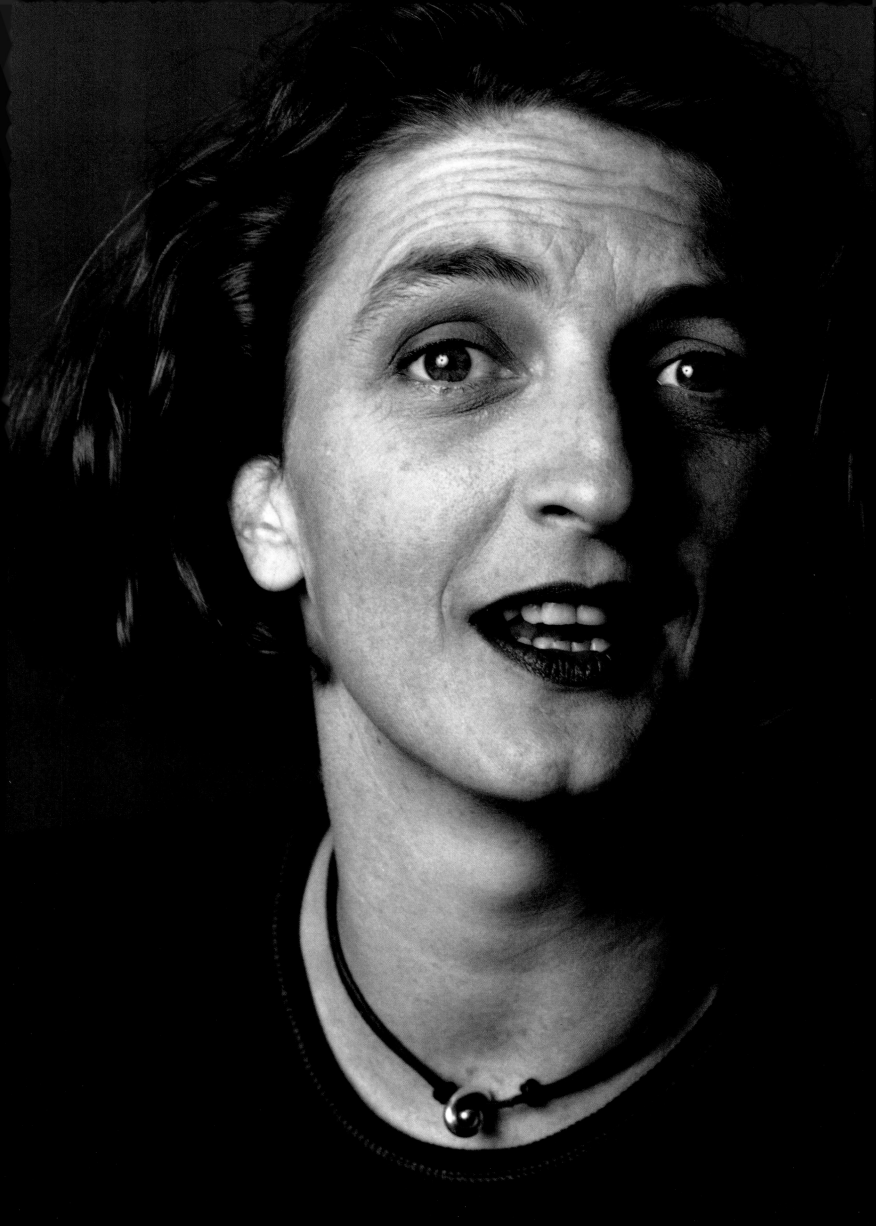

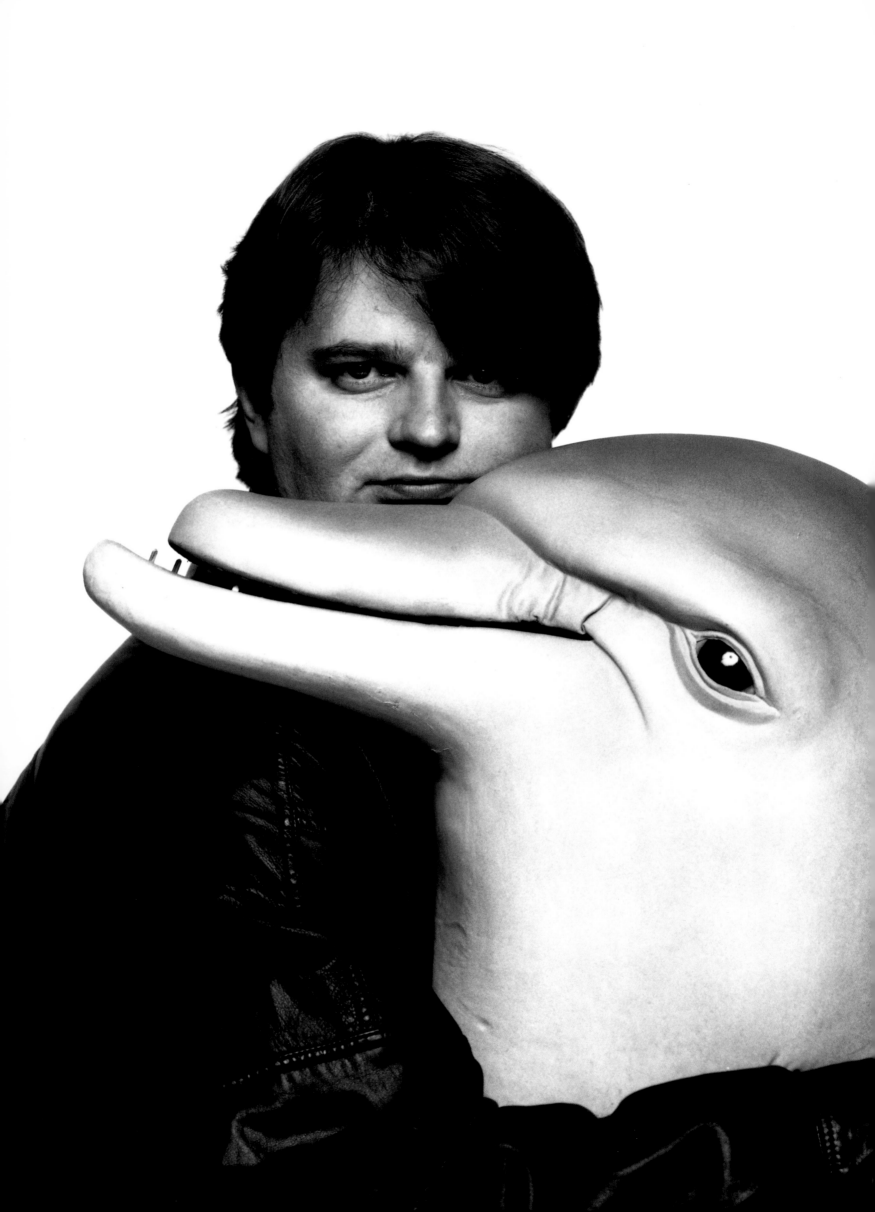

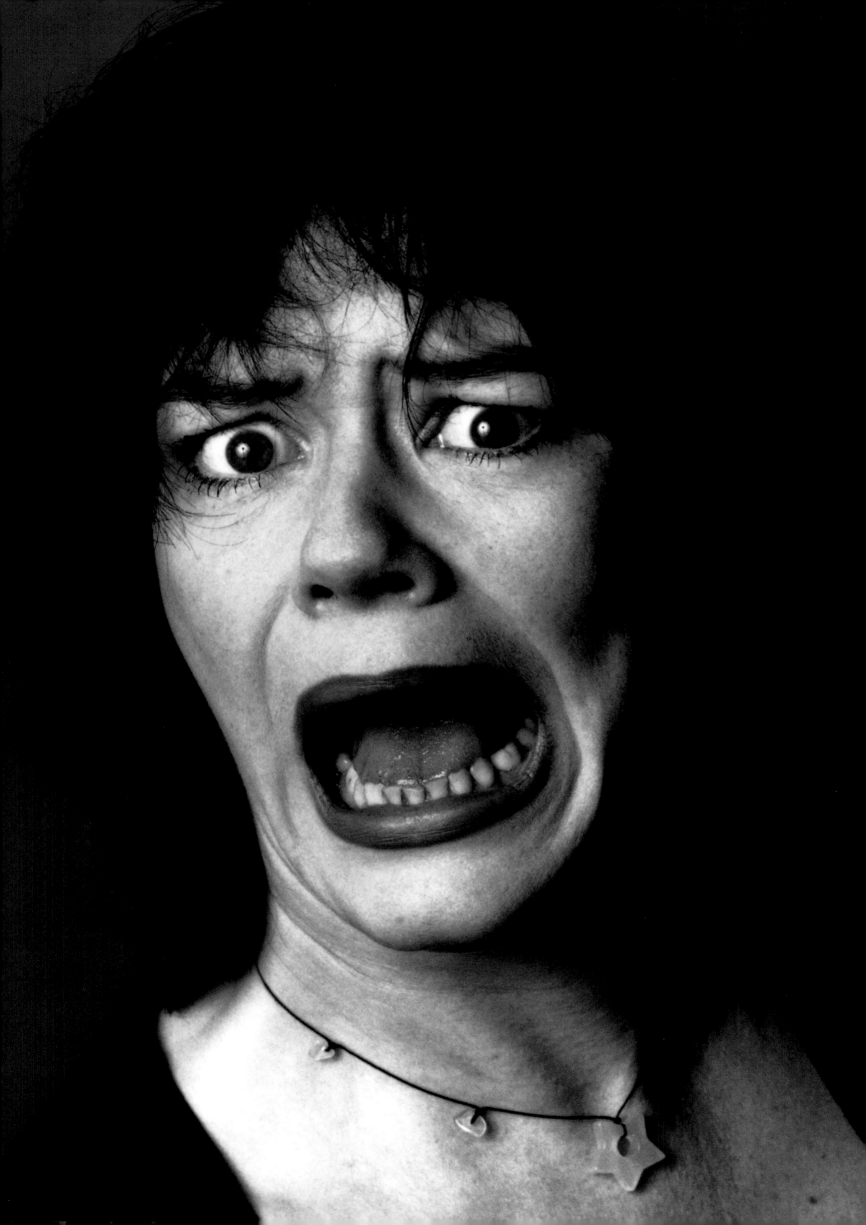

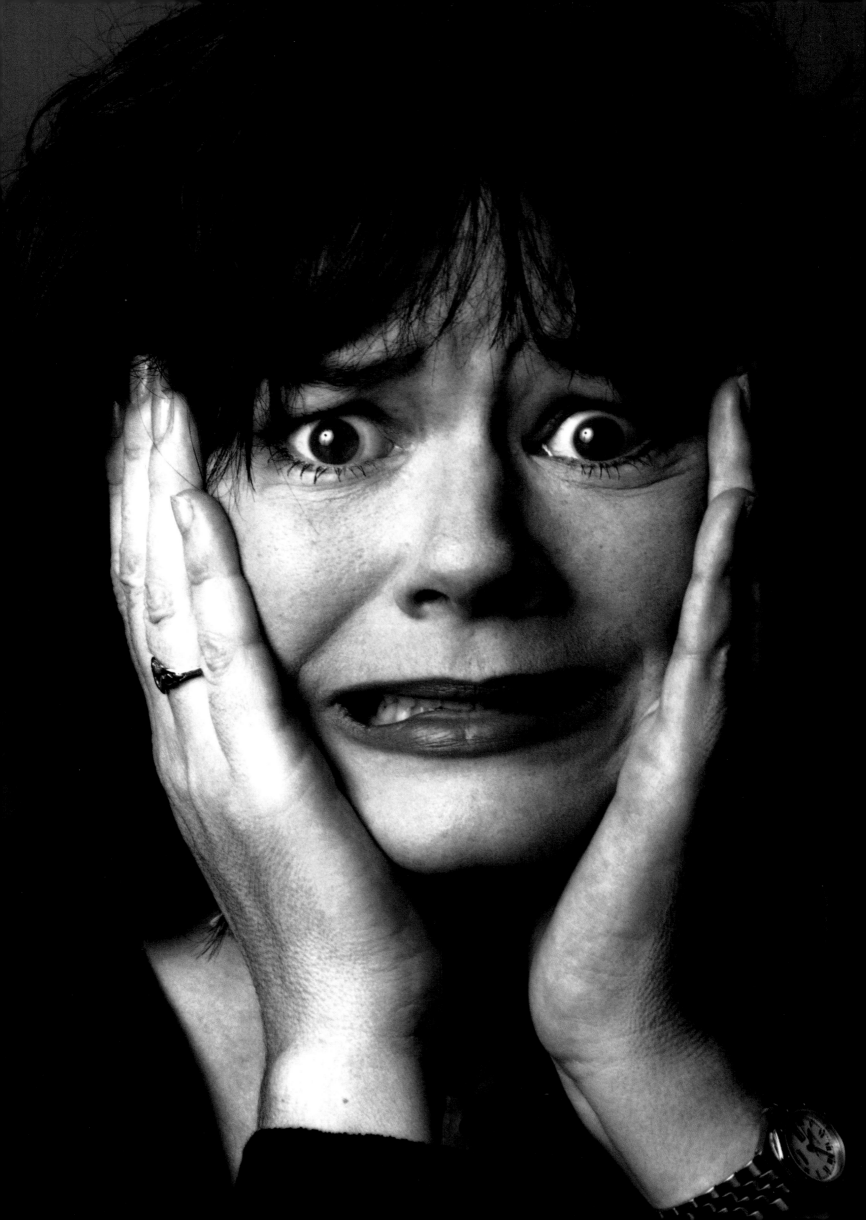

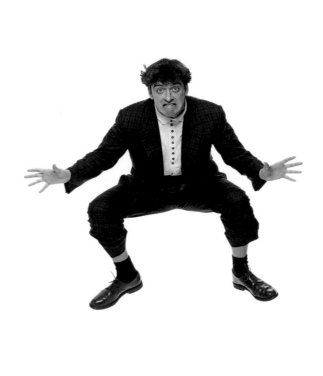

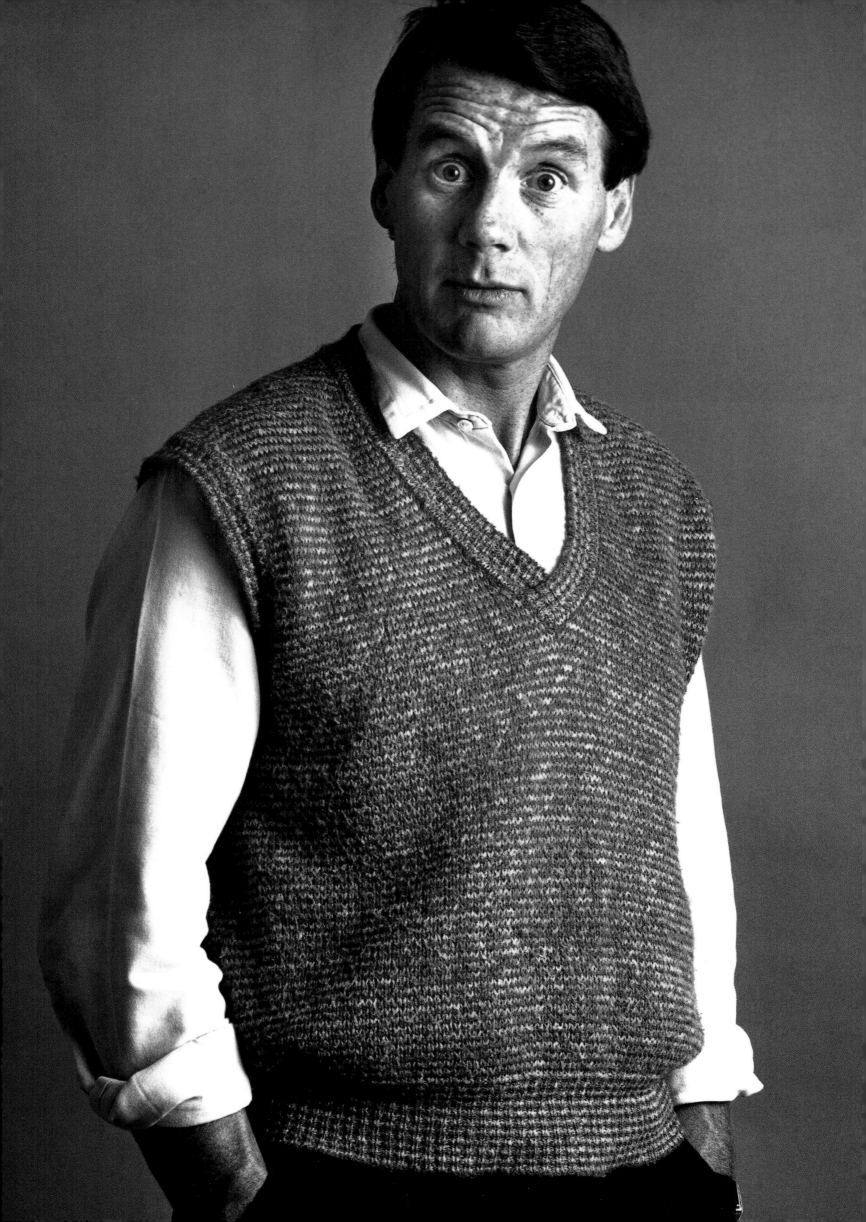

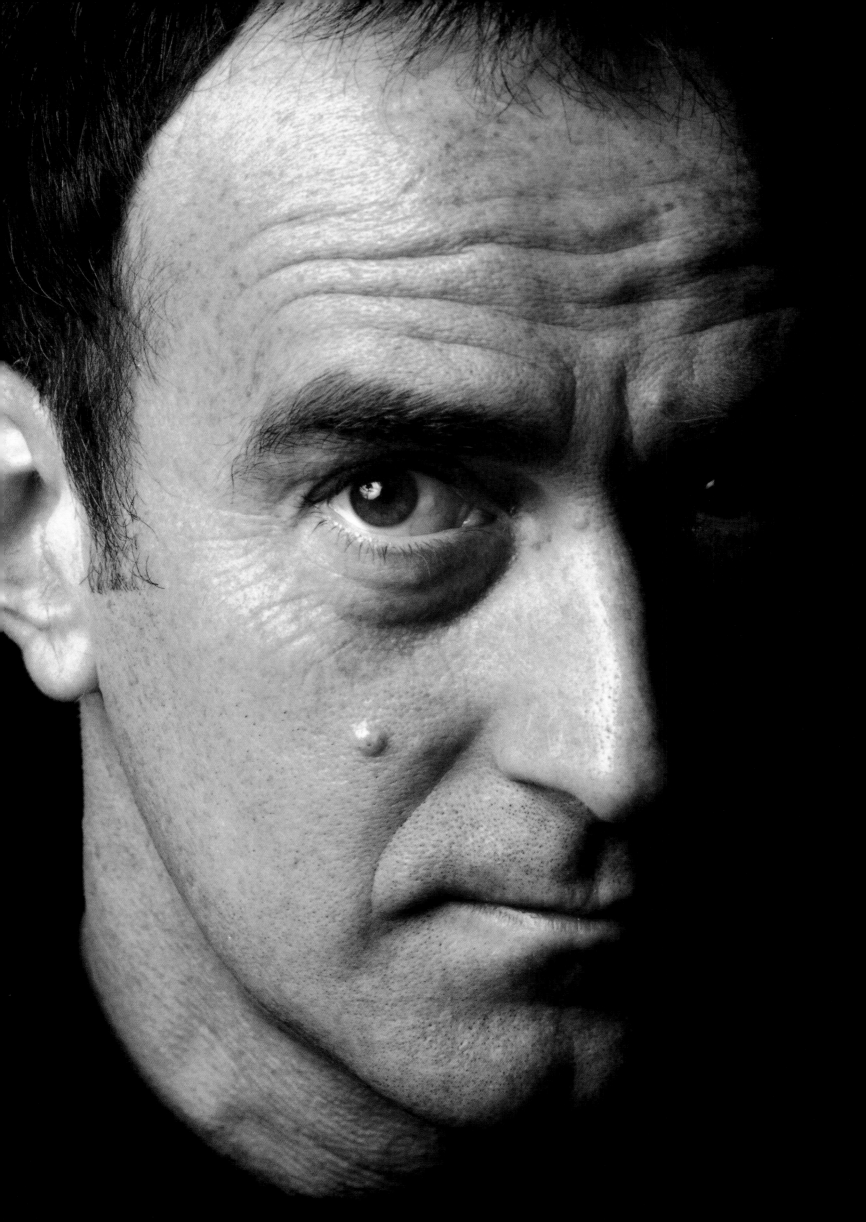

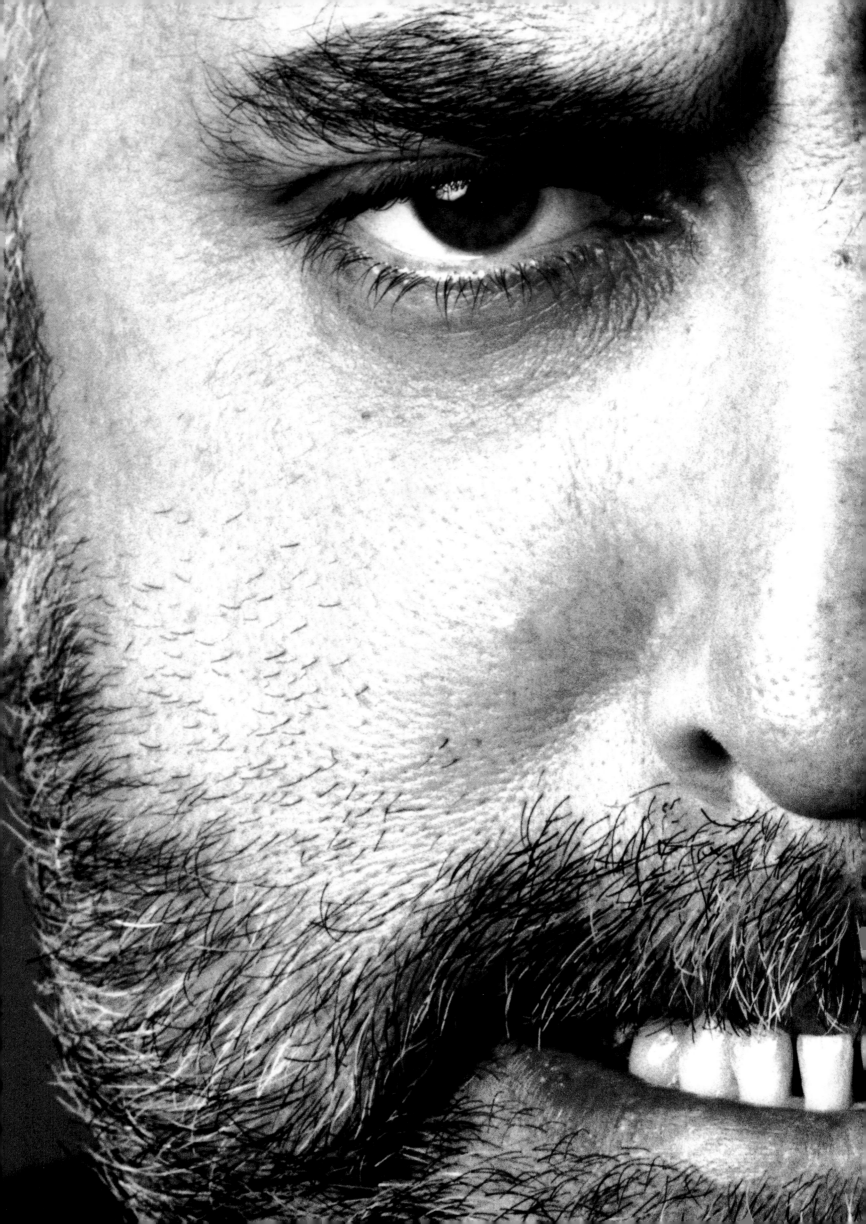

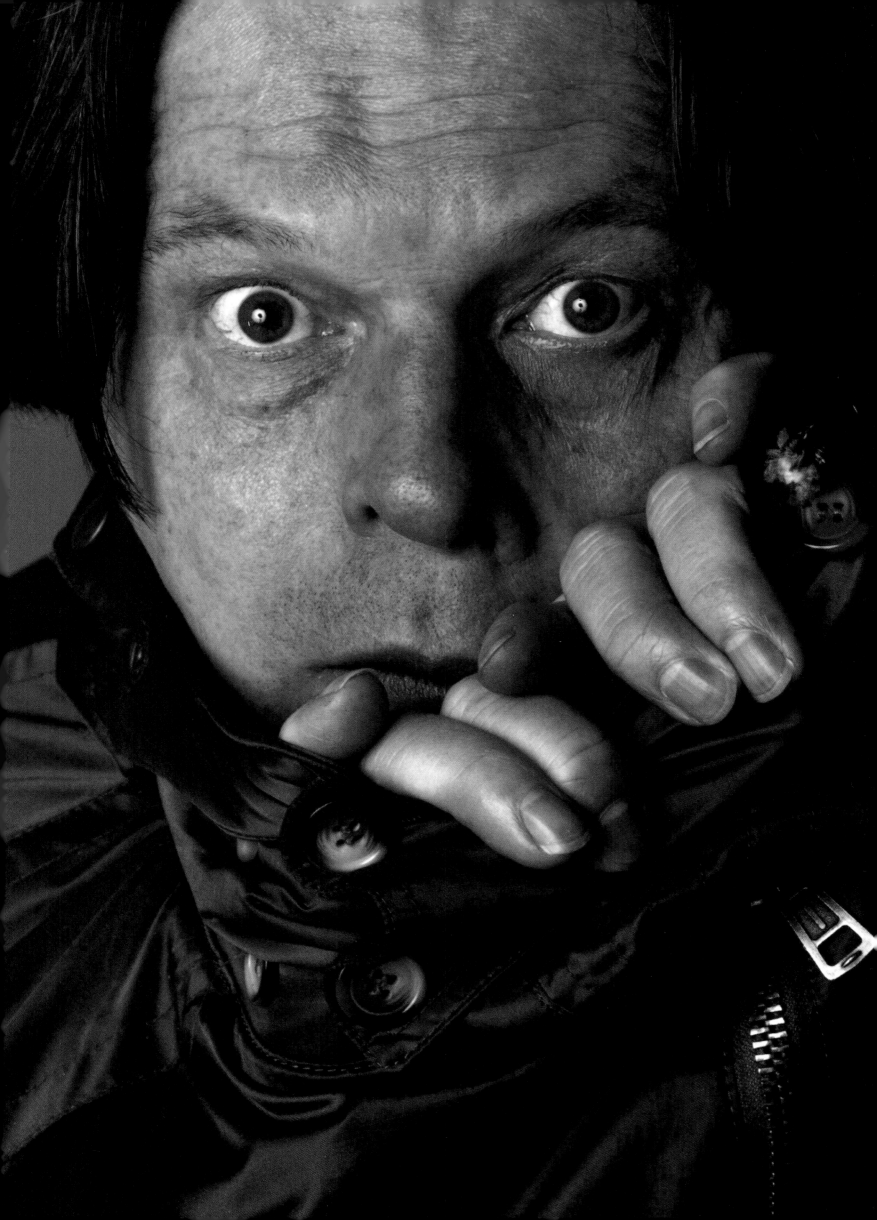

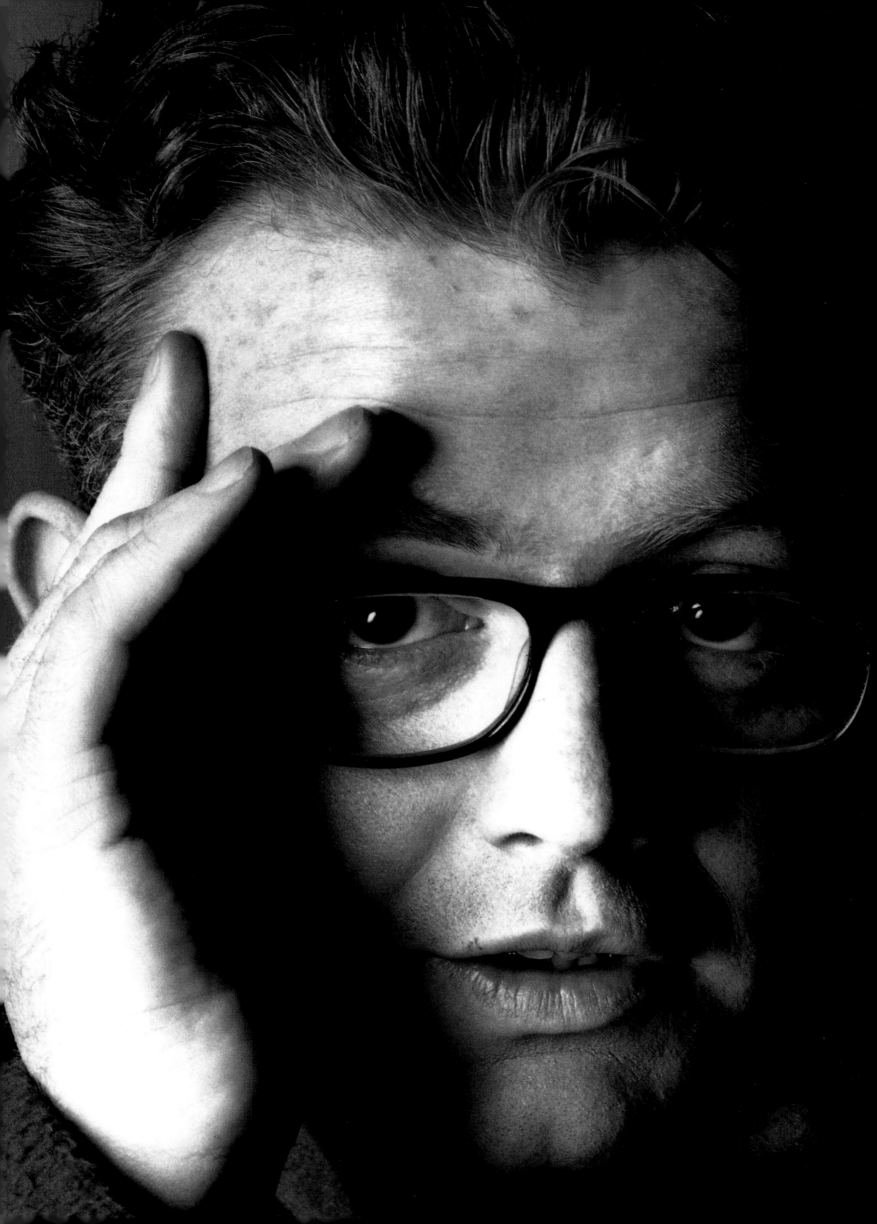

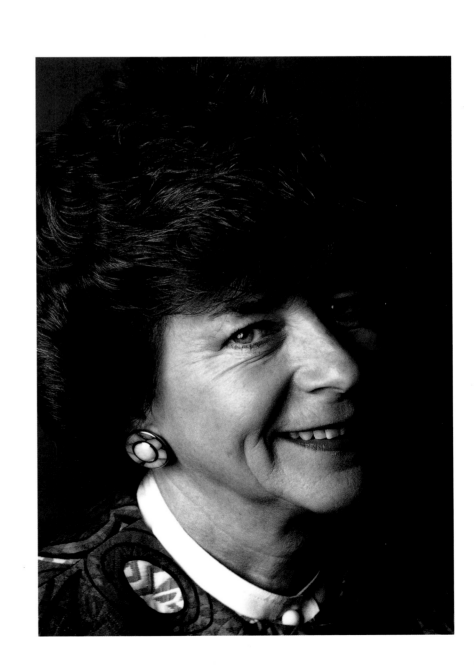

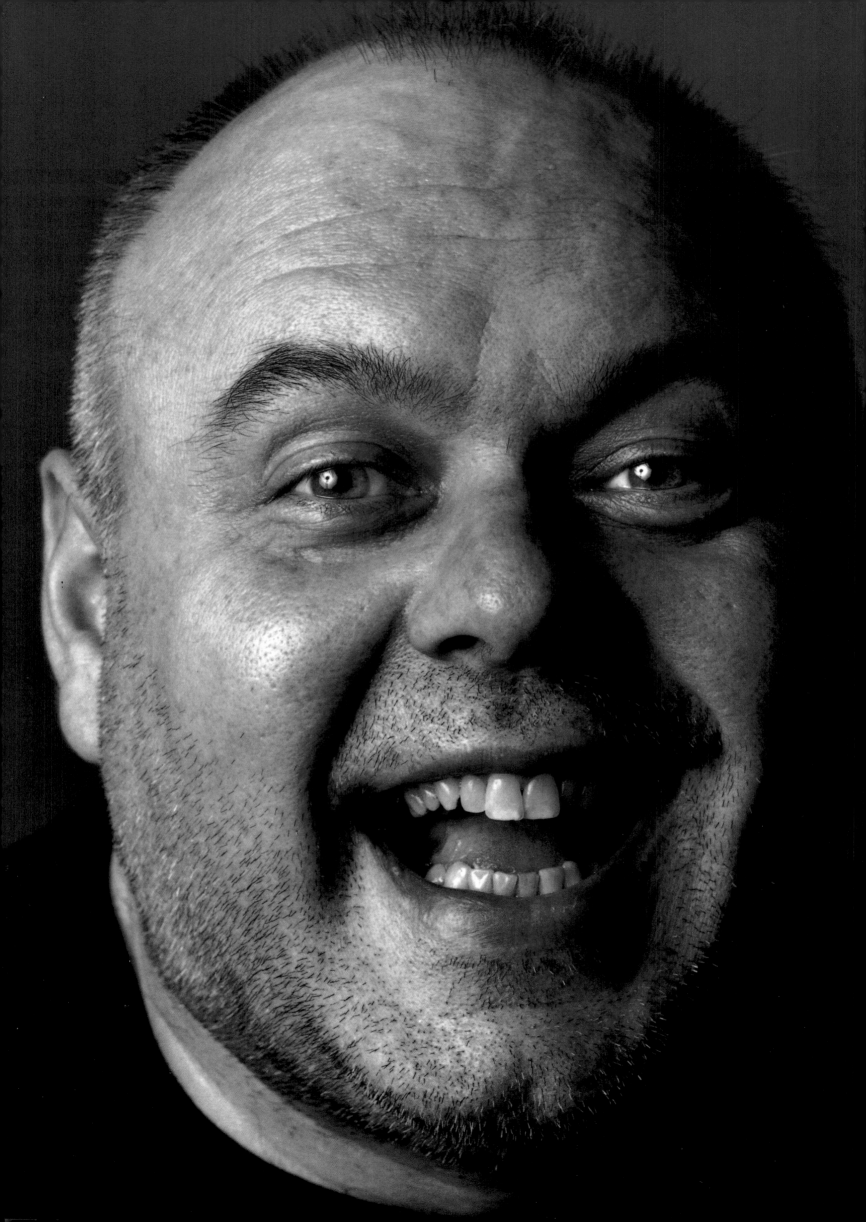

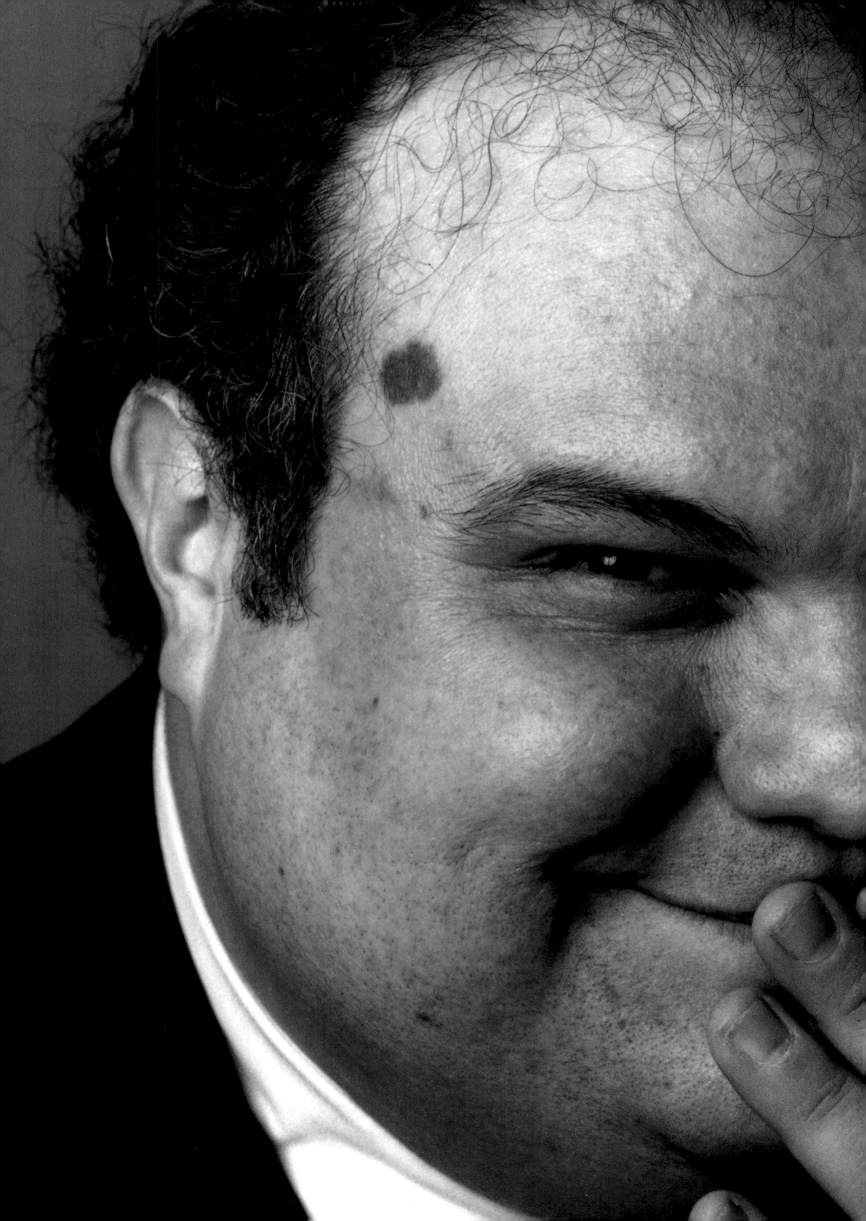

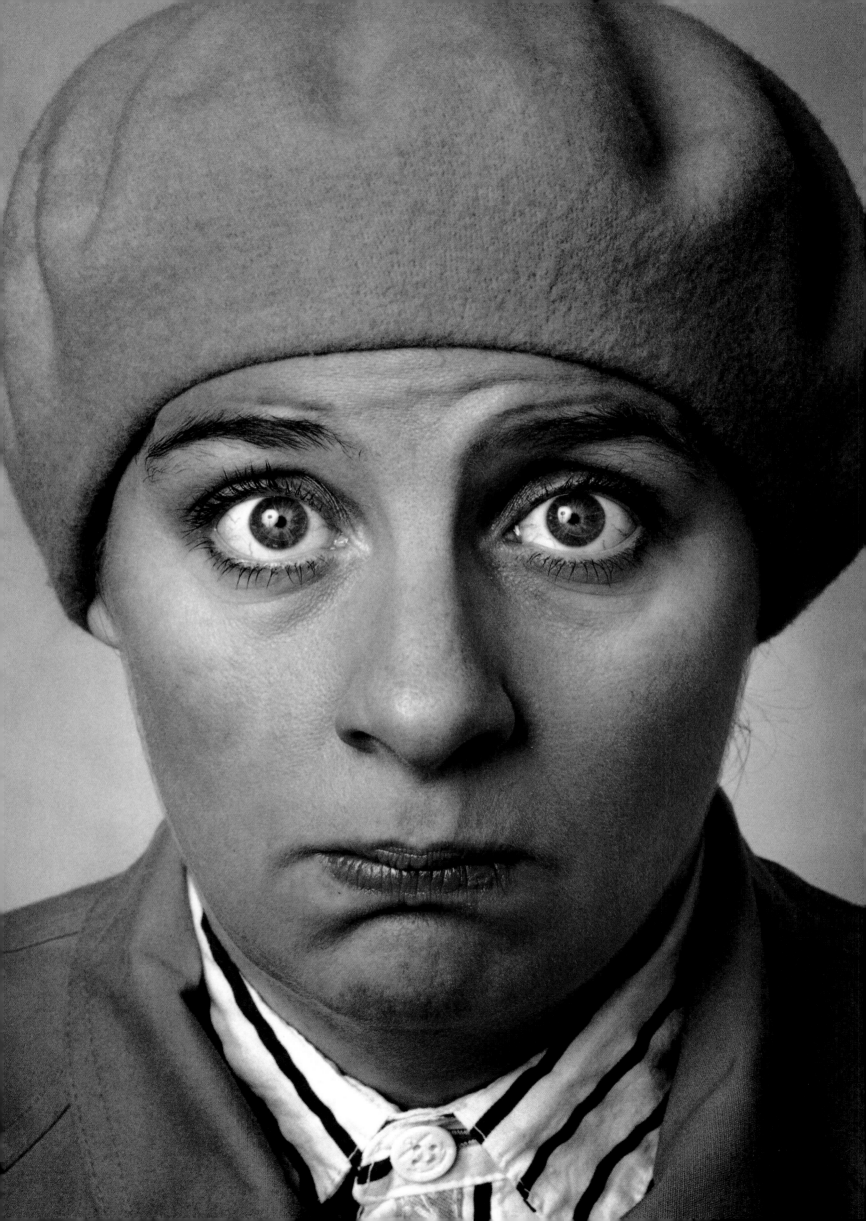

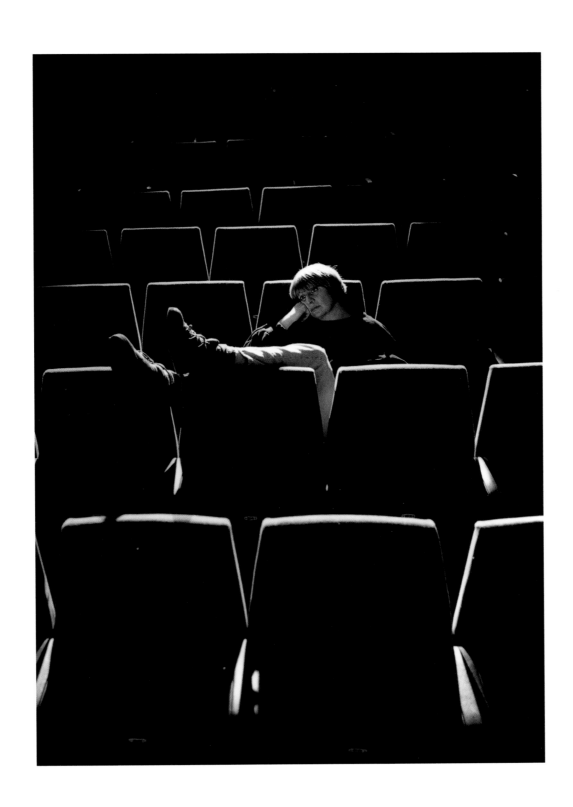

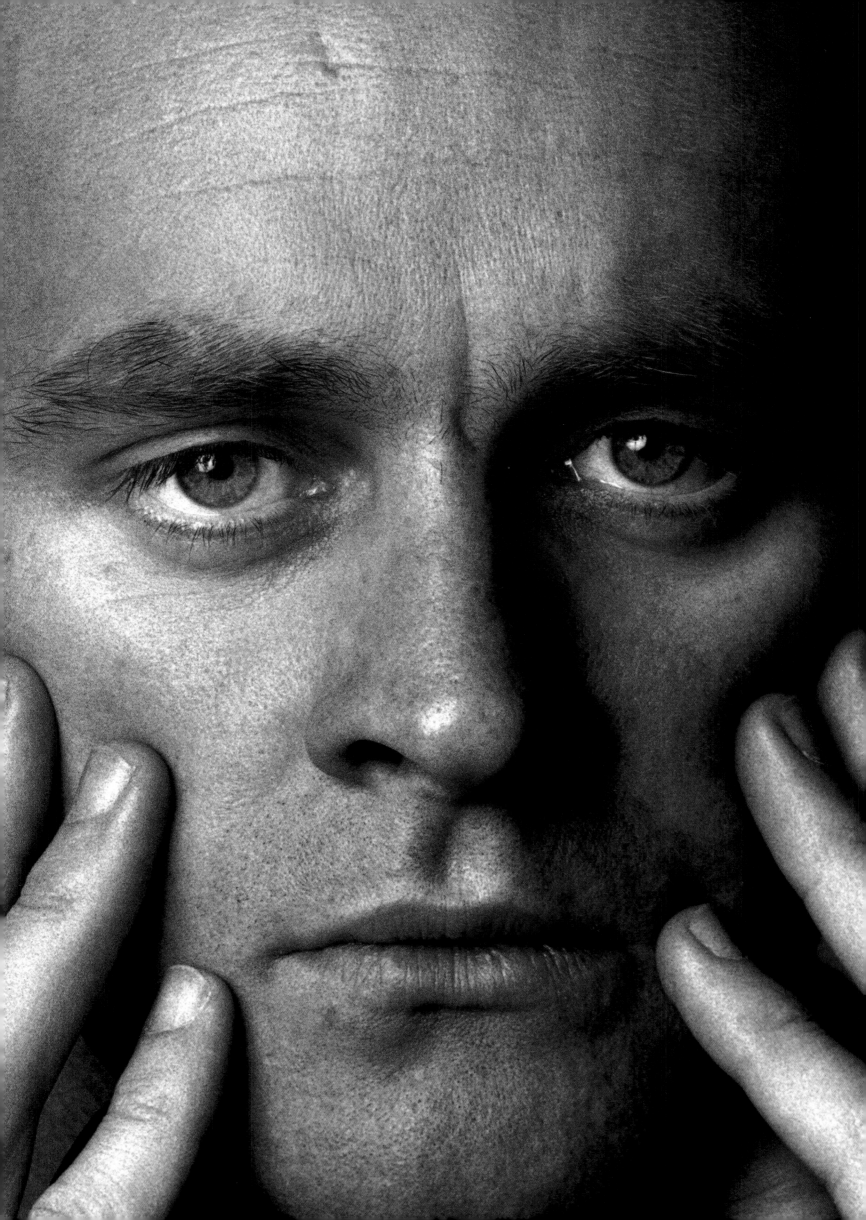

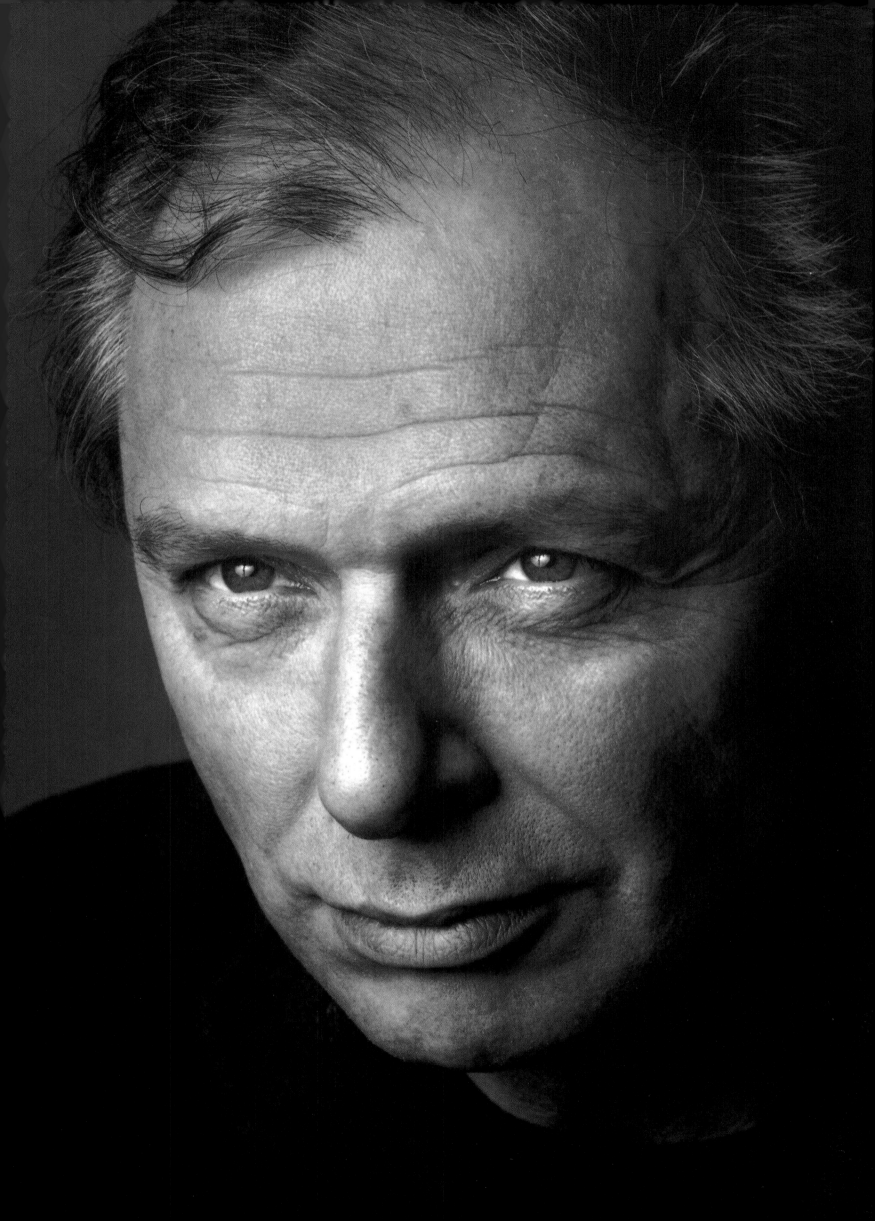

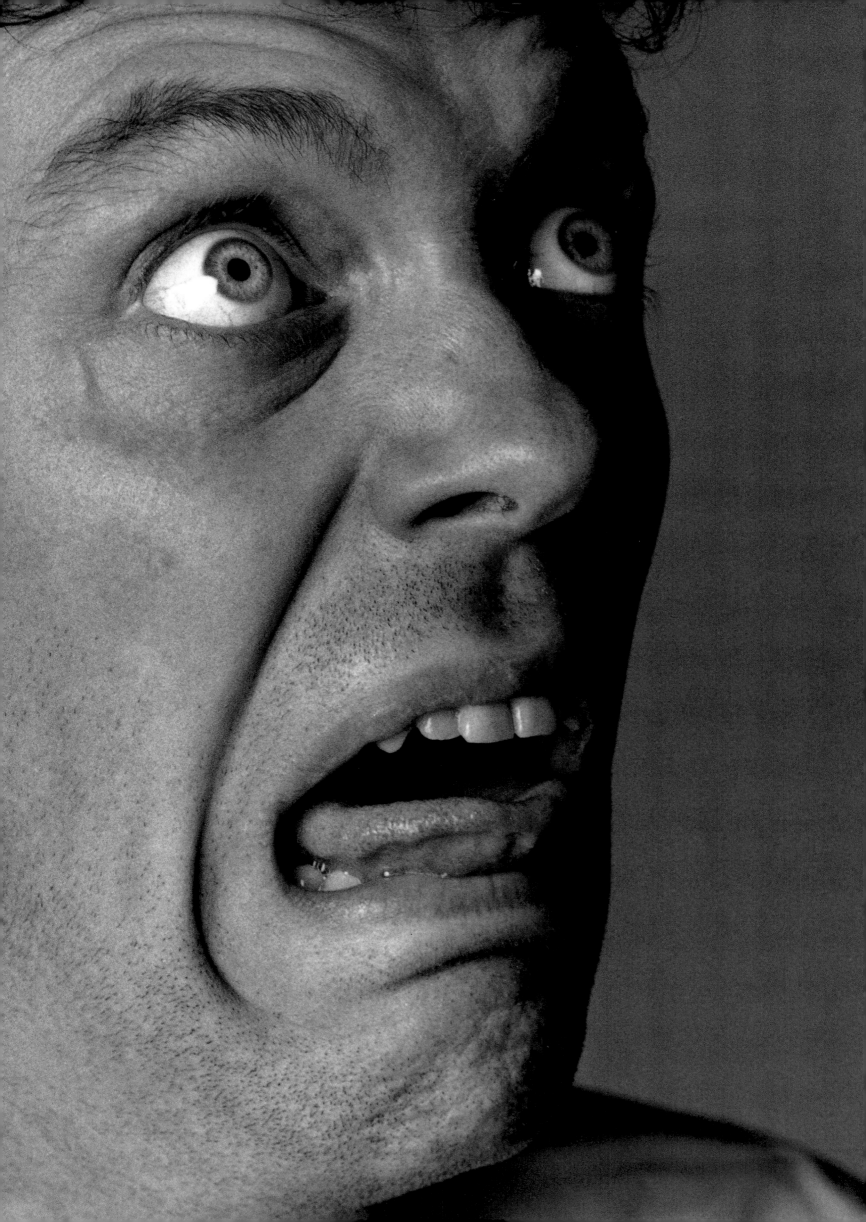

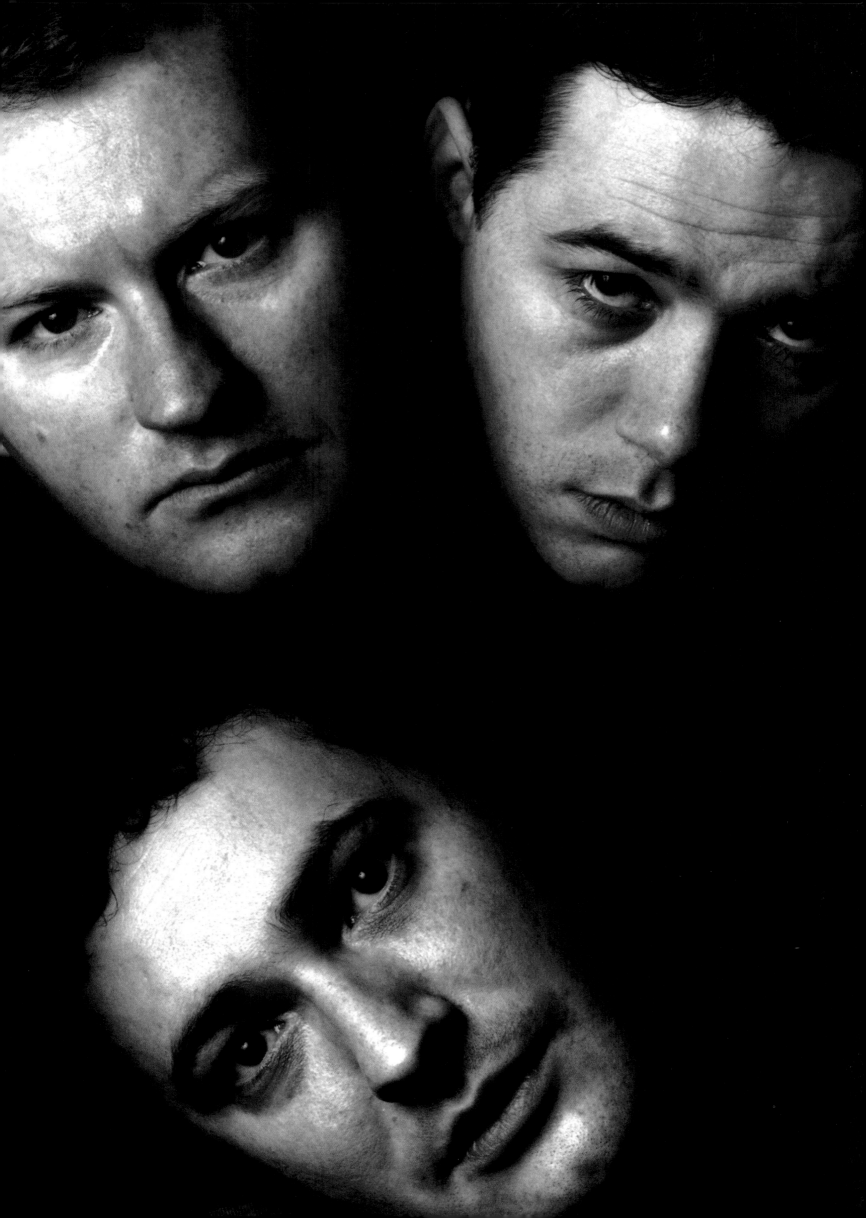

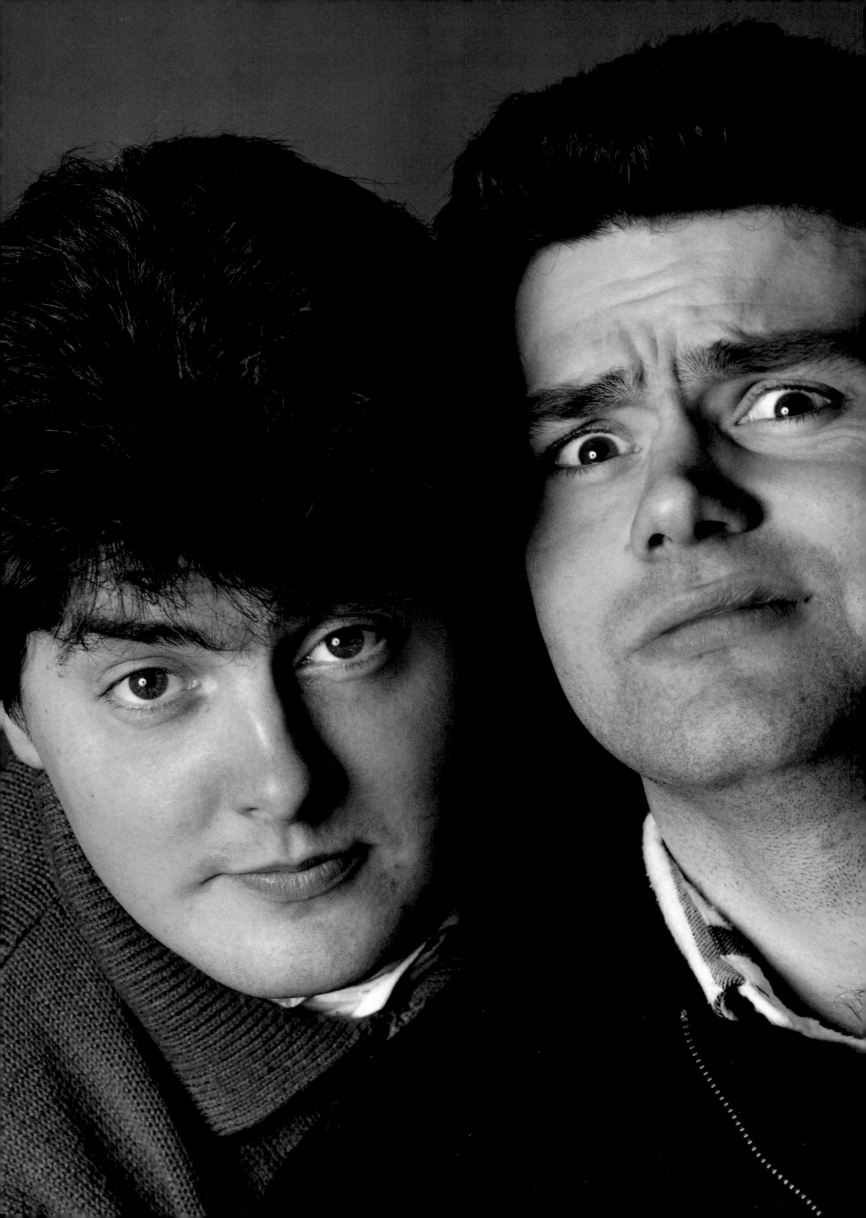

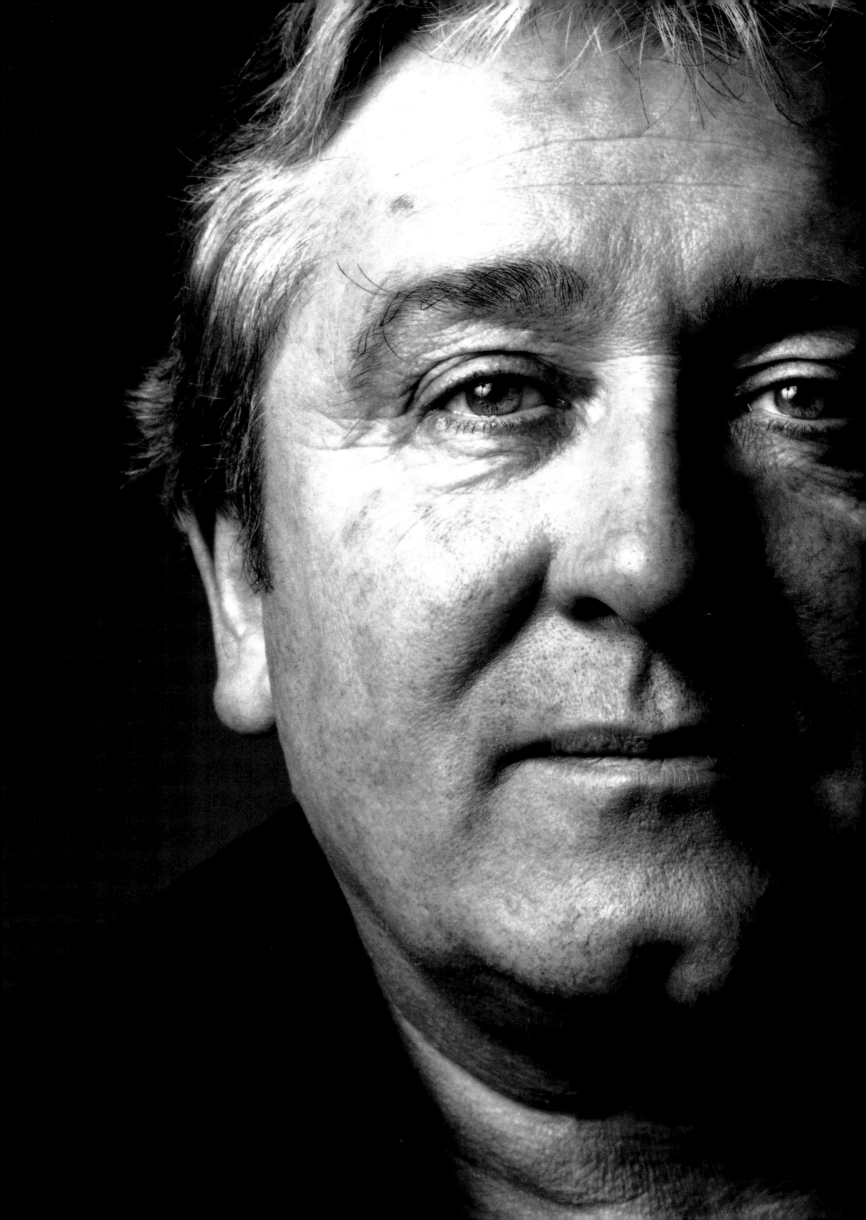

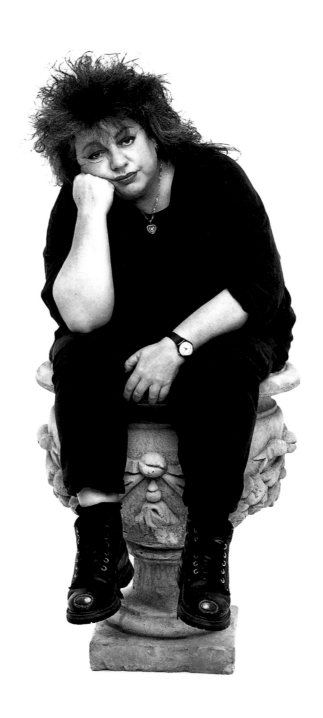

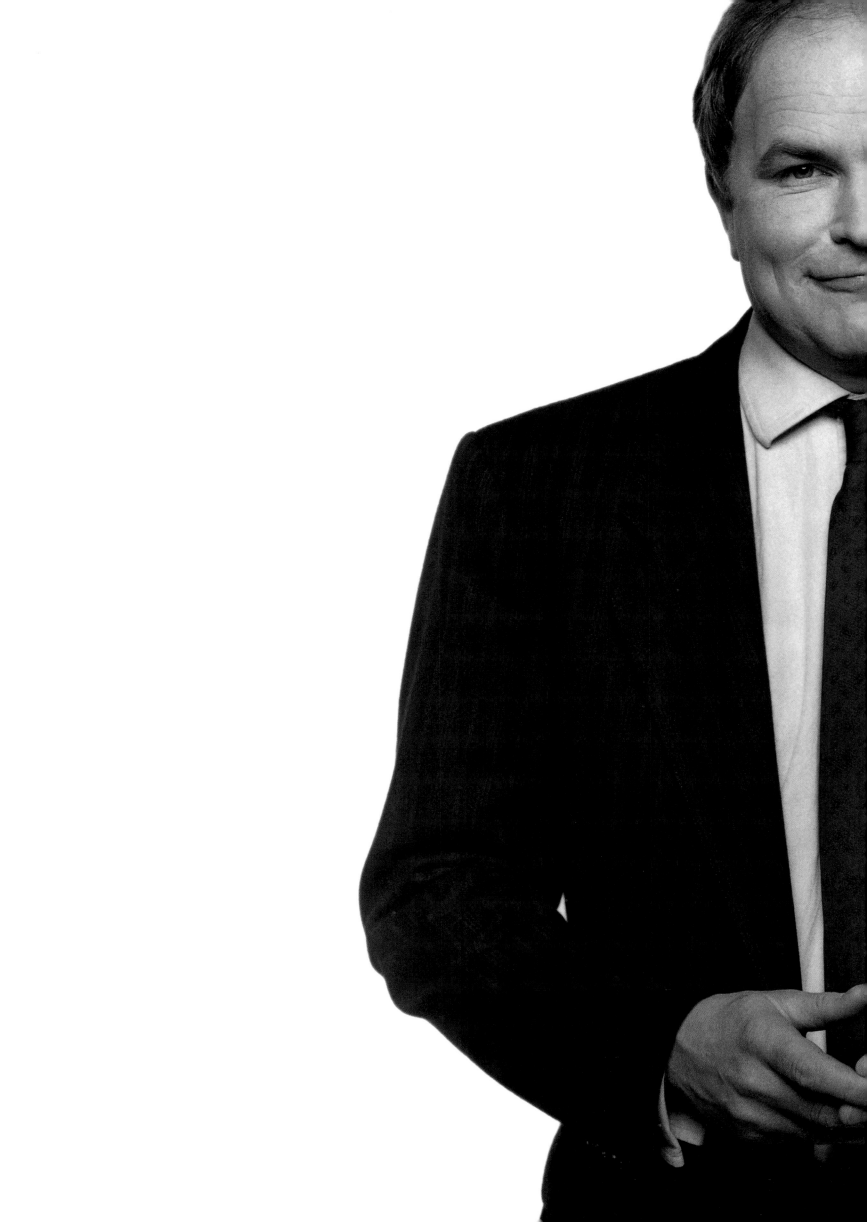

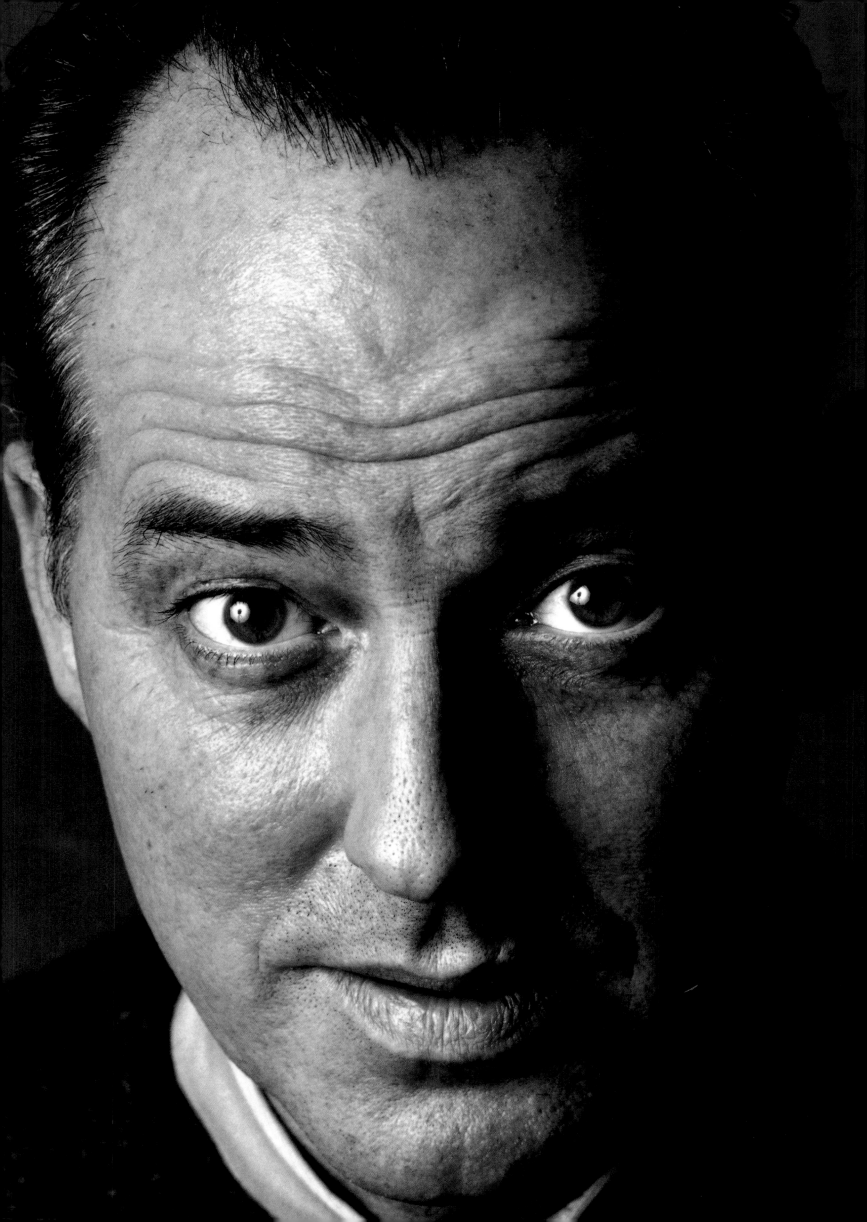

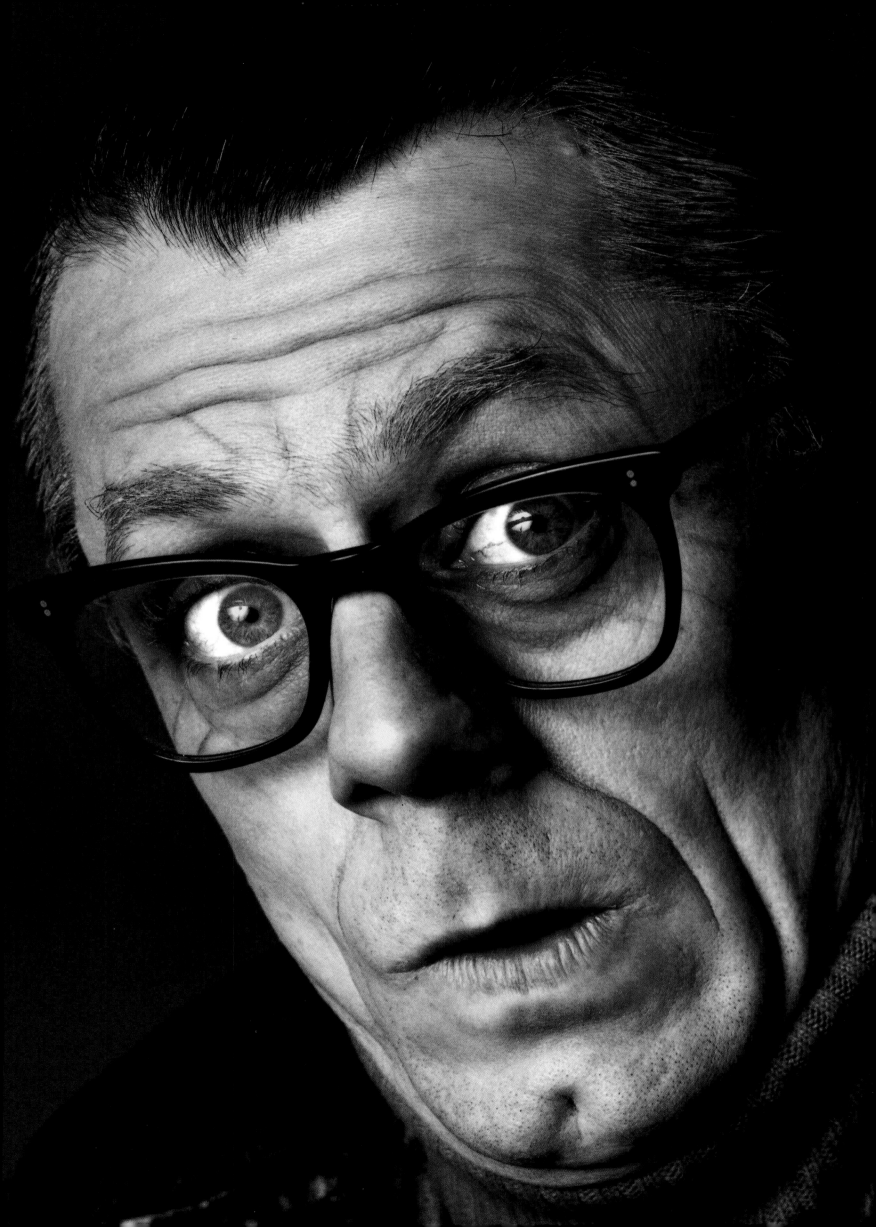

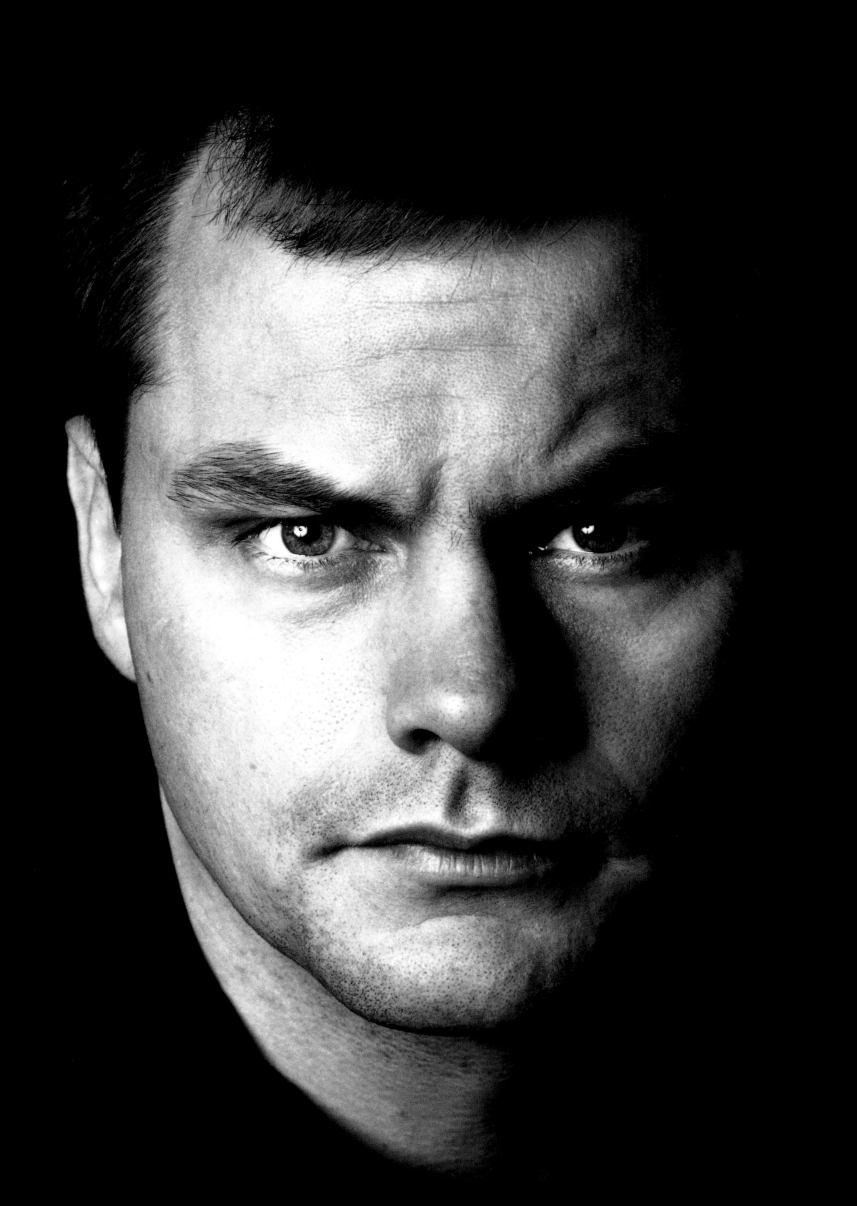

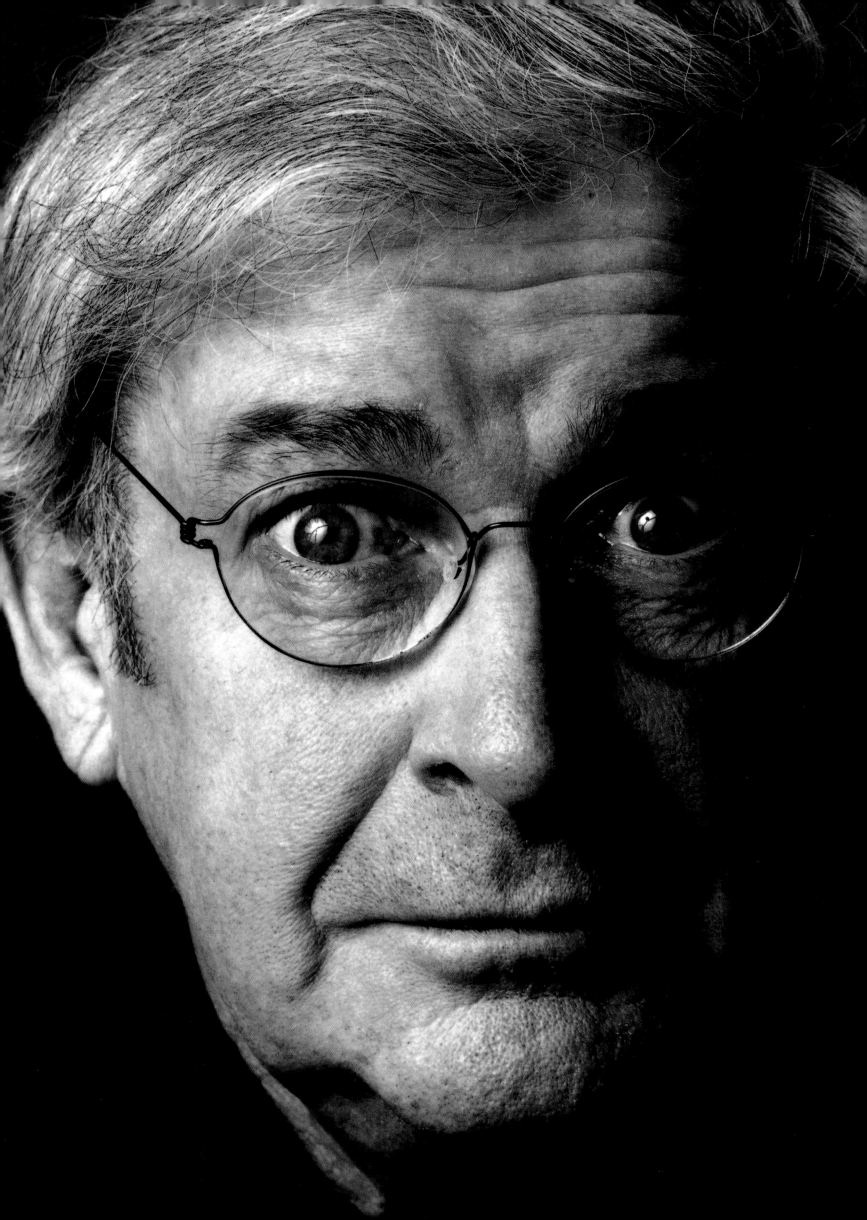

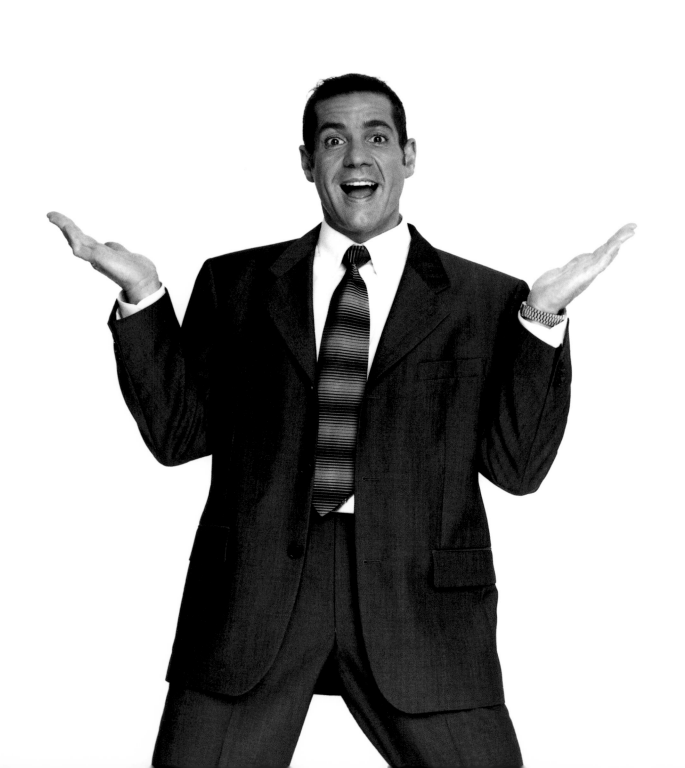

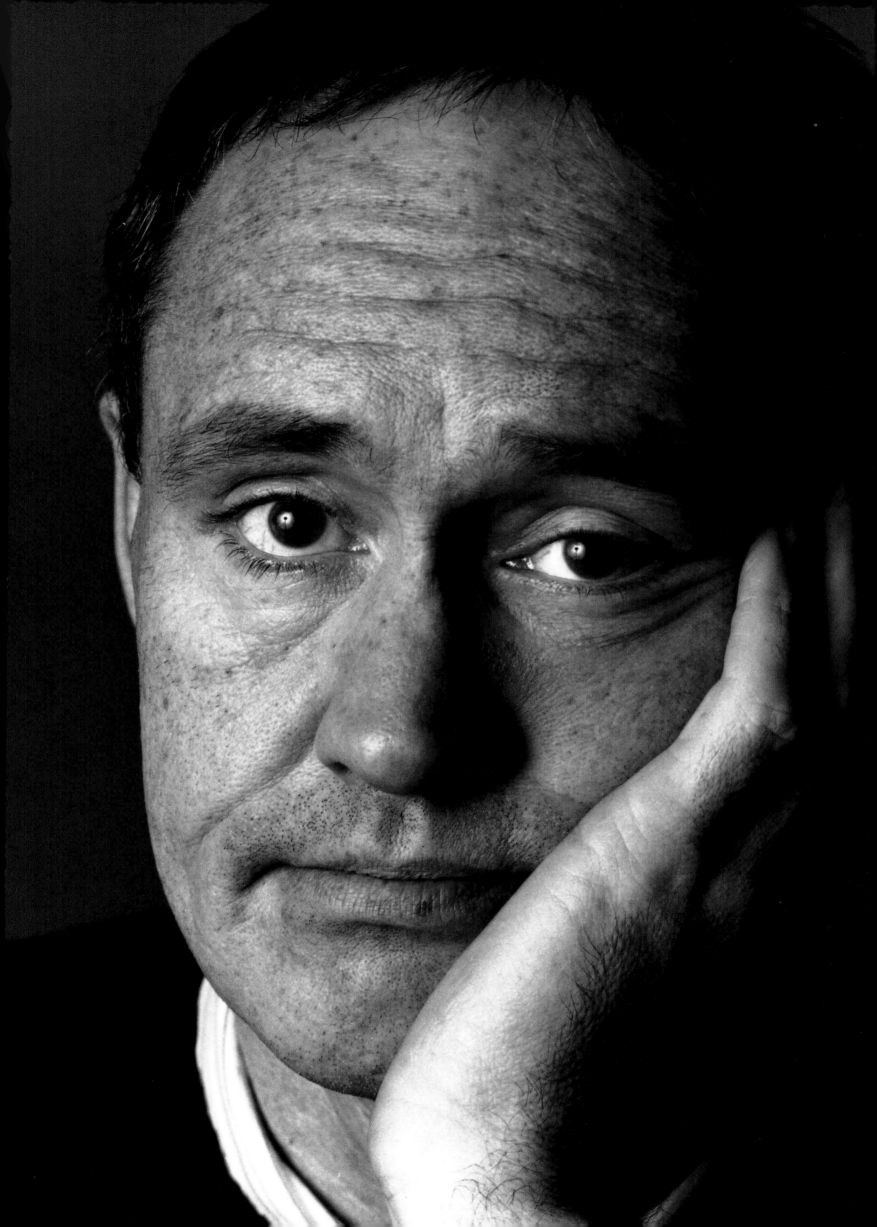

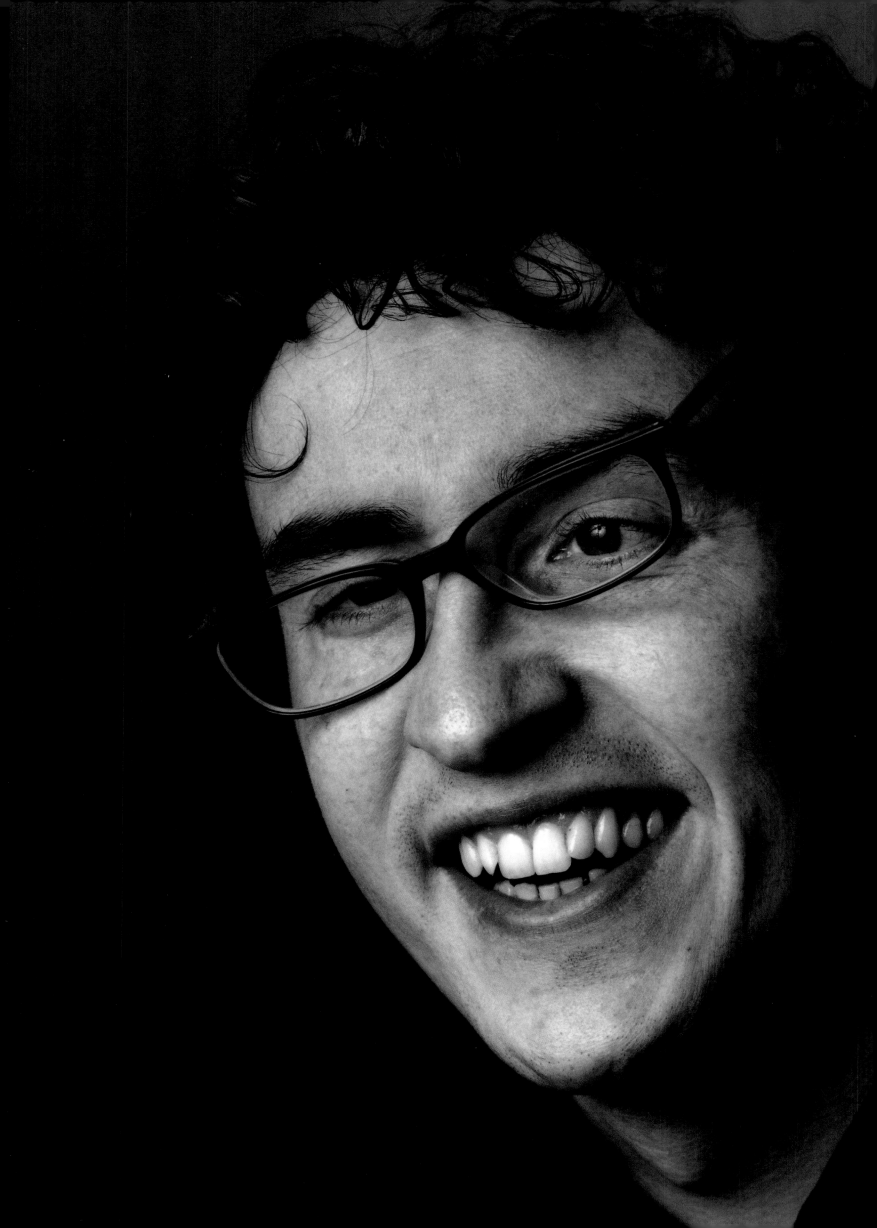

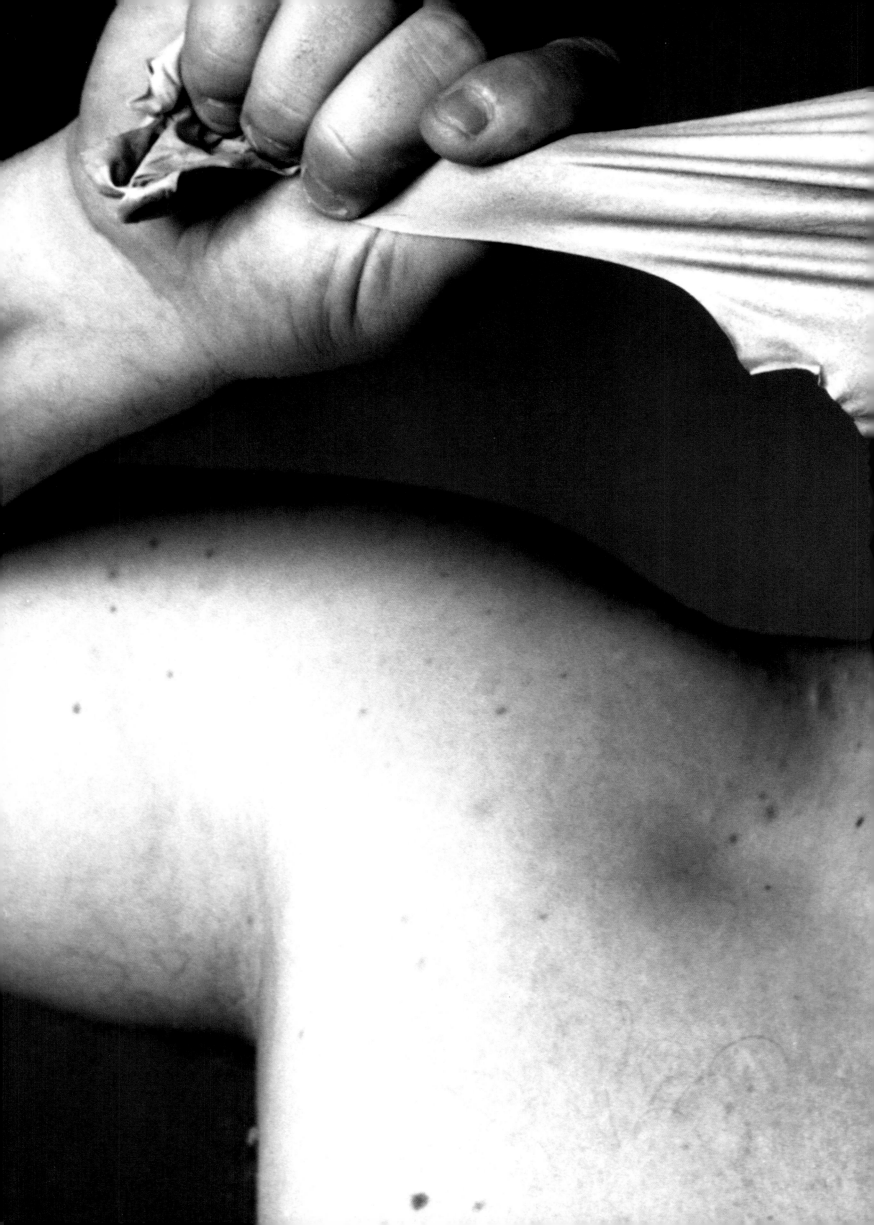

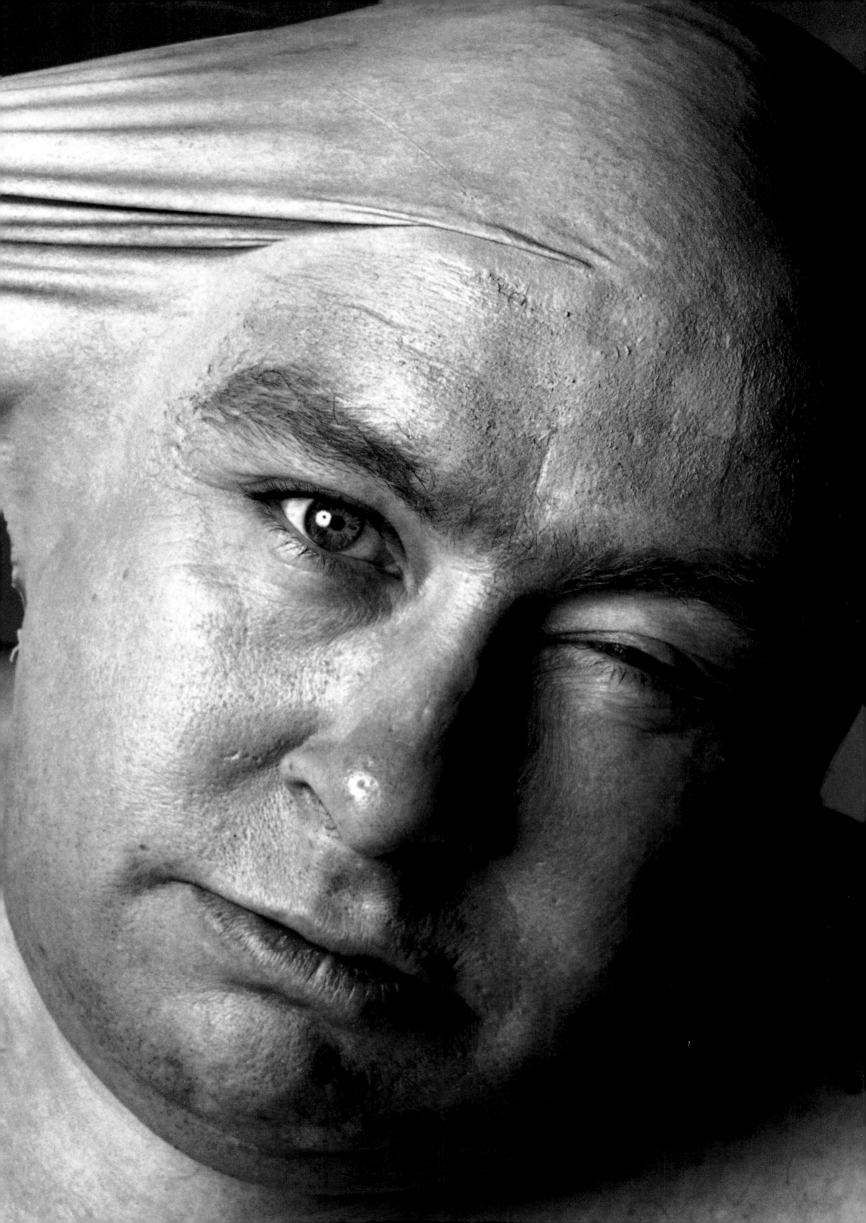

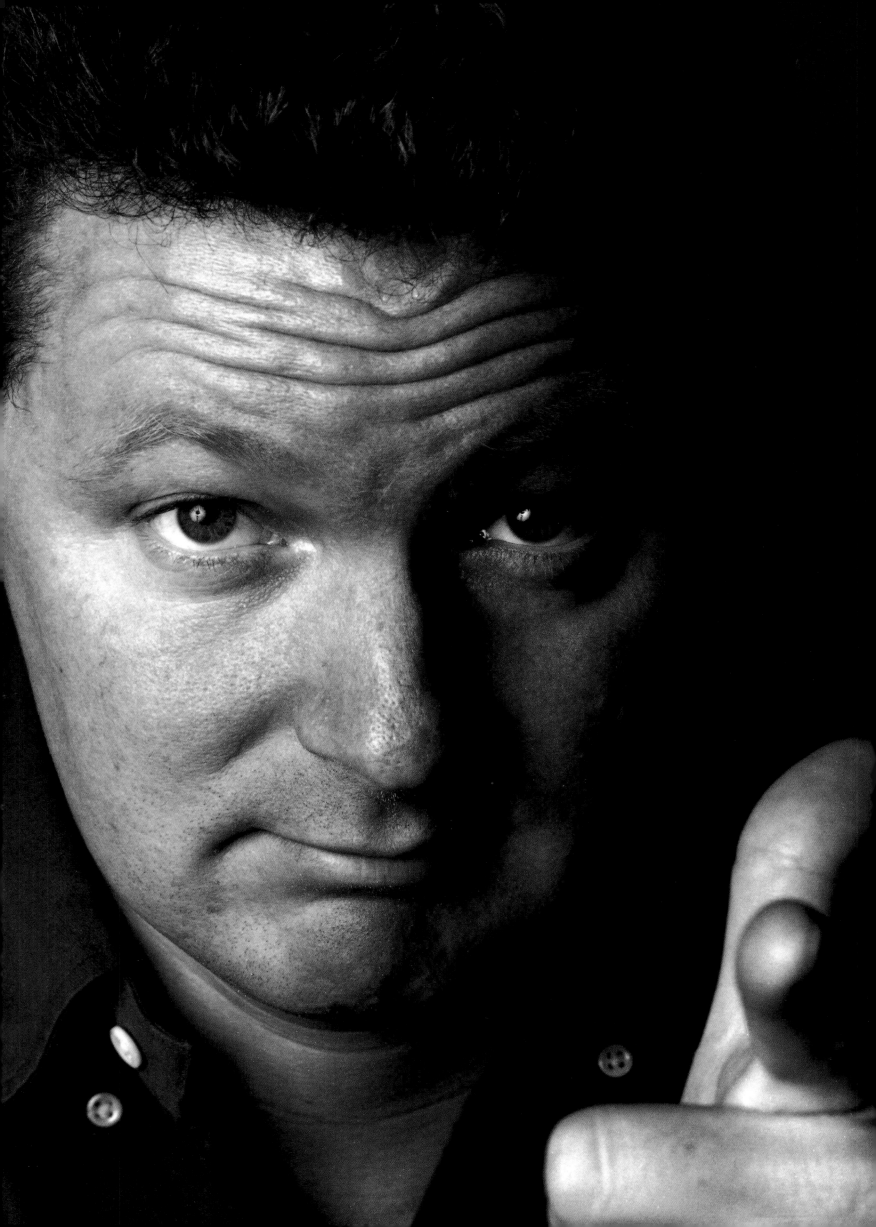

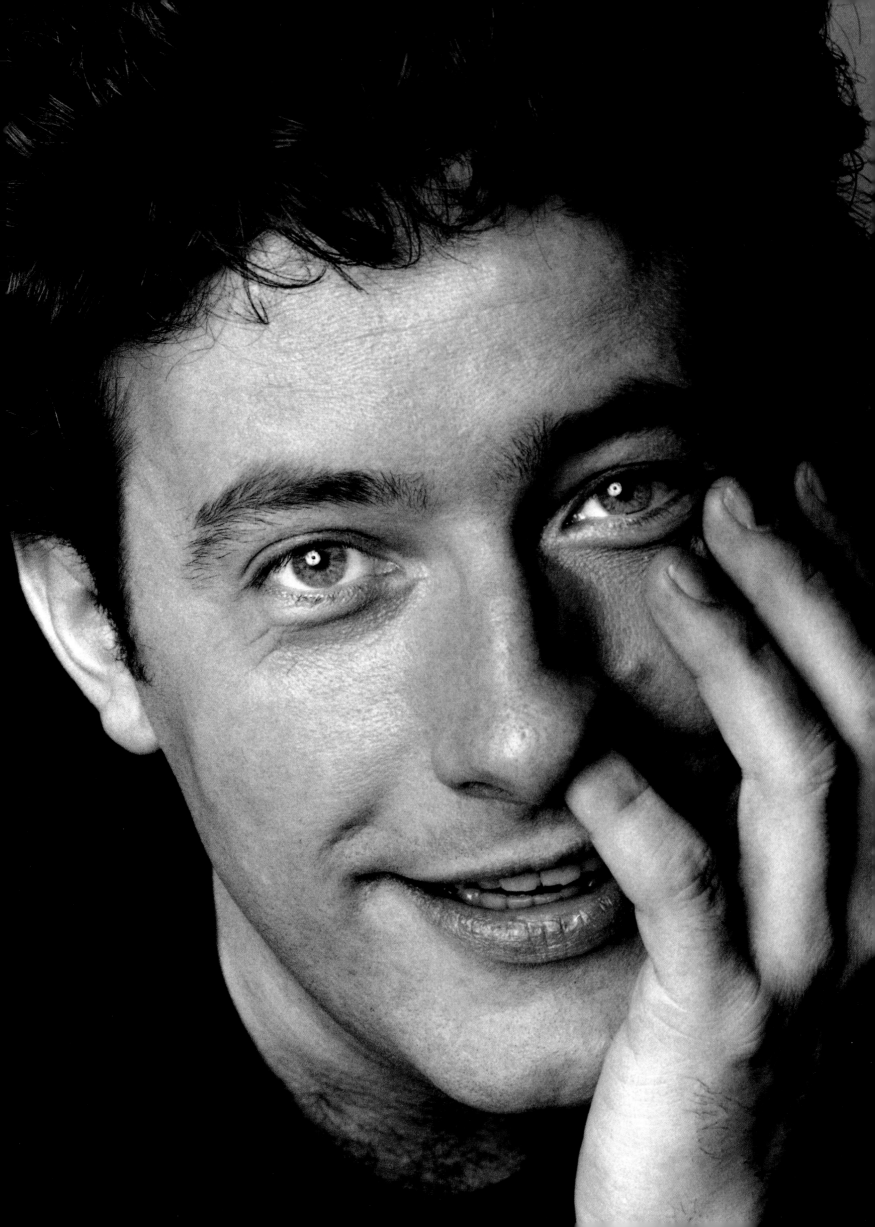

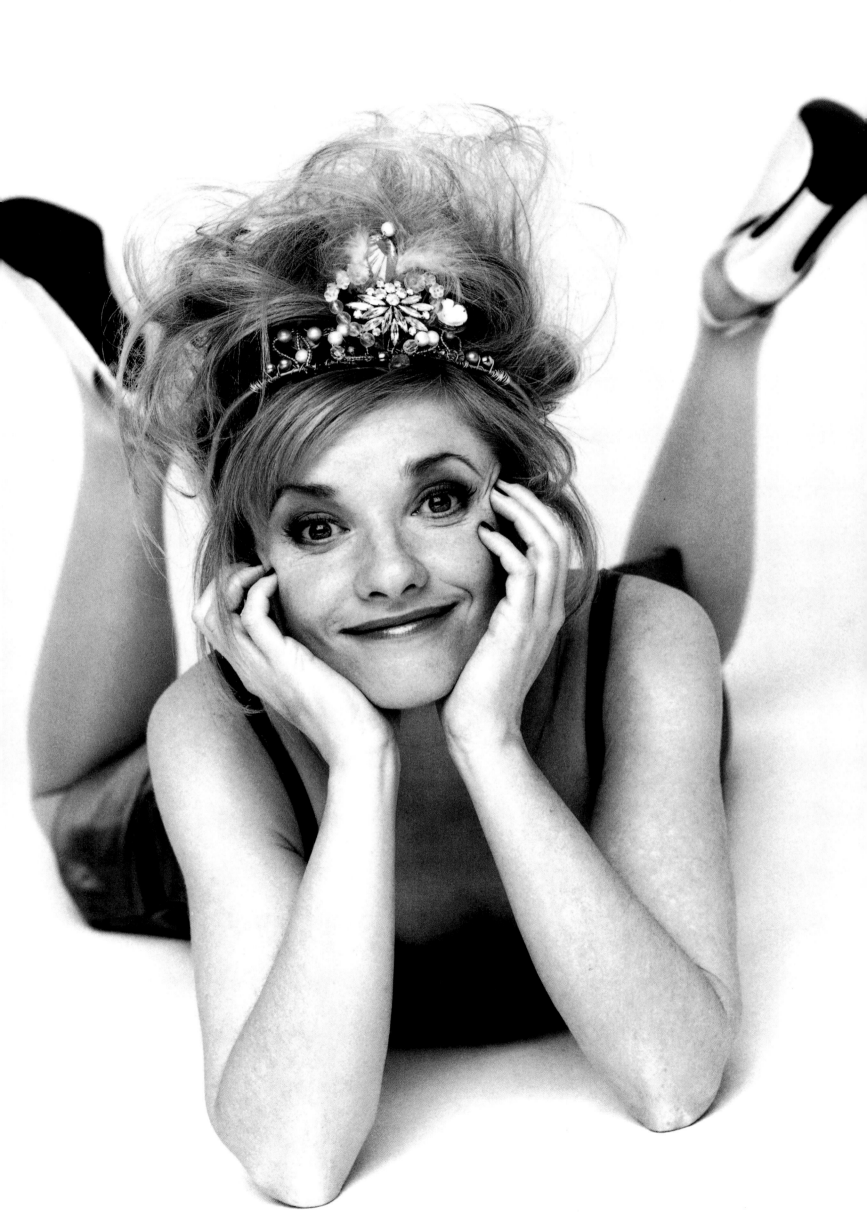

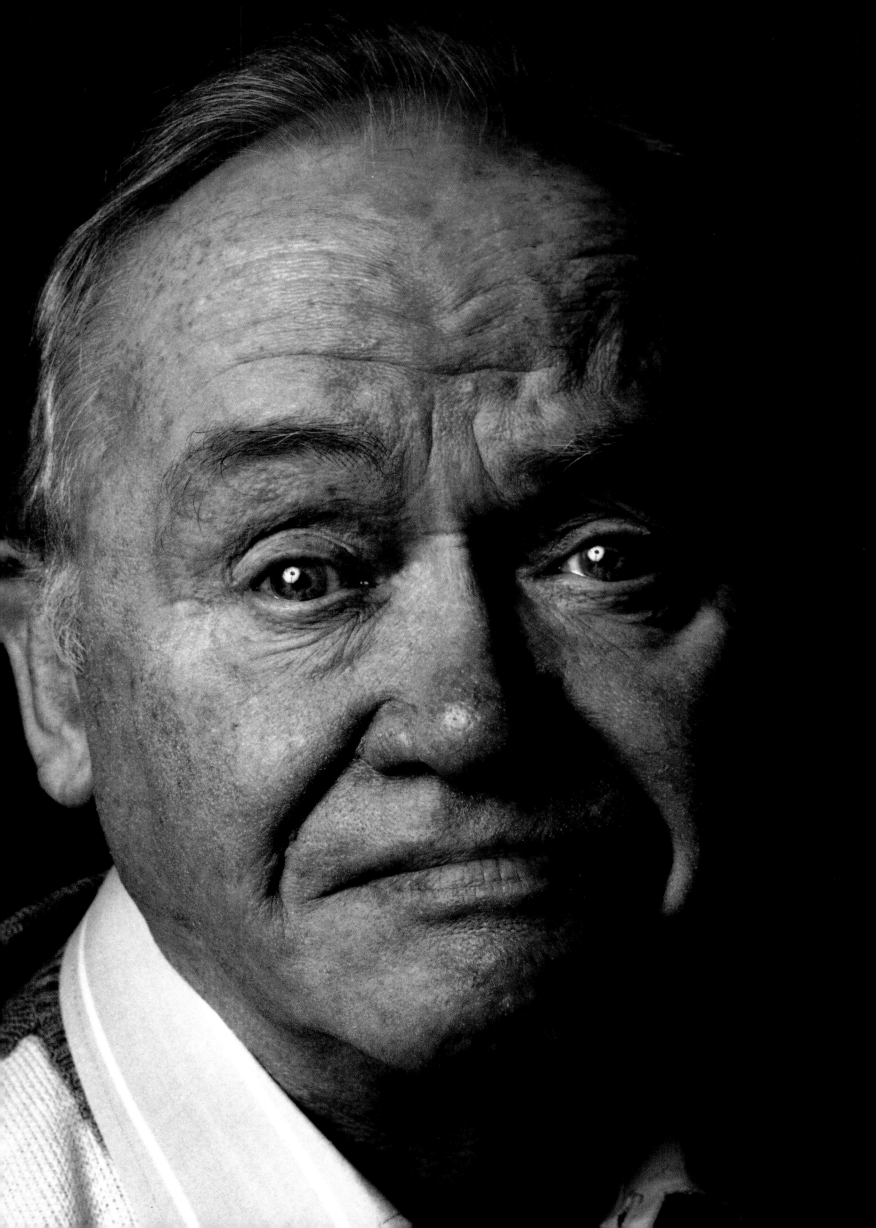

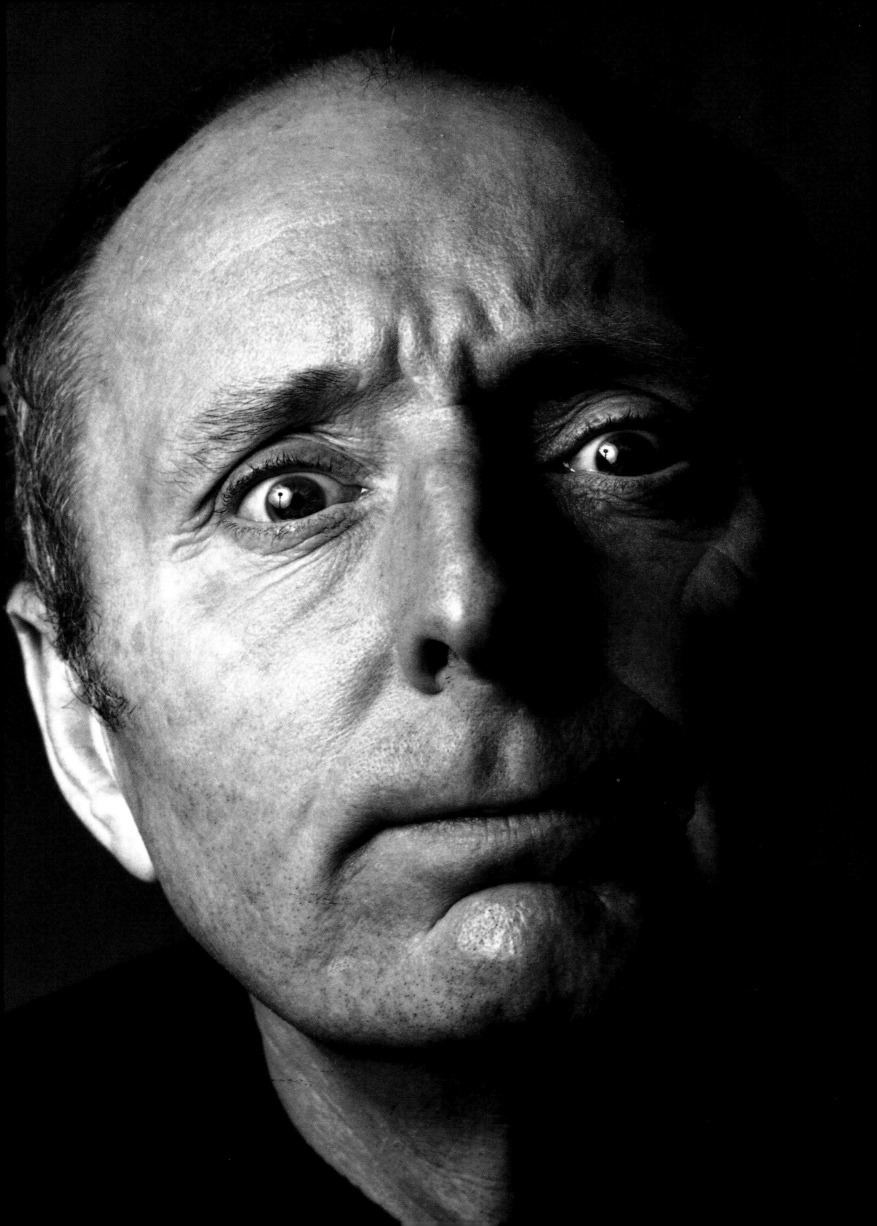

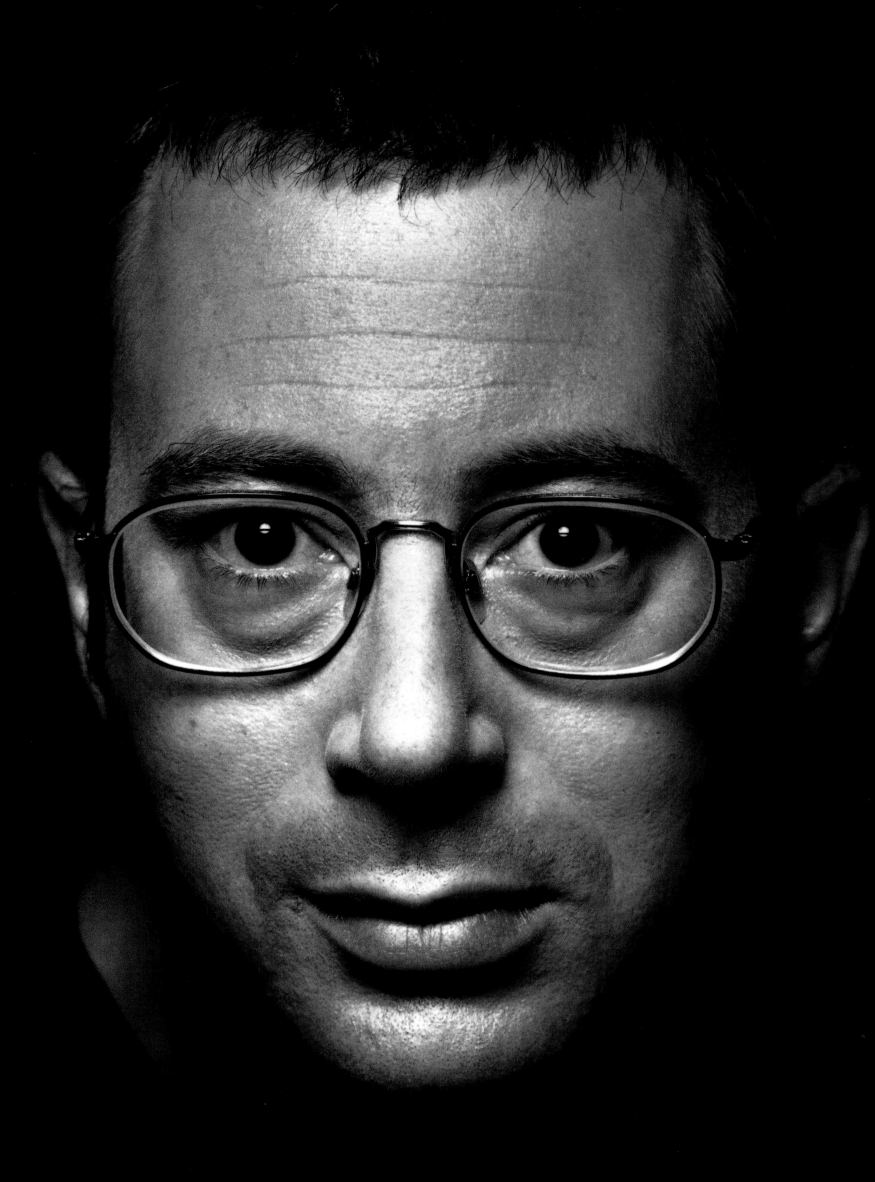

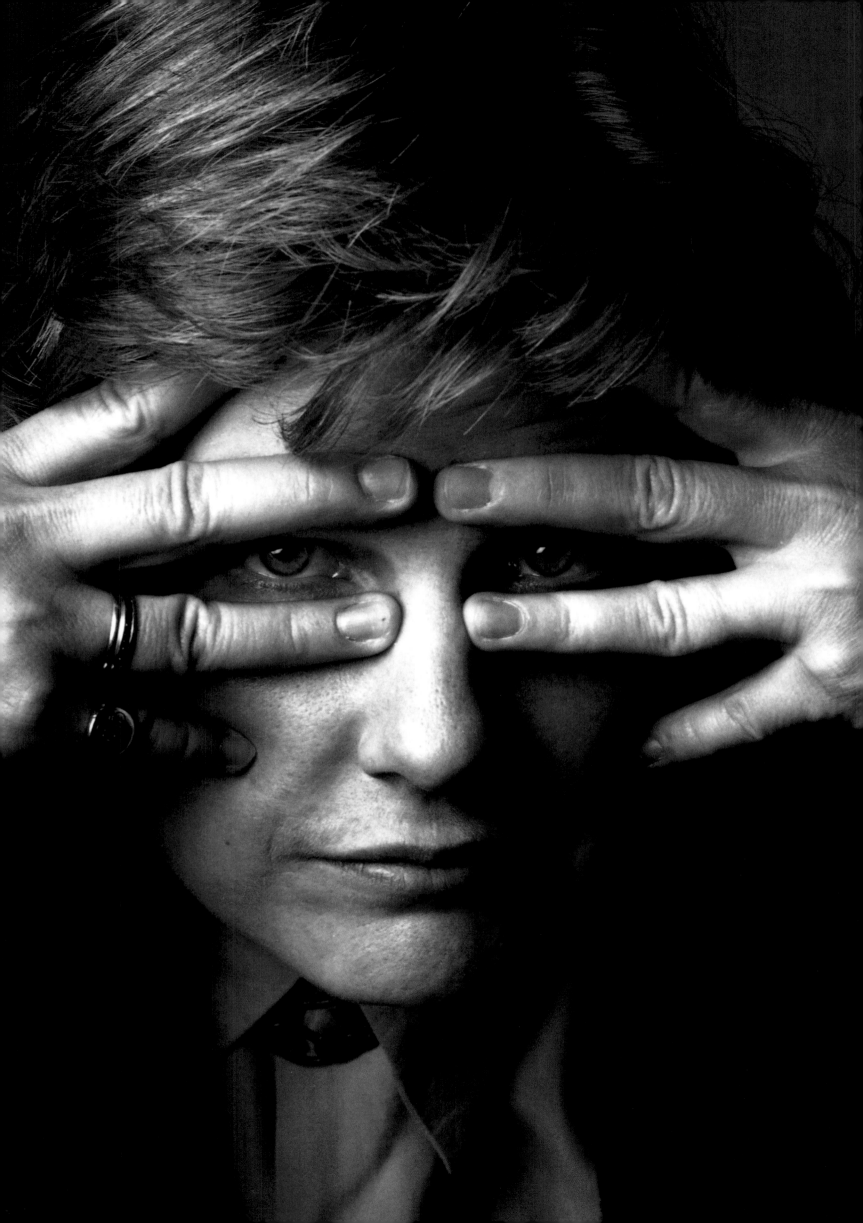

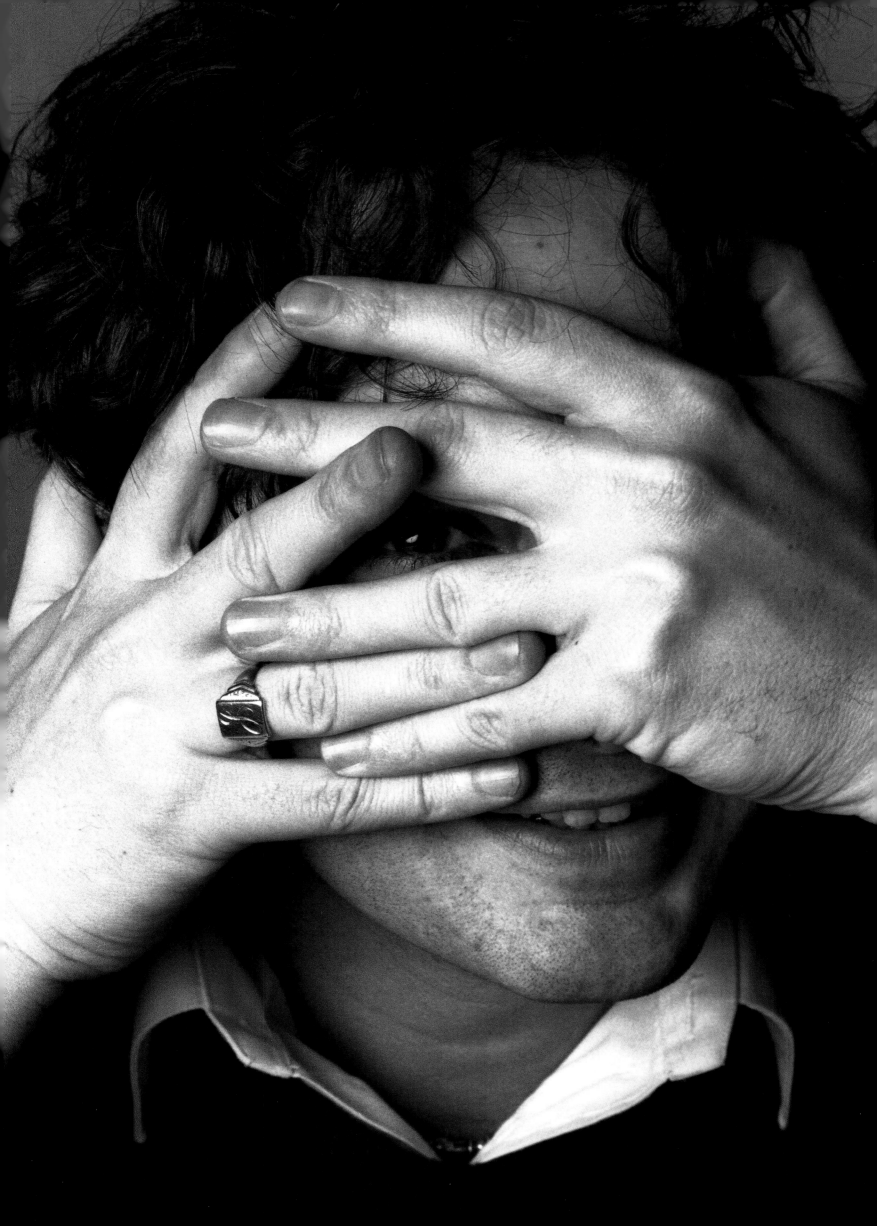

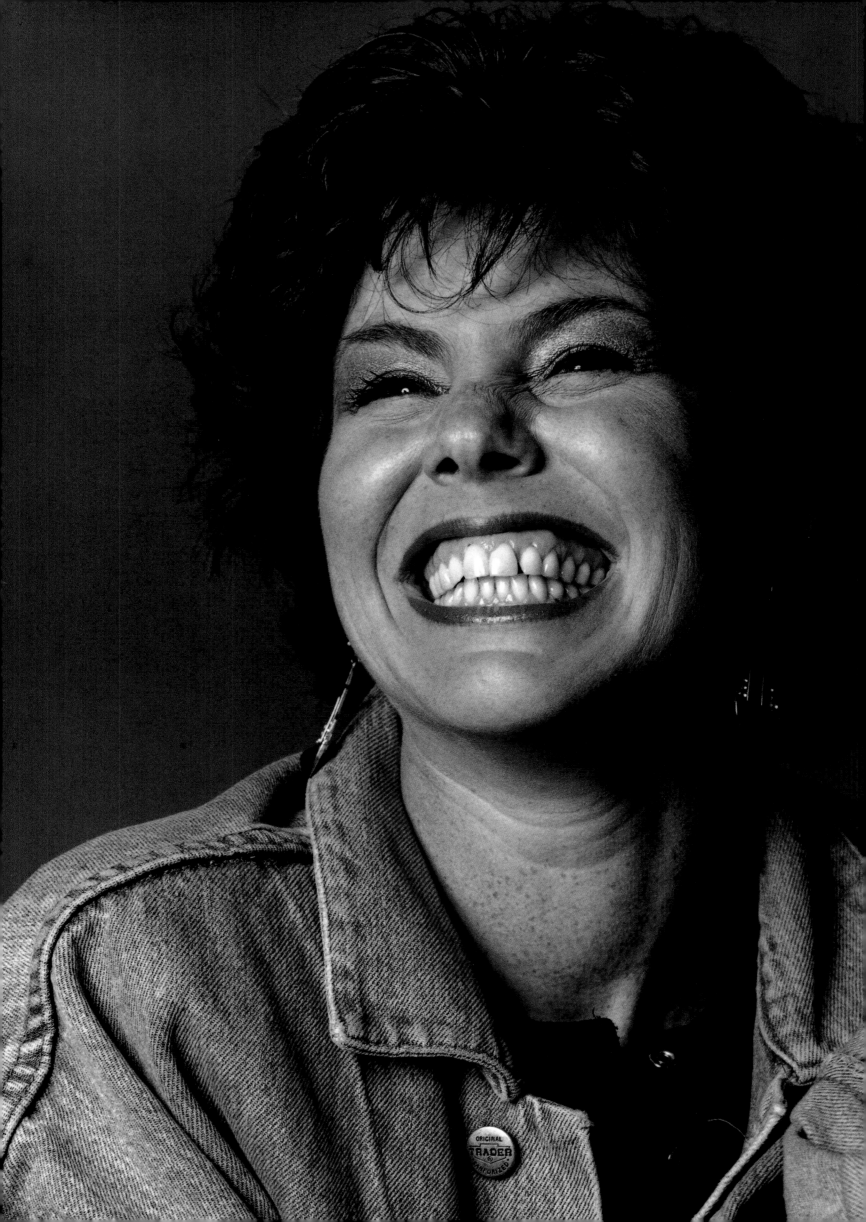

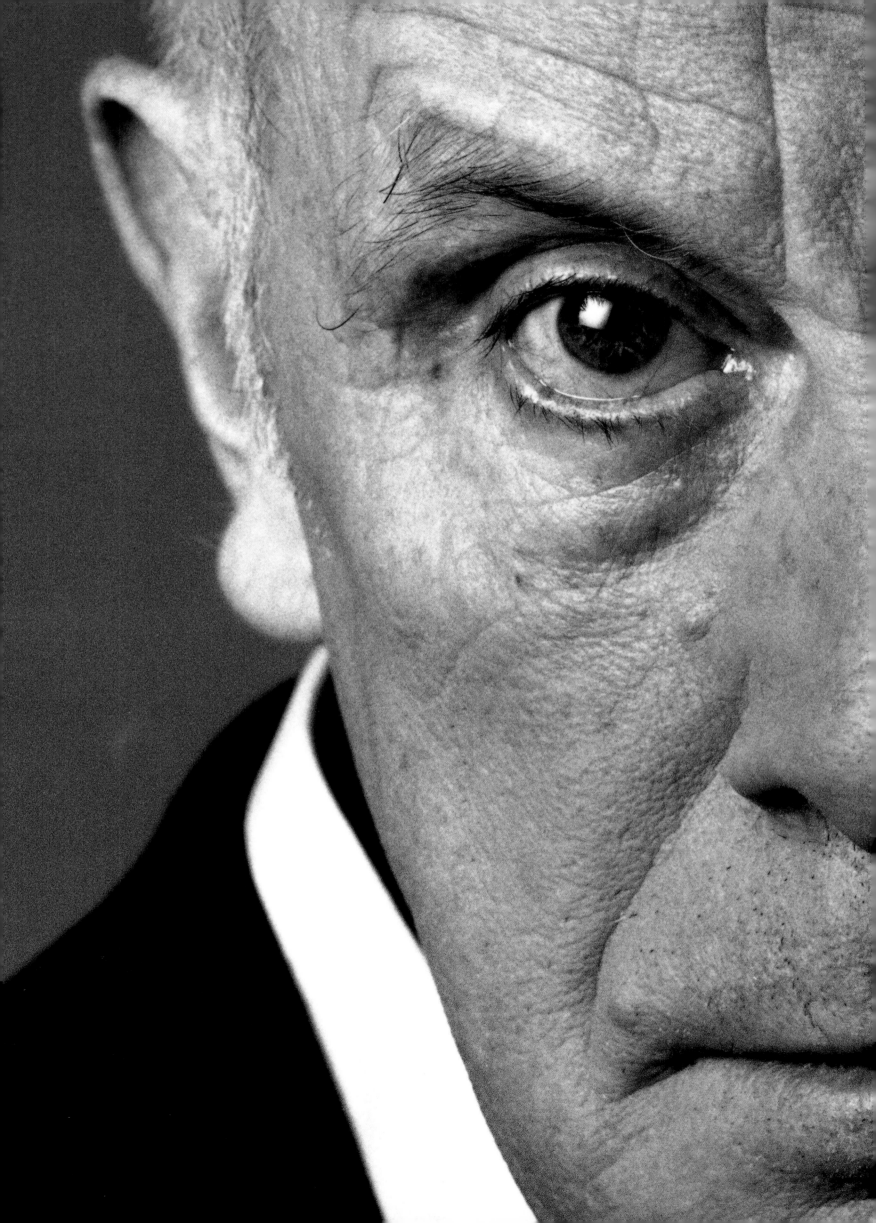

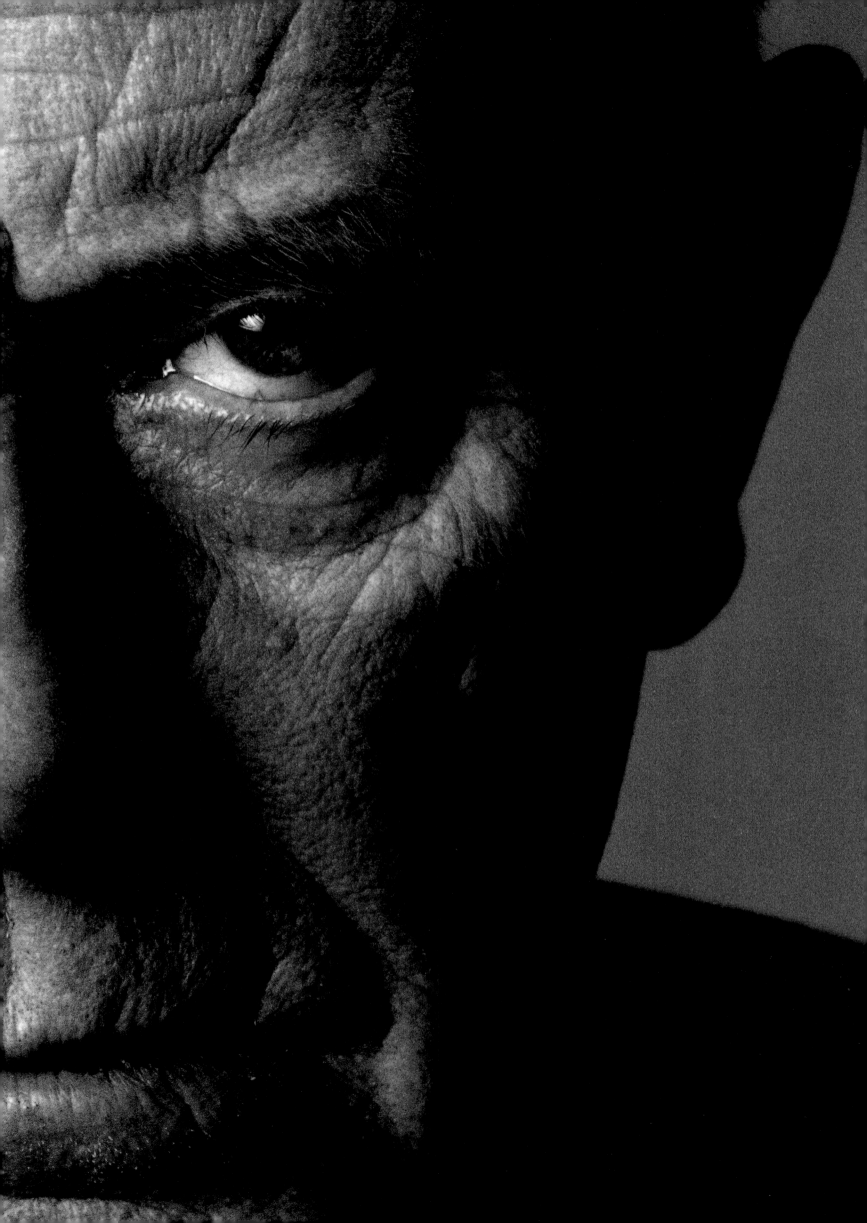

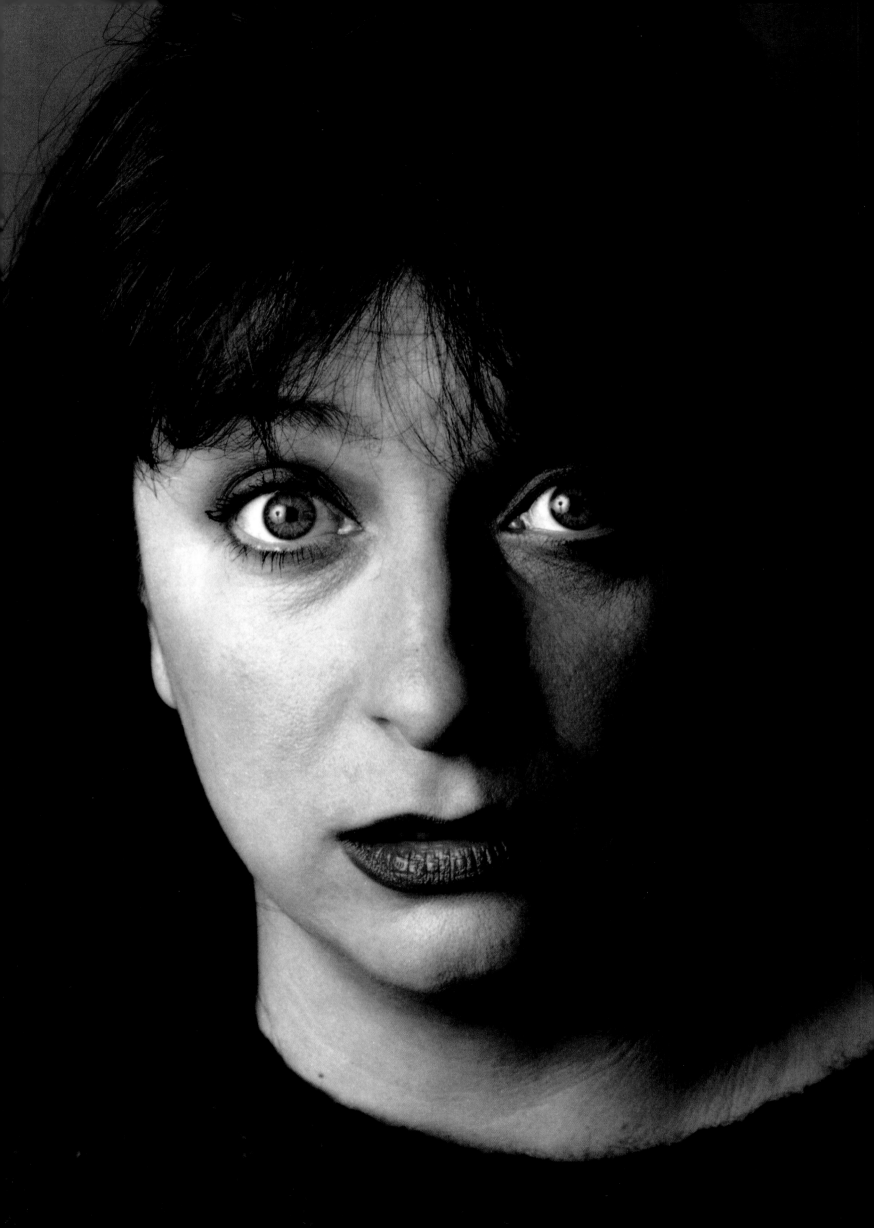

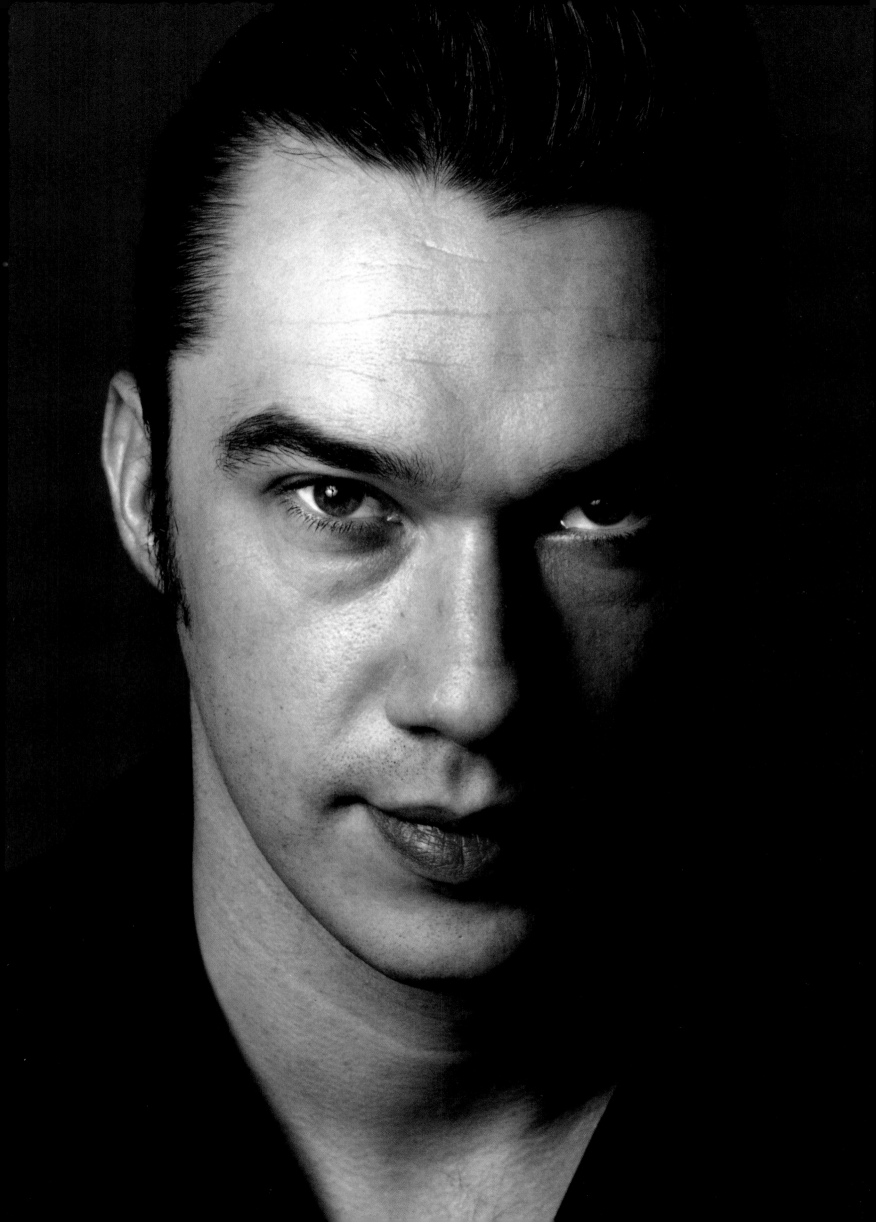

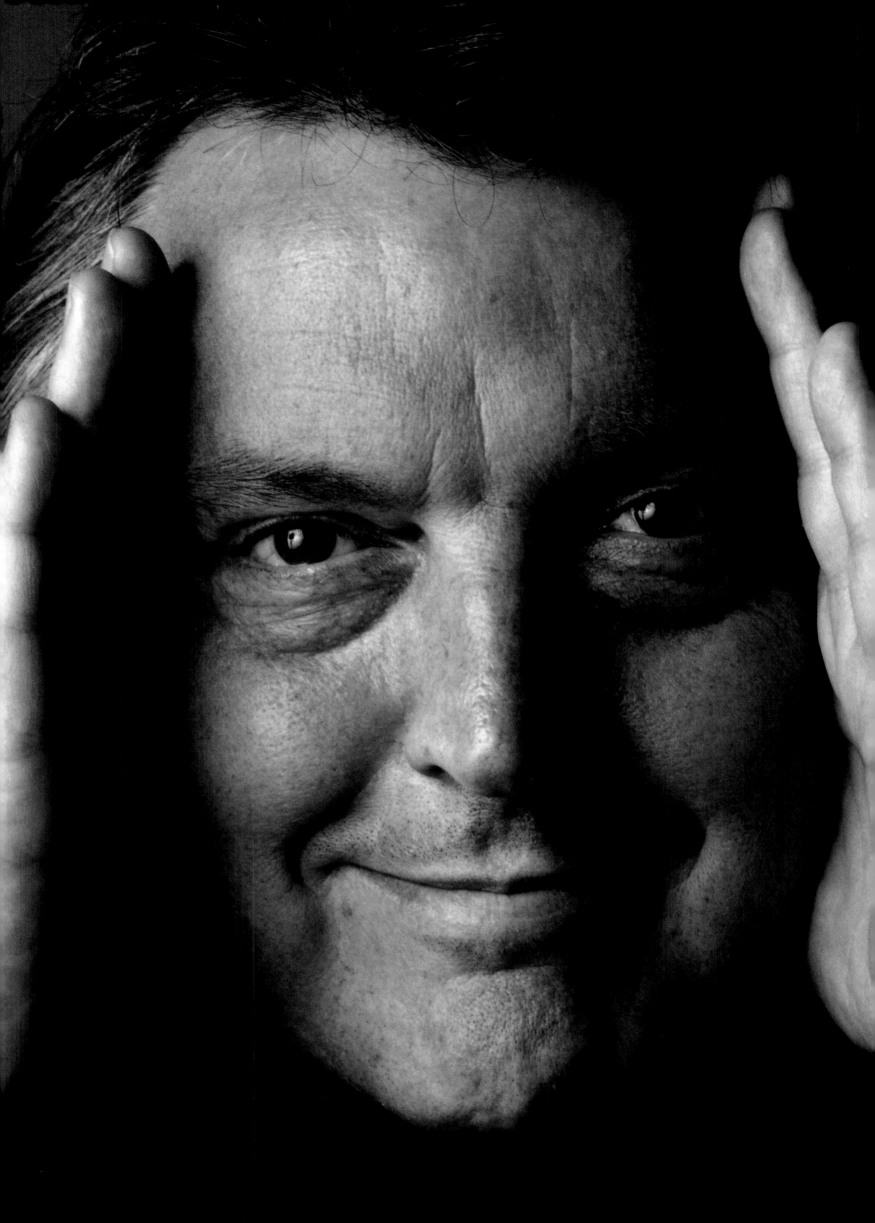

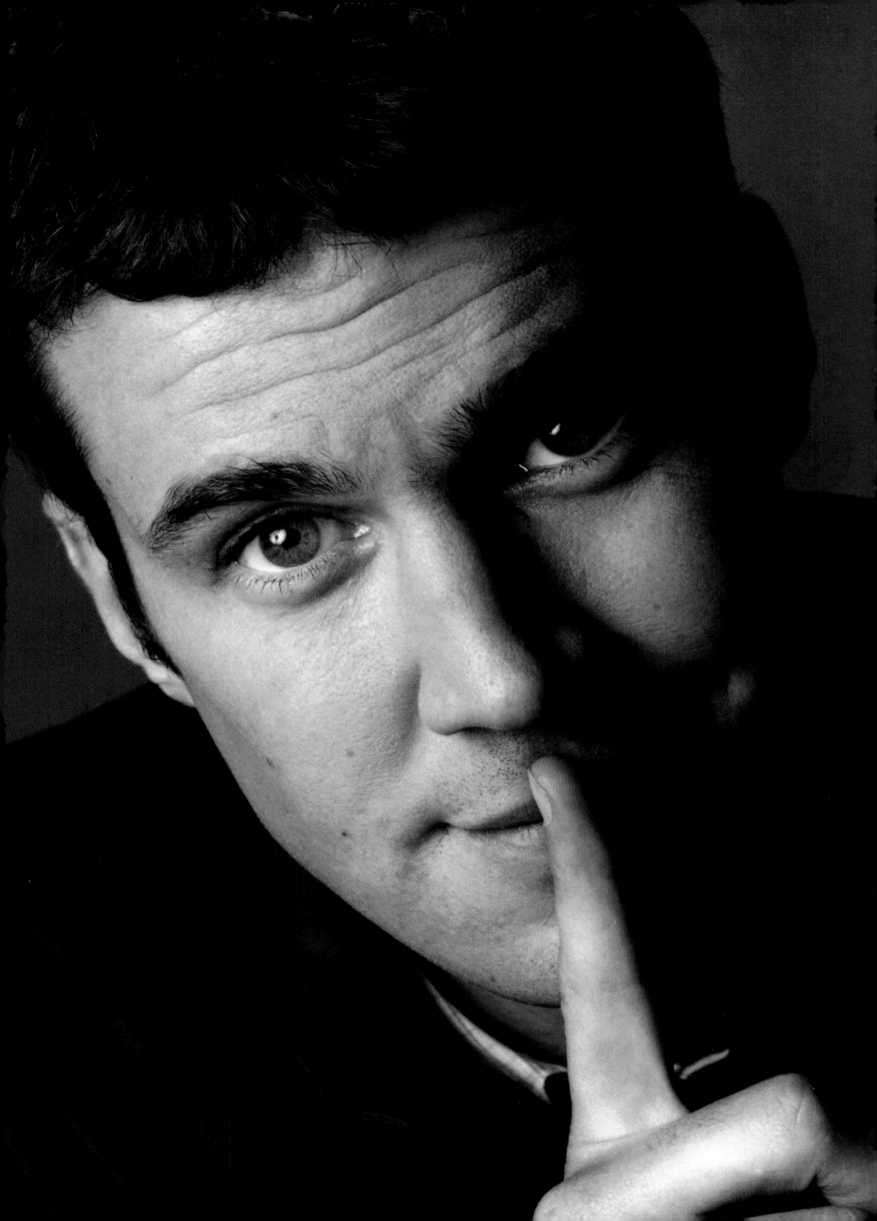

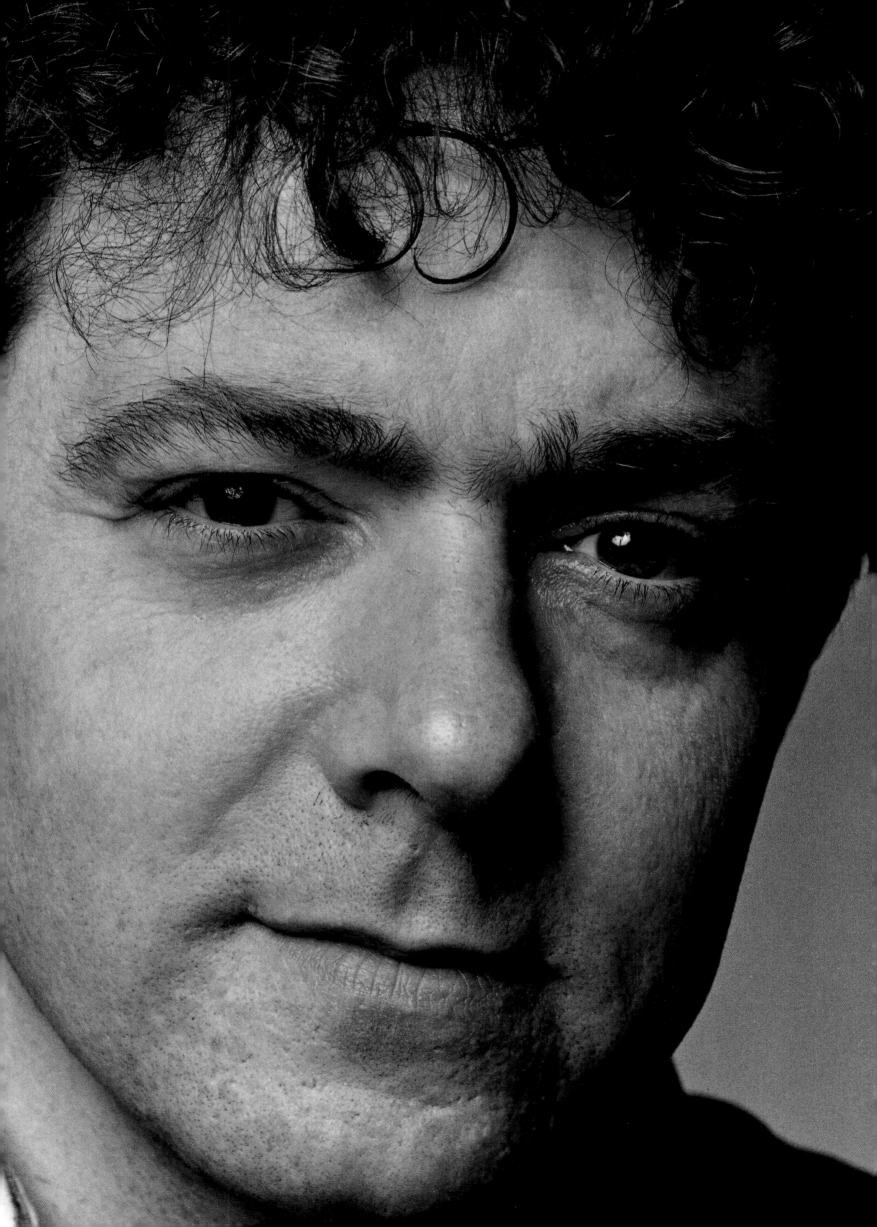

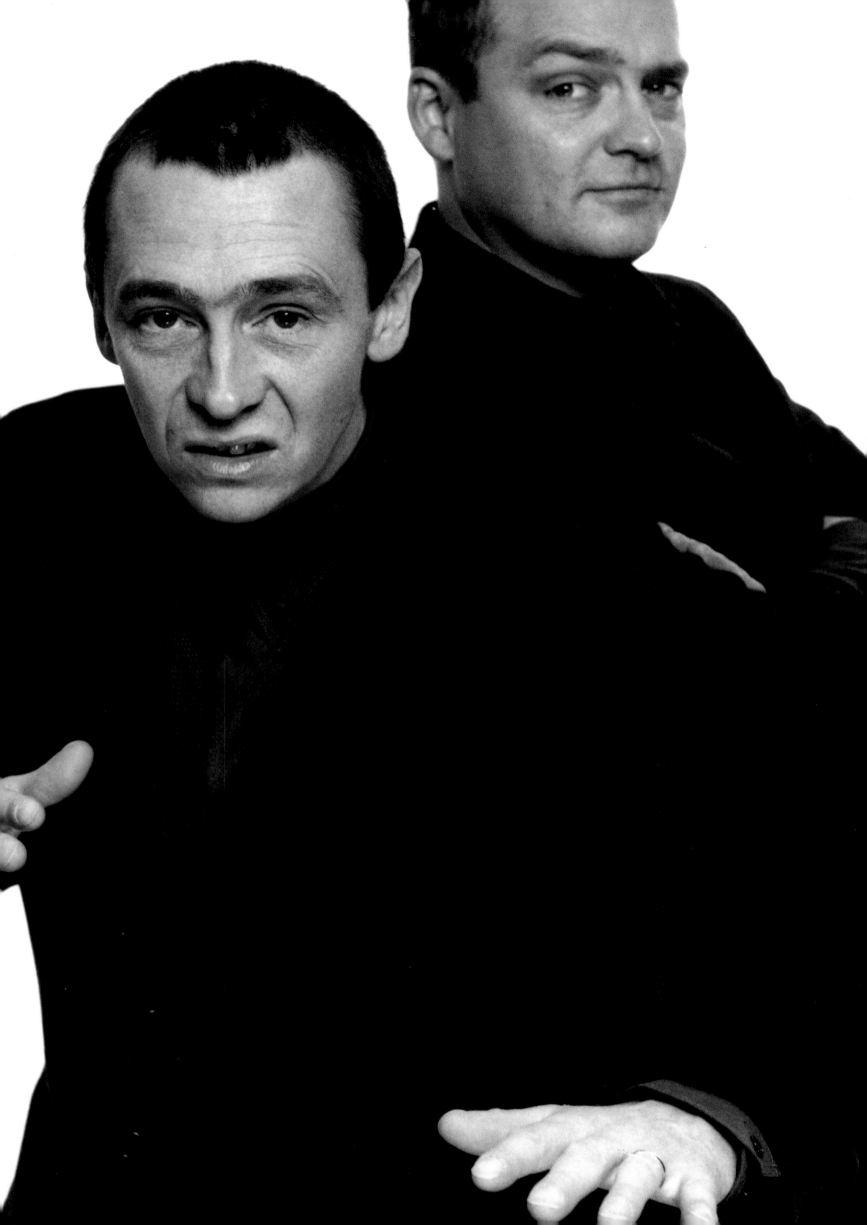

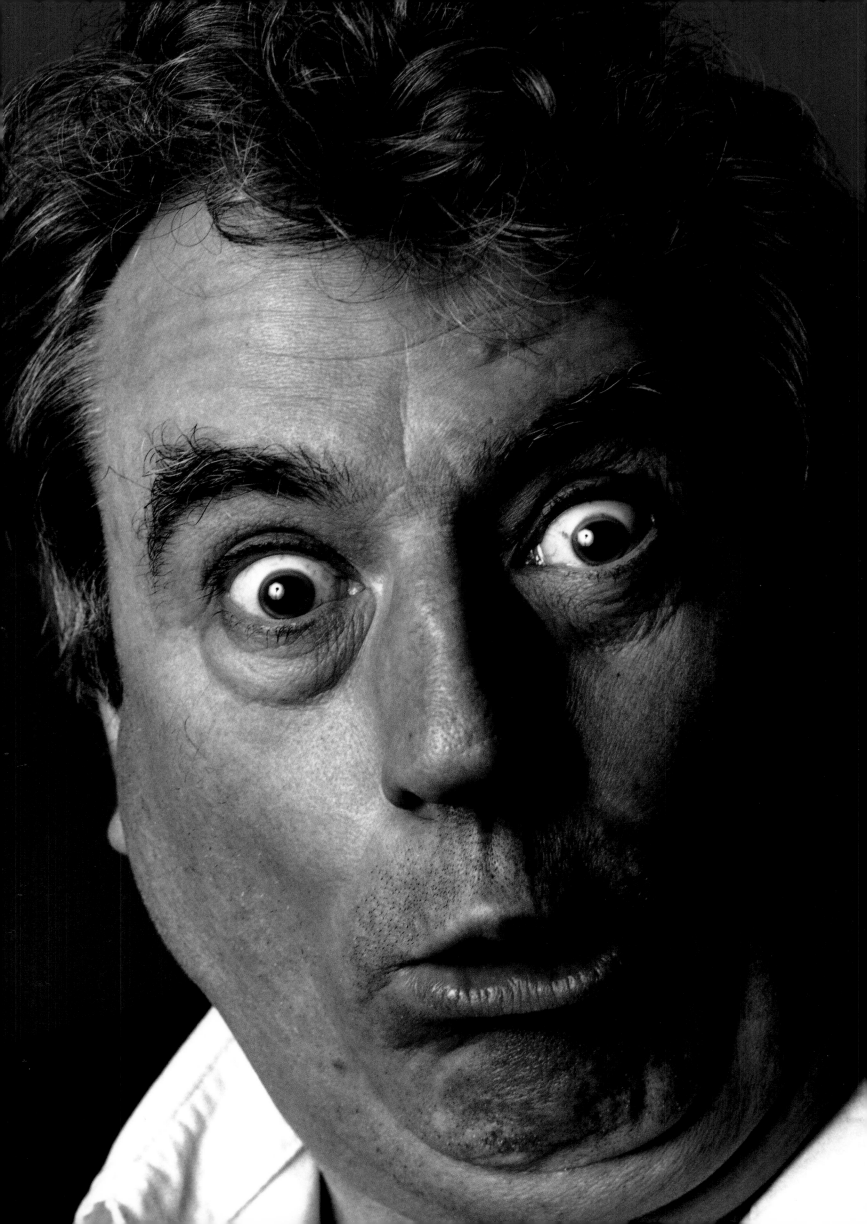

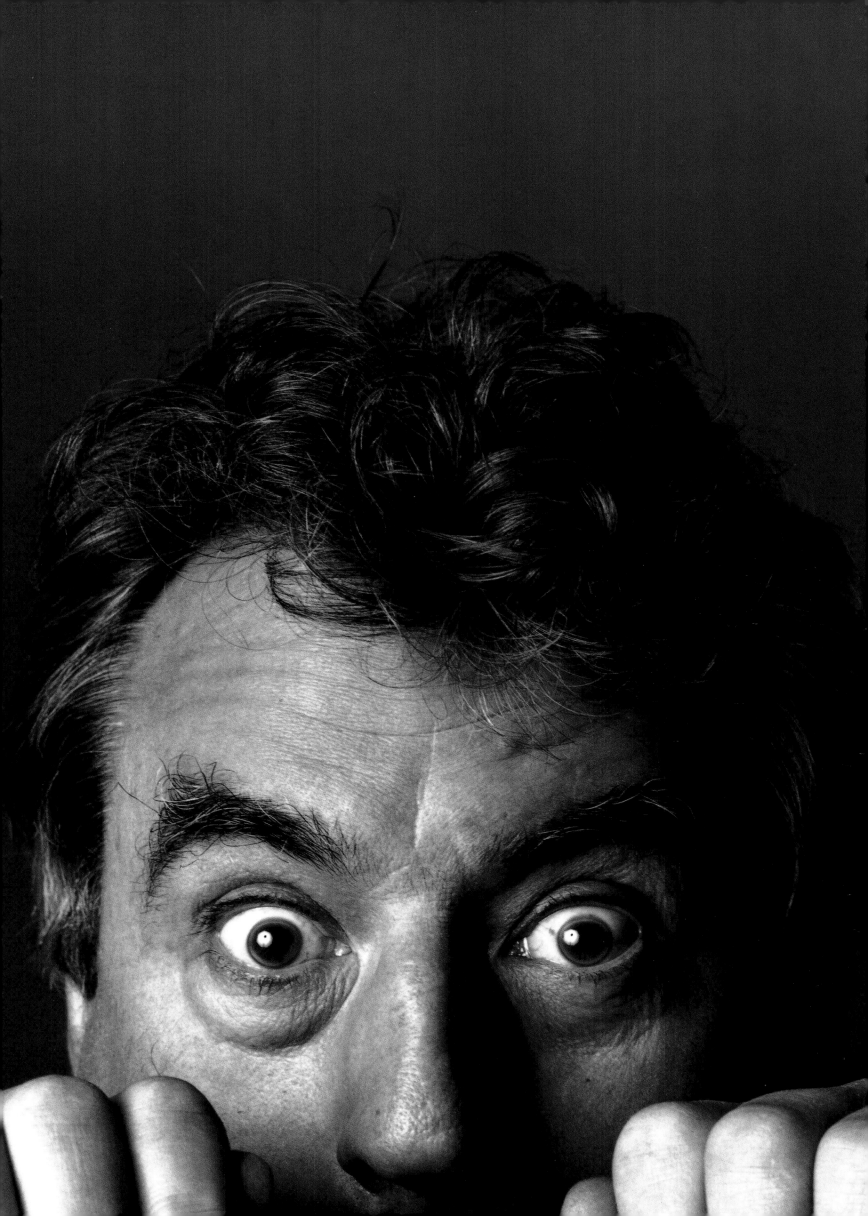

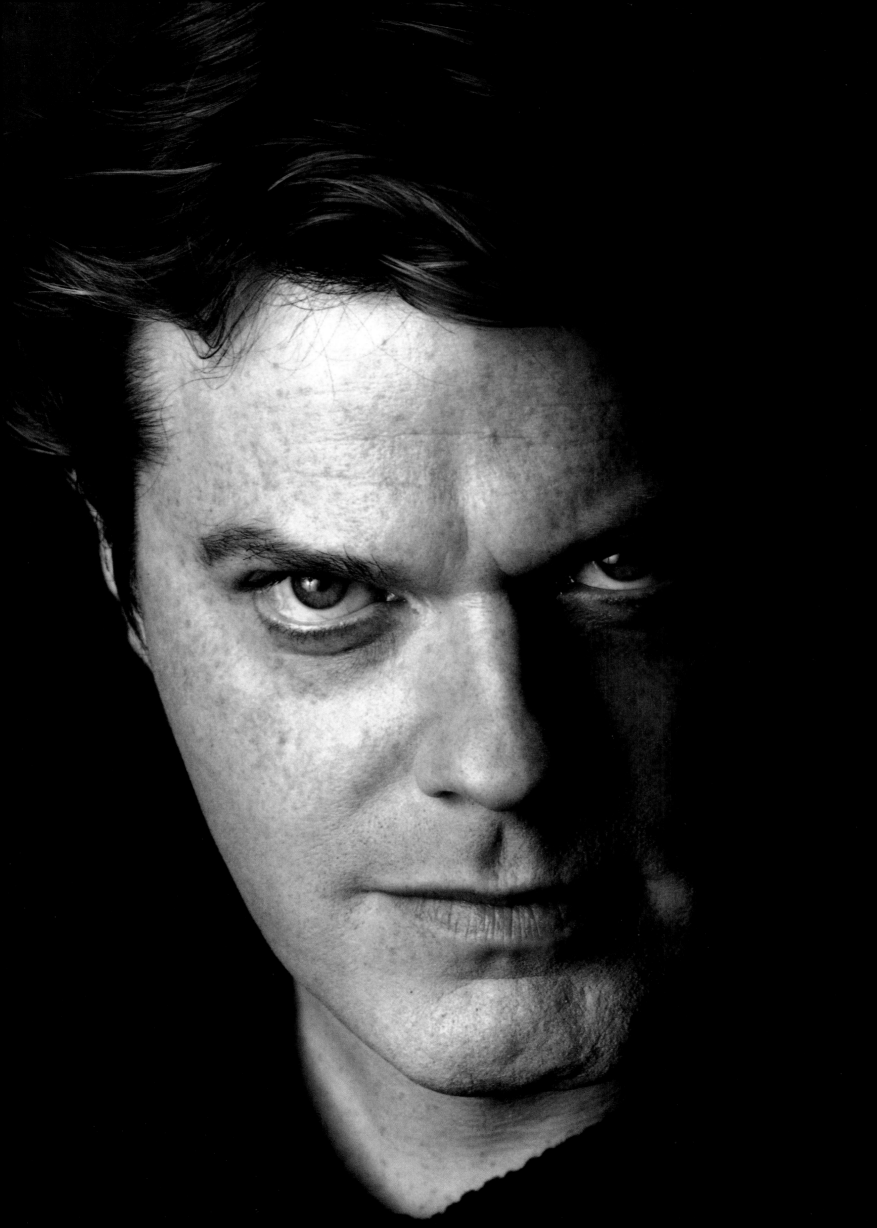

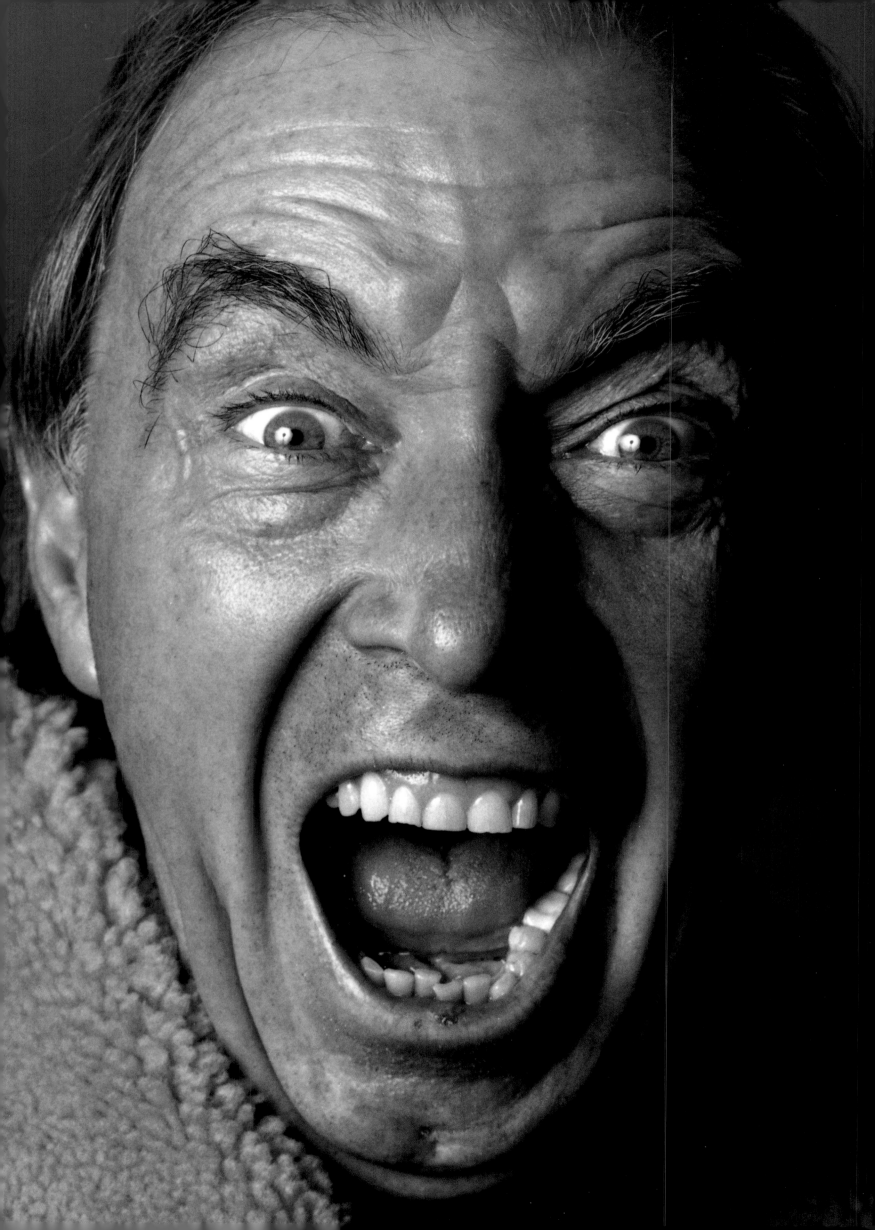

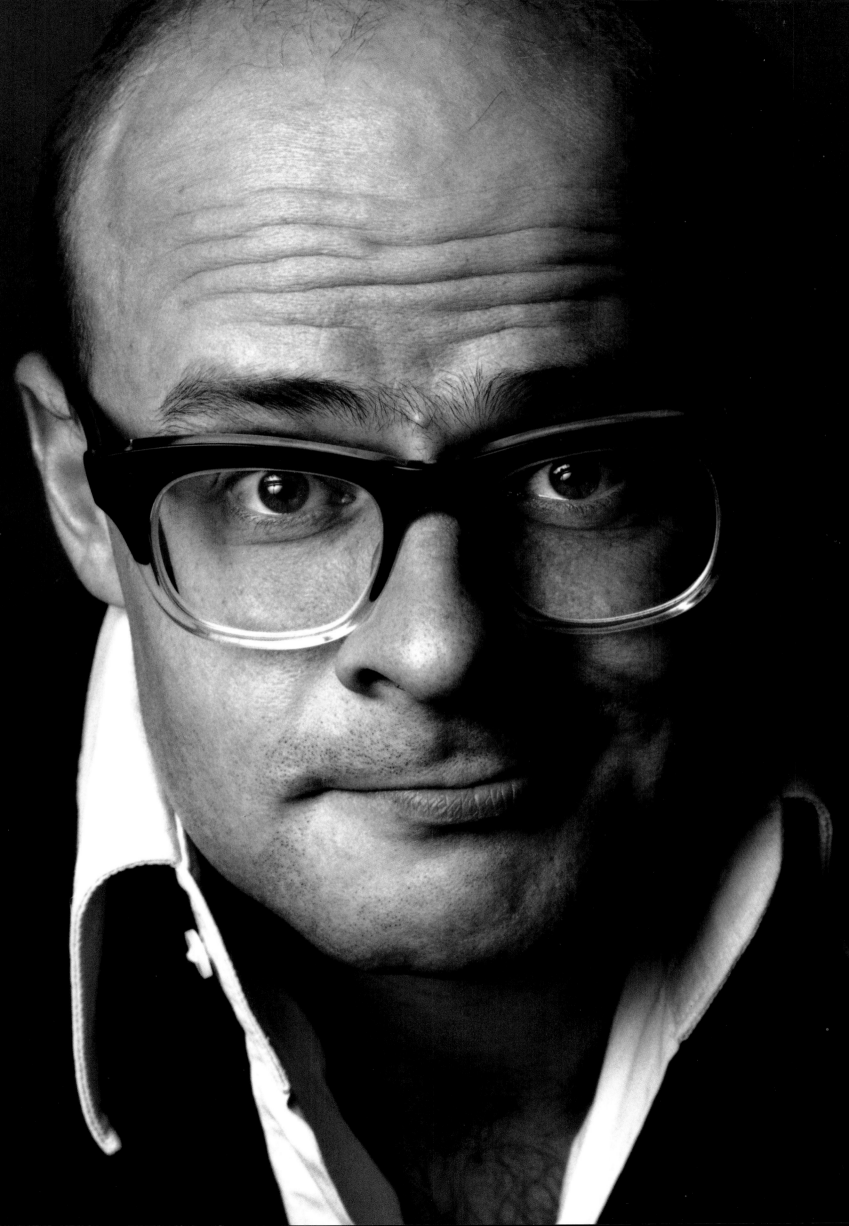

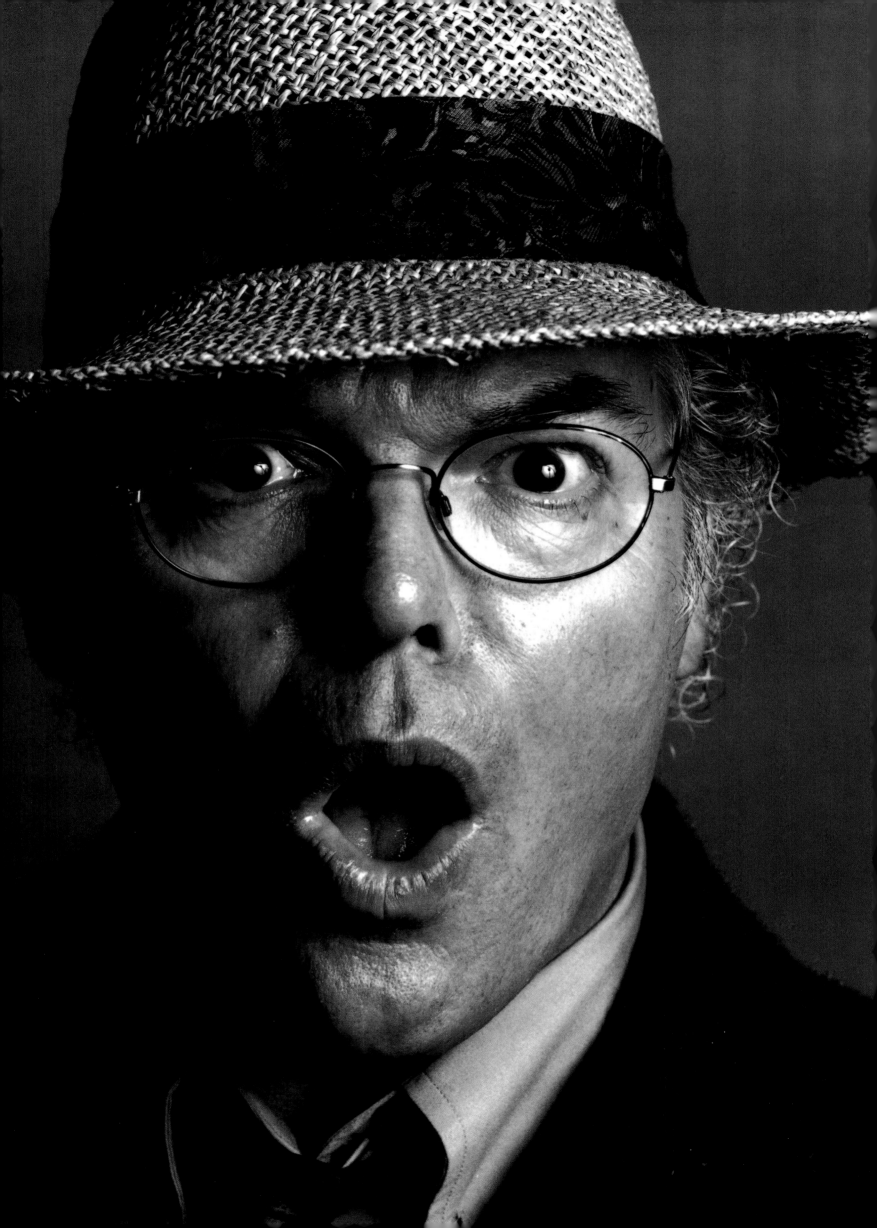

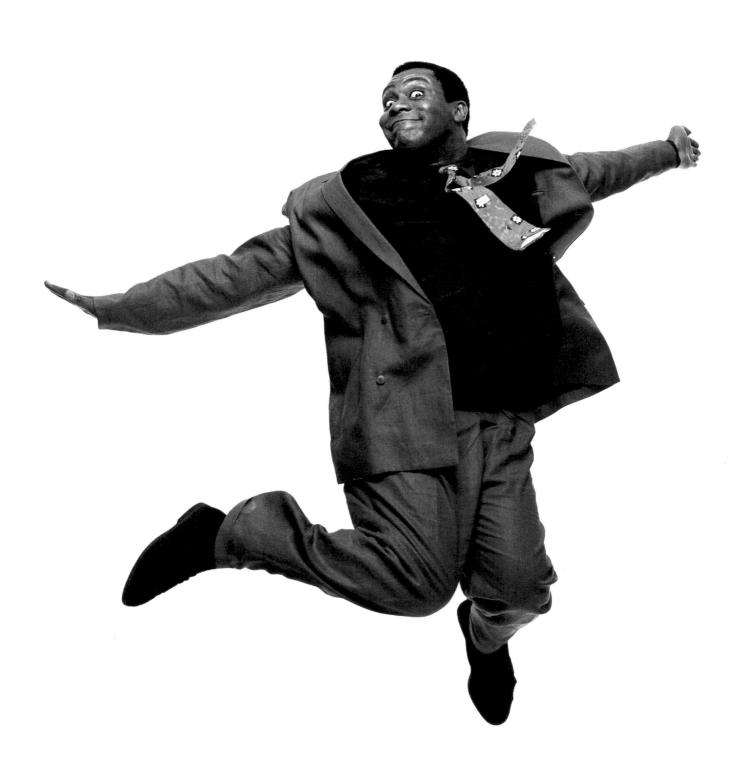

For all the comedians who said yes, I thank you

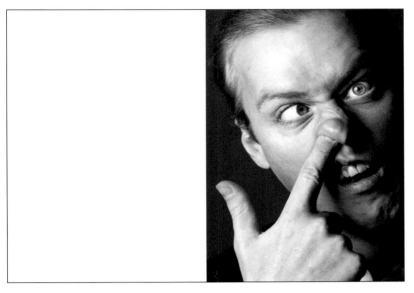

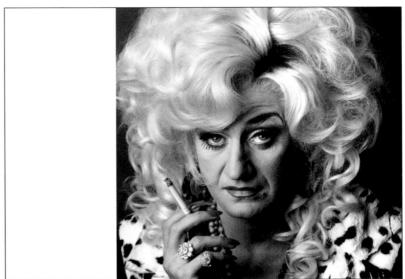

Adrian Edmondson Lily Savage

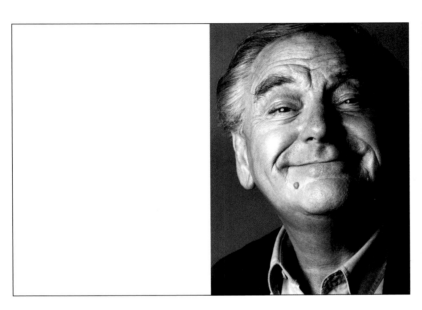

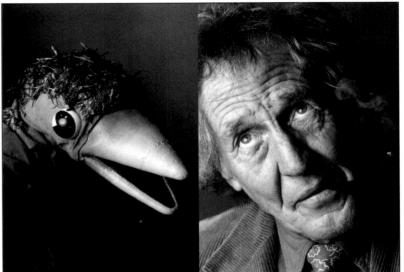

Bob Monkhouse Emu Rod Hull

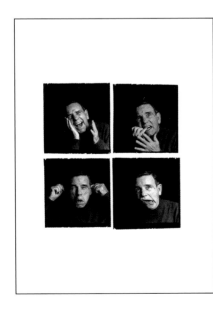

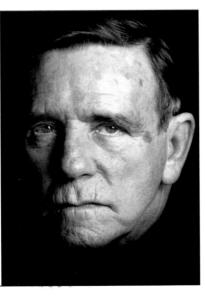

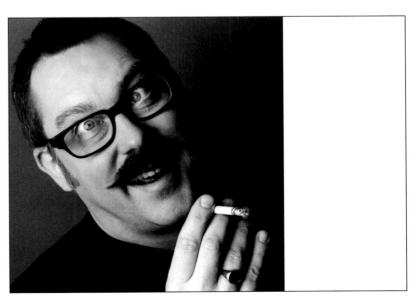

Norman Wisdom Vic Reeves

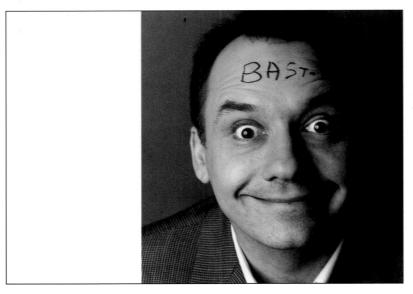

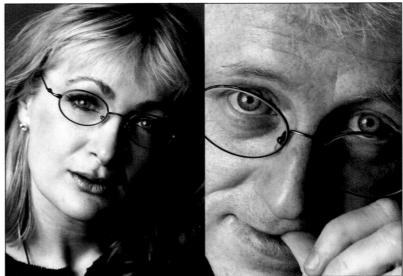

Bob Mortimer Caroline Aherne **Richard Curtis**

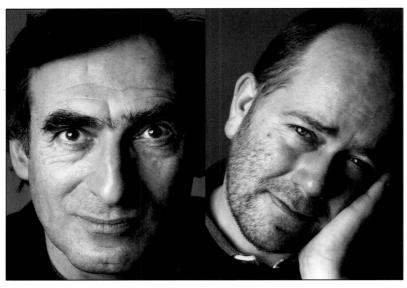

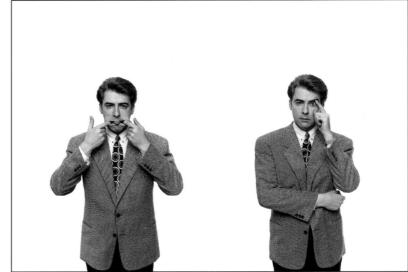

Arnold Brown **Simon Nye** **Jonathan Ross**

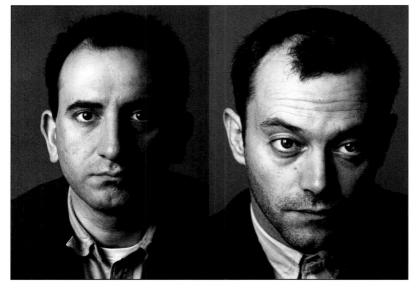

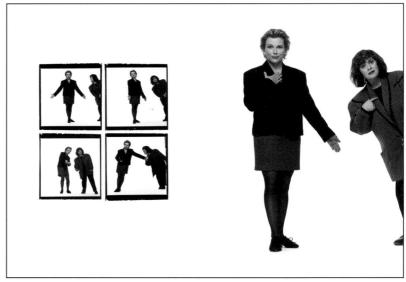

Armando Iannucci **Keith Allen** **Dawn French and Jennifer Saunders**

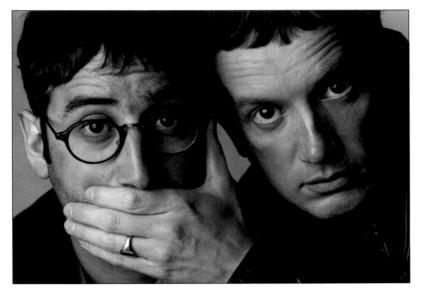

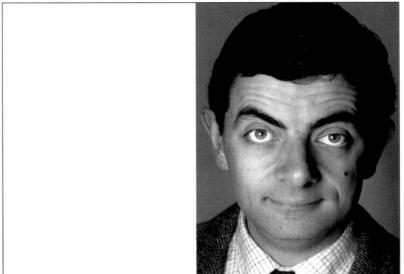

David Baddiel and Frank Skinner

Rowan Atkinson

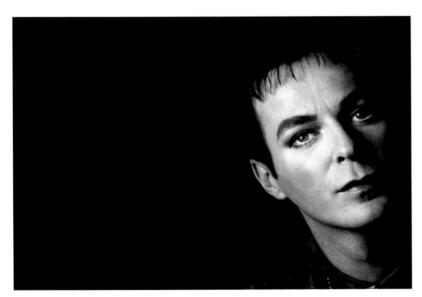

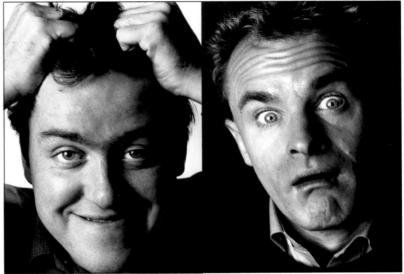

Julian Clary **Griff Rhys Jones**

Bobby Davro

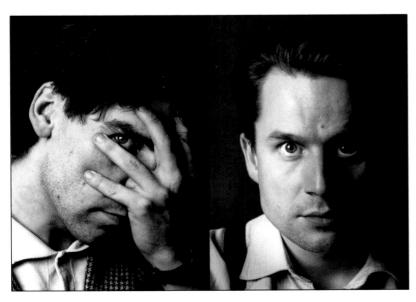

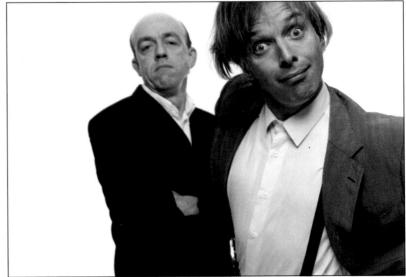

Danny Peacock

Jeremy Hardy

Rik Mayall and Andy de la Tour

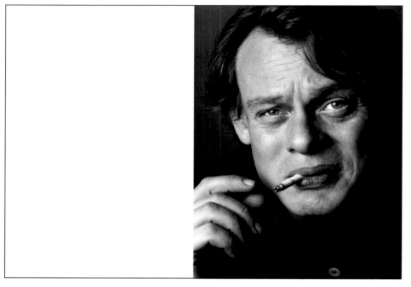

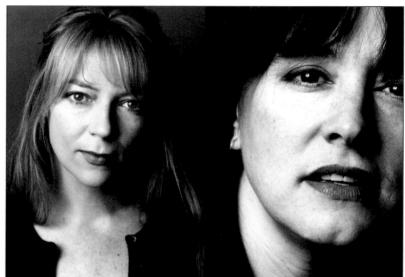

Martin Clunes Morwenna Banks **Arabella Weir**

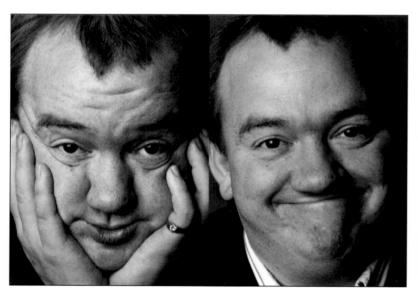

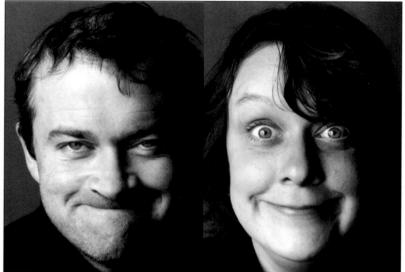

Mel Smith Harry Enfield **Kathy Burke**

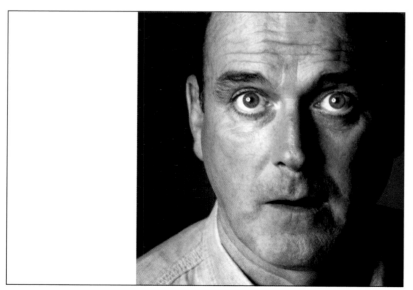

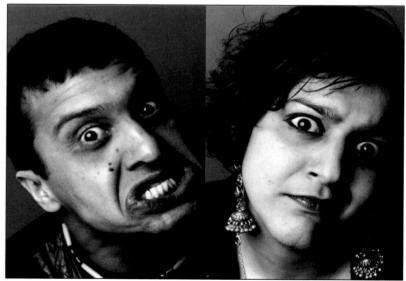

John Cleese Kulvinder Ghir **Meera Syal**

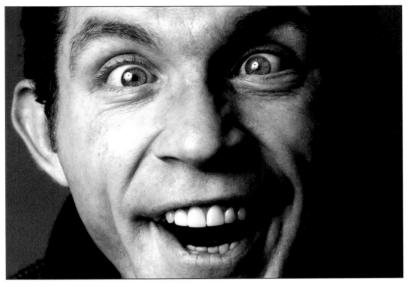

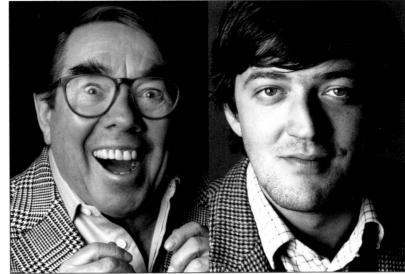

Lee Evans

Ronnie Corbett **Stephen Fry**

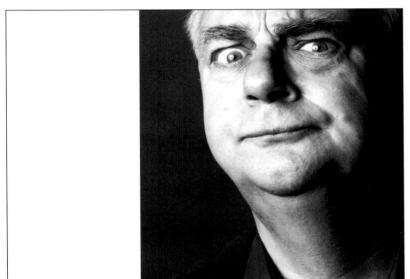

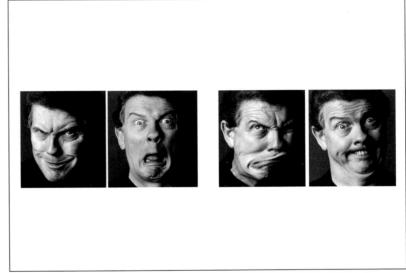

Roy Hudd **Phil Cool**

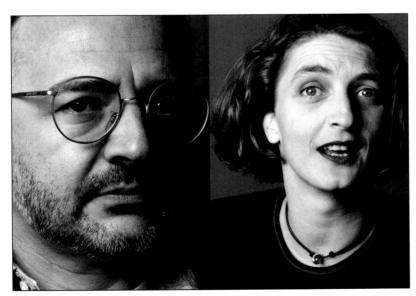

David Renwick **Donna McPhail** **Paul Merton**

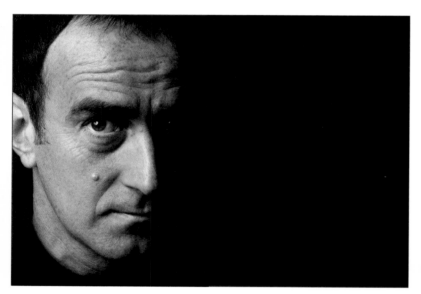

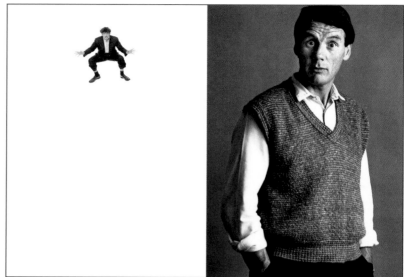

Josie Lawrence

Craig Ferguson

Michael Palin

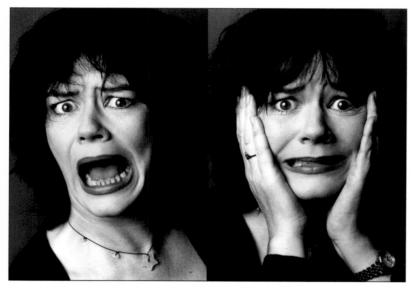

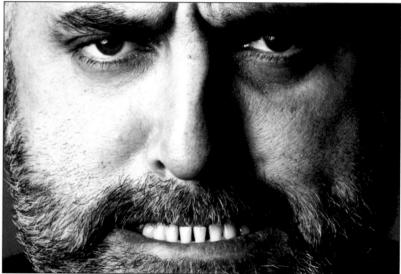

Angus Deayton

Alexei Sayle

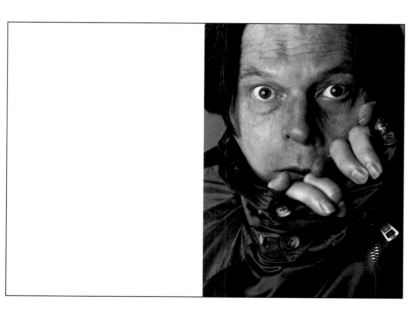

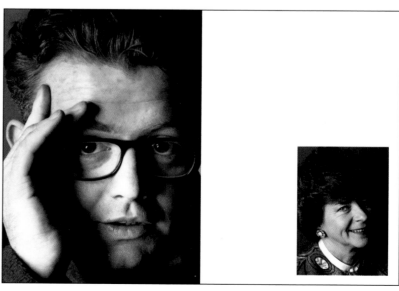

Terry Gilliam **Chris Evans**

Pam Ayres

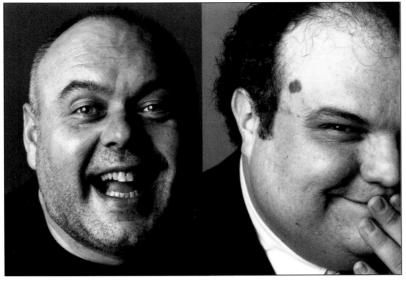 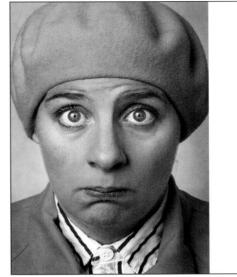

Andrew Marshall **Mike McShane** **Victoria Wood**

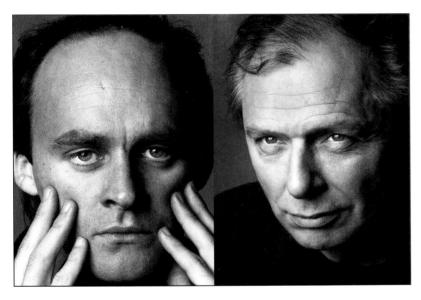 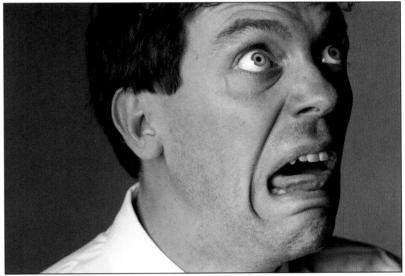

Tim McInnery **Peter Richardson** **Hugh Laurie**

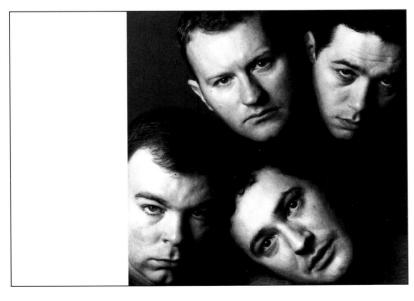 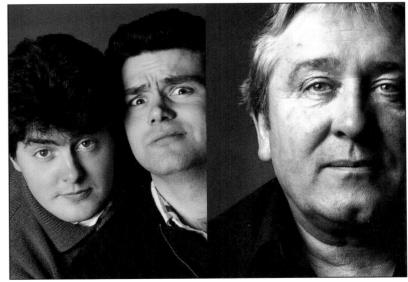

League of Gentlemen **Nick Hancock and Neil Mullarkey** **John Sullivan**

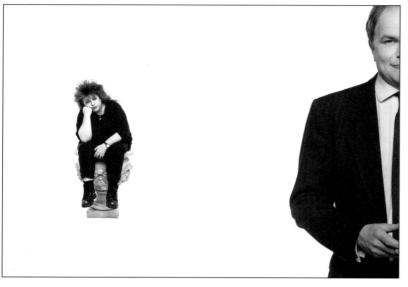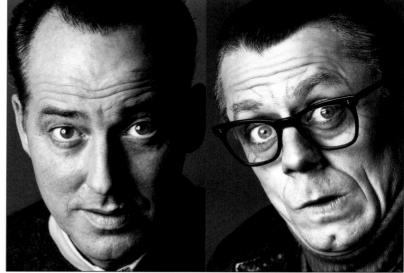

Jo Brand Clive Anderson Michael Barrymore John Shuttleworth

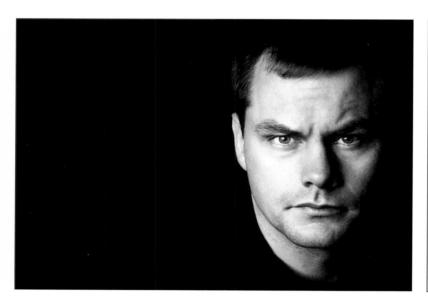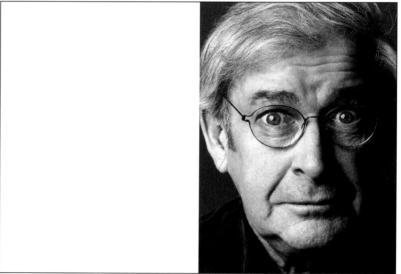

Jack Dee Dave Allen

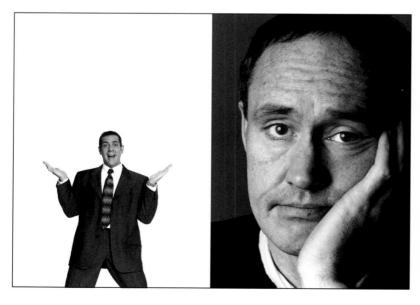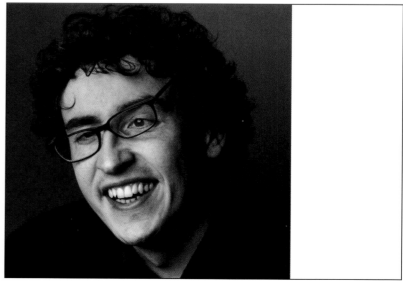

Dale Winton Nigel Planer Steve Coogan

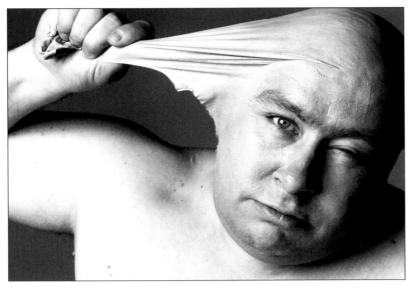

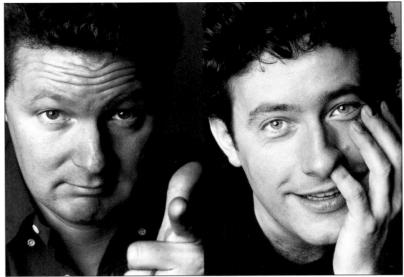

Gregor Fisher Rory Bremner **Roland Rivron**

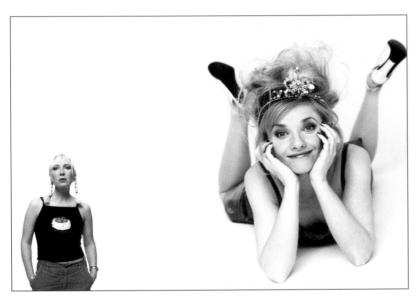

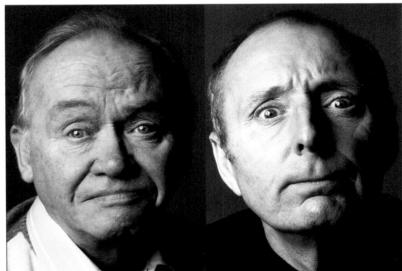

Jenny Eclair **Jane Horrocks Charlie Drake** **Jasper Carrott**

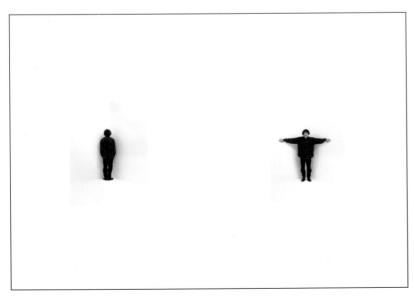

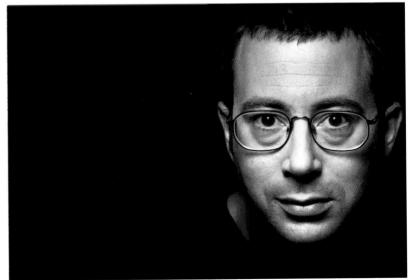

Alan Davies **Ben Elton**

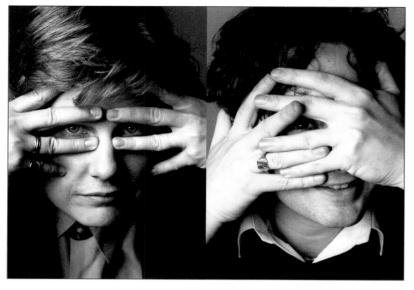

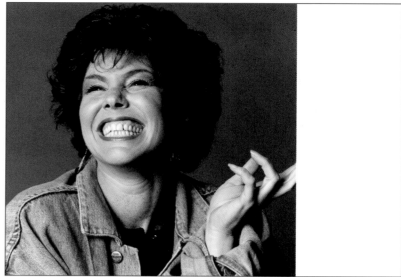

Sandy Toksvig

Jeff Green Ruby Wax

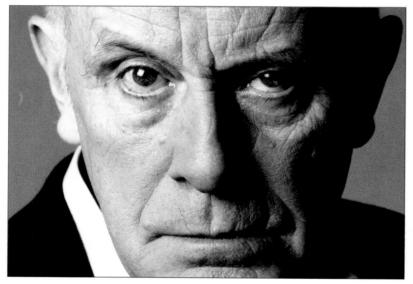

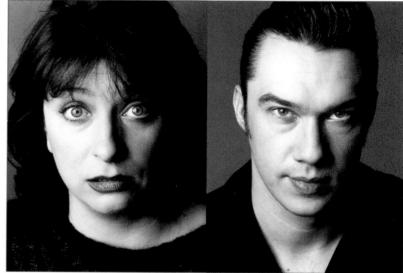

Richard Wilson

Caroline Quentin

Mark Lamarr

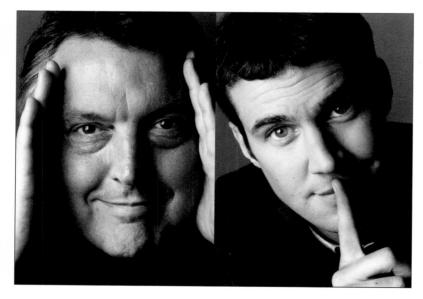

Kim Fuller

Johnny Vaughan

John Sessions

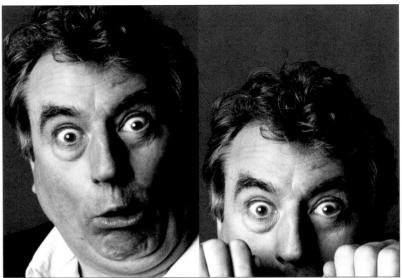

Paul Whitehouse and Charlie Higson Terry Jones

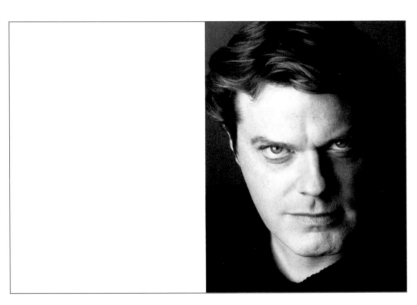
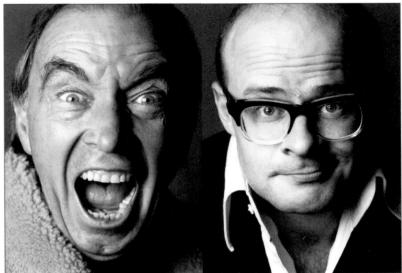

Eddie Izzard Bernie Clifton Harry Hill

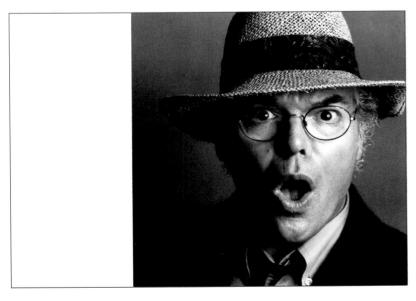
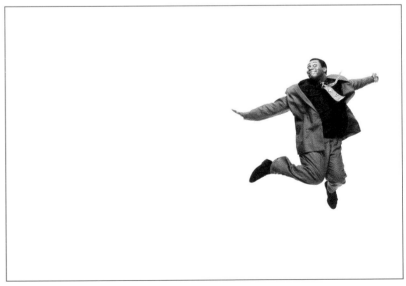

Roy 'Chubby' Brown Lenny Henry

Most special thanks to

My darling wife Rebecca and my children Rosie, Rocco and Spike.

Lenny and Dawn Henry for their unfailing support above and beyond the call of duty.

Long-suffering assistants
David Palmer, Paul Stewart, Dan Kenyon, Gordon Essler, Vernon Samuels, Adrian Saunders, Sam Richardson, Ruth Craffer, Steven Glass, Corrie Bond, Louise Peters, James Burns.

A very special thanks to Nick Powell for being a great friend.

My gorgeous sisters Trish and Sandra.
My later brother-in-law, Lloyd for giving me strength and determination to succeed.

Stephen Johnston for showing me the way.

Kari Allen and Terrance Pepper for believing in me.

Piers-Russell Cobb – Mr Fix-It.

Colin Webb for saying yes.